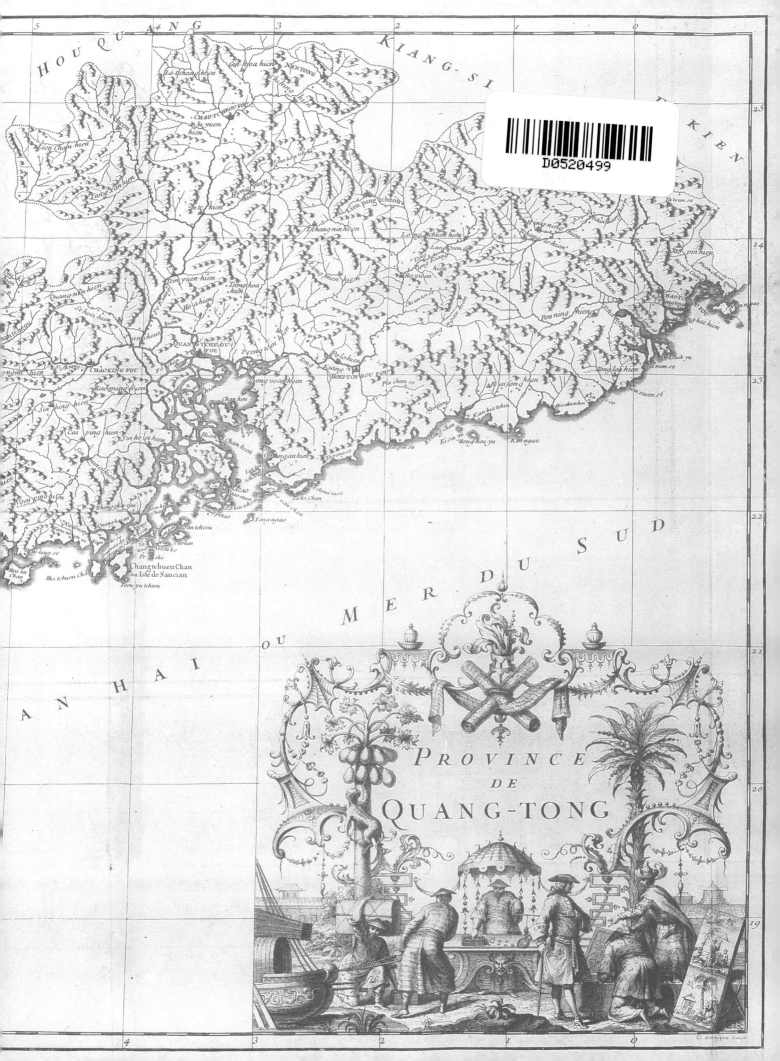

BLUE & WHITE CHINA

A. Humblot del. Baquoy Sculp.

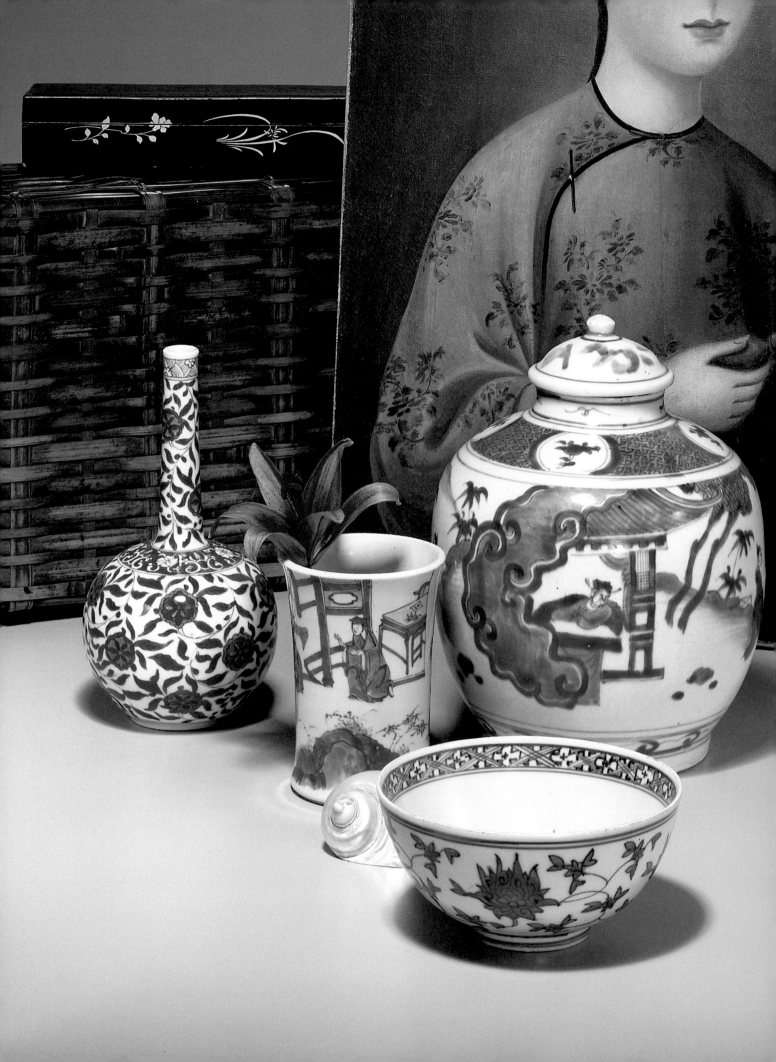

BLUE & WHITE & CHINA

ORIGINS / WESTERN INFLUENCES

edited by
JOHN ESTEN

photographs by
OLOF WAHLUND

text by
ROSALIND FISCHELL

Little, Brown and Company
Boston • Toronto • London

For
Ethel Harper Esten Sanders,
who often said,
"A successful room should have
a touch of red
and something Chinese."

HALF-TITLE PAGE:
Engraving of European ship anchored in the Pearl River
in the province of Canton. First published in
A Geographic Description of the Empire of China, Paris, 1735.

OPPOSITE TITLE PAGE:
Four underglaze blue Chinese porcelain vessels
from the Jiajing, Transitional, and Kangxi periods.
FOREGROUND: Ming dynasty, Jiajing period (1522–1566).
Bowl decorated with four large lotus flowers.
Diameter: 5¾".
LEFT: Qing dynasty, Kangxi period (1662–1722).
Bottle with an overall floral design. The underside is marked in
underglaze blue with the symbol *G.*
Height: 9⅜."
CENTER: Qing dynasty, Kangxi period (1662–1722).
Brush pot decorated with figures.
Height: 4⅞."
RIGHT: Ming–Qing dynasty, Transitional period (1620–1683).
One of a pair of covered jars with a figure in a garden pavilion.
Height: 9½".
All, courtesy Ralph M. Chait Galleries.

FIRST EDITION
SECOND PRINTING

Library of Congress Catalog Card No.: 87–3863

Published simultaneously in Canada
by Little, Brown & Company (Canada) Limited

PRINTED IN JAPAN

CONTENTS

ACKNOWLEDGMENTS

Blue and white porcelain has different meanings for different people — childhood memories, aesthetics, rarity, even prestige. Imagine possessing a teacup once owned by a duchess. I remember so many early happy times associated with blue and white china, and now, since the concept and completion of this book, I have a whole new store of pleasant associations and memories connected with its preparation.

Many people have contributed in many ways — some with scholarship, others with interest and enthusiasm, and still others with kindness, patience, and their time.

Probably my greatest pleasure in producing this book was working with Olof Wahlund, whose unerring eye and taste have resulted in these extraordinary photographs. Along with Olof, there was the added pleasure of Kathy Wahlund, his wife, who helped to smooth the many irksome details connected with a project of this magnitude. Paul Hollerbach, Olof's assistant, was an integral part of this project, both in the studio and on location, lugging equipment.

Roz Fischell, a friend and colleague of many years, assumed the Herculean task of making sense of the vast subject of this book. It is a subject that contains many contradictions, and writing it entailed the difficulties of coping with uncertain facts and dates as well as with the complexity of the Chinese language itself.

Most of the porcelain and other objects photographed in this book were borrowed from private collections or from dealers who specialize in porcelain. Without the interest and enthusiasm of these individuals, a book of this scope could never have been achieved.

Mildred Mottahedeh, who owns one of the finest private collections of China trade porcelain, not only allowed us to borrow choice pieces from the collection to photograph but also was extremely generous in lending rare books and other research works from her personal library.

I would like to mention especially the lenders:

John Anderson, Michelle Beiny, Doris Leslie Blau, Princess Amédée de Broglie, Allan Chait, Catharine Dives, Ferdinand Flores, Linda Gracie, Ronald Grimaldi, Marion Chait Howe, Rebecca Rice Jones, John Rosselli, Helene Rubin, Jack Seidenberg, Carl Steele, Sylvia Tearston, William Thompson, Paul Vandekar, Michael Weisbrod, Arthur Williams, and Edith Wolf.

I am very grateful to the people who allowed us to photograph in their homes and who endured most graciously all the disruption that always entails. In particular, I would like to thank Roy Bernat, Michelle Beiny, Ronald Kane, Inman Cook, Jay Crawford, Sol Grossman, John and Penny Hunt, Carl Steele, and Robert Wright, as well as Margo Burnette, executive director of The Philadelphia Society for the Preservation of Landmarks, and Margaret Spigler of the Powel House in Philadelphia.

Sir Francis Watson, former director of the Wallace Collection in London and a distinguished scholar whose work on mounted porcelain we have liberally drawn upon for that section of the book, was more than generous with his help.

Pat Coman and Kathryn Deiss of the Thomas J. Watson Library at the Metropolitan Museum of Art, Mary Dougherty of the Photograph and Slide Library of the Metropolitan Museum of Art, Marguerite Lavin of the Brooklyn Museum, Peter Rose and Louisa Smith of Christie's, Letitia Roberts and Andrea Kust of Sotheby's, J. D. Culverhouse of Burghley House, Alexandra Munroe of The Japan Society, Marion Pennink and Charlotte Bralds of the Consulate Generat of the Netherlands, Norman Fischell, Dr. Jay Weiss, Berkley Leeds, Janet Roberts, Jill Felson, Miki Dehhof, Elizabeth Holloway, Dorothy Straight, Amanda Freymann, Rick Tetzeli, and especially Maggie Brown have greatly contributed to this book in various ways.

Ray Roberts, with his foresight and belief in the concept of this book, and his help and advice in putting it together, has made this project a continuing pleasure.

John Esten

PREFACE

It seems as though the Chinese invented everything— from paper to pasta to porcelain. Yes, real true porcelain, but not decorated with blue. It was an exciting moment when they were first able to combine the blue on the white porcelain. What a winning combination! Everybody wanted it, as the other options were quite limited — earthenware, wood, pewter, or, if you were an emperor or khan, silver or gold.

Imagine, if you can, actually seeing the first porcelains brought back from China by Marco Polo. There was nothing to compare them with —absolutely nothing. This was the beginning of the Western craze for porcelain. Popes collected it, princes tried to copy it, and Queen Elizabeth I gave it as very special gifts. And what gifts — certainly they were considered more valuable than gold. The queen actually had her porcelain mounted with silver-gilt— a classic example of "gilding the lilies."

The popularity of blue and white china is still remarkable — almost everyone loves it, collects it, eats off it, or remembers it with nostalgia. It's been said that the earliest memory for some children is of the blue of an unclouded sky — that very same blue reflected on one's grandmother's treasured set of English Willow. Remember how the strawberries and cream looked and tasted in those blue and white bowls?

Think of all the books and magazine pages devoted to rooms. Somehow a room without blue and white porcelain somewhere included seems like a portrait without a smile. It's fascinating how a piece of blue and white china adds a certain presence or shimmer to a room, as flowers can sometimes do too.

Here's *real* romance — hearing the distant tinkling of camel bells under a star-encrusted sky, or smelling the scent of jasmine on an early summer breeze as you progress up the Pearl River toward Canton after a six-month sea voyage.

Here's adventure — the amazing discovery of sunken treasure in the South China Sea, or the plight of an alchemist kept a virtual prisoner by a king obsessed with finding the recipe for porcelain.

Here's the whole glittering panoply of the China trade, along with its impact on lives, fashions, and many things we now take for granted every day — including blue and white.

John Esten

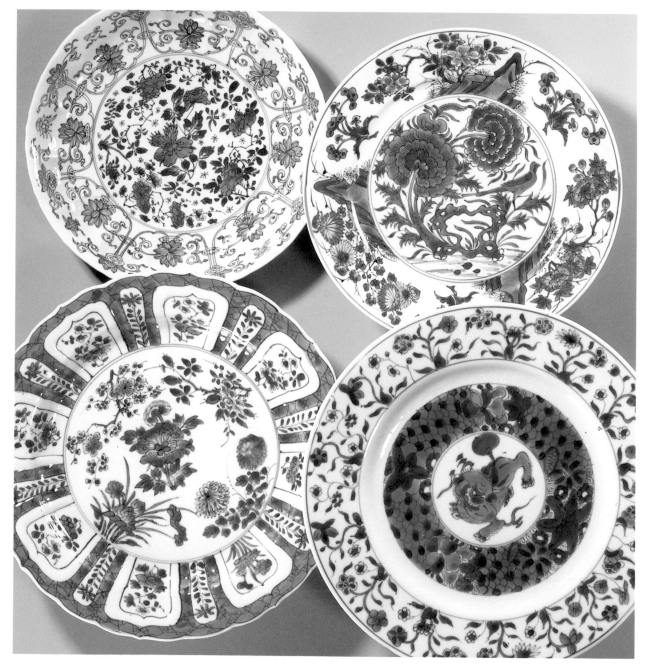

QING DYNASTY, KANGXI PERIOD (1662–1722).
Underglaze blue plates decorated with flowers and mythical animals.
Largest diameter: 9½".
All, courtesy Ralph M. Chait Galleries.

INTRODUCTION

In a sixteenth-century account of the French royal treasurer's Oriental collection, mention is made of porcelain "white and beautifully decorated with small paintings."[1] At this time, when few Europeans had ever seen porcelain, only aristocrats and princes of the church could afford to possess objects made of this rare and costly substance.

Although they were unaware of the complex symbolism underlying those small paintings, Europeans were fascinated by the exquisitely observed details of the natural world. The subjects included birds, animals, insects, and plants, and represented an aesthetic sensibility far different from that of the West.

Then there was the porcelain itself, fine and smooth in the hand, superior to all other ceramics in the world. In combination, the blue painting and the dazzling white porcelain exerted a compelling attraction.

Europe probably saw porcelain for the first time when Marco Polo brought some examples back to Venice after his extended sojourn at the court of Kublai Khan. The West had no name for these mysterious objects that were musically resonant, paper-thin (so that one could see through them), and yet so hard the sharpest blade could not cut them. Marco Polo called them *porcellane* — Italian for "little pigs" — a word also used for the cowrie shell, which was white and shiny like porcelain and served as currency in China.[2]

The Chinese had invented porcelain as long ago as the Tang dynasty (618 – 906), but they managed to keep its formula a closely guarded secret for a thousand years and more. Merchant venturers, diplomats, missionaries — indefatigable travelers along the old Silk Roads across Central Asia — were deliberately misled about what they thought they saw at the places of porcelain manufacture.

During the fourteenth and fifteenth centuries, occasional pieces of blue and white porcelain found their way from far-distant China to the Islamic world of the Middle East, and eventually reached Europe. In 1461, the Sultan of Egypt presented a gift of twenty pieces of blue and white porcelain to Doge Pasquale Malipiero of Venice and later gave several more to Lorenzo de' Medici, *il Magnifico*.

These strange curiosities of the universe — for so was porcelain regarded — were often encased in gold or silver mountings and safeguarded in the treasuries of great cathedrals or displayed on sideboards in magnificent palaces. It was only much later, when it was more widely traded, that blue and white porcelain appeared on the tables of the wealthy as well as the noble, inspiring the dinner set of matching pieces, and, consequently, the custom of the dinner party, a new way of flaunting one's porcelain riches.

Artists of the Renaissance, baroque, and rococo periods, fascinated by the luminous blue and white porcelain, incorporated these exotic wares in their still-life paintings — the "modern" art of this time.

Legends of their supposed occult powers made blue and white ceramics even more desirable. The pieces presented to Lorenzo de' Medici were purported to be detectors of poison; it was believed that a porcelain cup would crack or break when poison was dropped into it. Considering the nature of Florentine politics at the time, the gift must have been gratefully received.

Another de' Medici, Francesco I, Grand Duke of Tuscany, achieved a noble if partial success around 1582 in his attempt to duplicate Chinese porcelain. Working side by side with the best scientists of his day, he tried to solve the mystery. He eventually succeeded in producing a soft-paste (low-fired) porcelaneous ware with a clay from Vicenza containing some kaolin. Only about sixty pieces of the beautiful Medici ware, part of what was a small

and isolated production, still survive.

In the seventeenth and eighteenth centuries, admiration for blue and white porcelain reached new heights. It was said that Louis XIV of France melted down all his silver dishes and bowls to underwrite his military misadventures; the suspicion is inescapable, however, that he was only too happy to replace his table silver with the Chinese porcelain he loved so much. In Saxony, Augustus the Strong's acquisitive passion was so obsessive that he traded a regiment of soldiers for forty-eight Chinese vases, most of them blue and white.

As it became more widely available, Chinese blue and white was coveted even more. With millions of pieces having been shipped to Europe in the eighteenth century, porcelain became a major factor in world trade. Fashionable circles on the continent and in England were swept by a mania for blue and white china, the new interior decoration. Rooms became mere backdrops for displays of blue and white china, which mirrored walls reflected into infinity.

The German alchemist or gold-maker Johann Friedrich Bottger discovered the formula for porcelain in 1709. Even earlier, the Dutch had developed their Delftware copies of Chinese blue and white porcelain. Other European and English ceramic industries, protected by tariffs, rushed to compete with imitations of their own.

Inevitably, the market was surfeited. Styles and tastes changed, and Chinese blue and white porcelain lost its special cachet, although there always remained those who cherished it. For connoisseurs today, the pleasure in and quiet contemplation of these prized objects are enhanced by the long-lost worlds they conjure up.

Rosalind Fischell

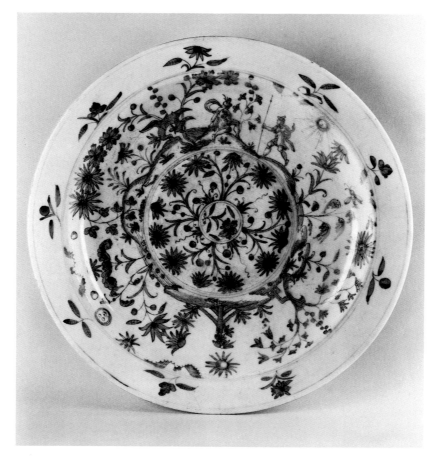

MEDICI WARE, ca. 1580.
Underglaze blue dish, one of about sixty pieces of soft-paste porcelain produced at the Fonderia in Florence. The decoration combines Chinese, Turkish, and Renaissance design elements.
Diameter: 11".
Metropolitan Museum of Art, New York.
Gift of Mrs. Joseph V. MacMullan and Fletcher Fund, 1946.

BEGINNINGS

ierce Mongol tribes, commanded by Kublai Khan, swept down from the north in 1279 to vanquish the armies of the Southern Song Empire, which had lasted 319 years. Kublai proclaimed himself Great Khan of the Celestial Kingdom and, in a politically astute move, chose the Chinese name Yuan for his dynasty.[*]

With this victory, the vast empire founded by Kublai's grandfather Genghis Khan was finally consolidated. It extended from Korea and the Chinese mainland across the interminable deserts and grassy steppes of Central Asia to the Middle East and Europe, stretching westward to the Danube River and the Adriatic Sea. Within this colossal domain, all barriers to trade and the exchange of ideas and scientific discoveries disappeared, along with national boundaries.

Both the seaways to the spices of India and the great Silk Roads traversed by camel caravans during the Han dynasty (206 B.C.–220 A.D.) were now reopened.[†] Missionaries, diplomats, and traders, including Christians, Persian Muslims, Greeks, and Jews, were lured to China by the easier travel and Kublai's enlightened attitudes. These people exchanged new technologies, ideas, and products.

One of the most significant Western products introduced by Kublai Khan to China, according to many scholars, was a superior-quality cobalt blue from Persia, which had been used there for centuries in ceramic decoration, in the form of smalt (powdered glass made from silica, potash, and oxide of cobalt).

No one knows exactly when, but sometime during the Yuan dynasty potters at the important manufacturing center of Jingdezhen, in Jiangxi Province, began to paint miniature pictures on their unfired clay vessels using this blue pigment.[‡] They called it at different times *wu ming yu* (nameless rarity), *su-ni-po* (Sumatra), or *hui hui ch'ing* (Mohammedan blue). One wonders whether in his stately summer palace at Shangtu, Coleridge's Xanadu, Kublai Khan dined off plates not only of gold and silver, but of blue and white porcelain as well.

It is generally agreed that Persian merchants were first to appreciate the Chinese porcelain, commissioning the Chinese potters to adapt their designs to Persian taste. The demand for blue and white porcelain was enormous in the Islamic countries of the Middle East. Islam discouraged representation of the human figure, and so the wares produced by the Chinese potters reflect Persian compartmentalization and geometric ordering of the clay surface; motifs of flora and fauna derive from both Persian and Chinese sources. The Chinese were always quite successful in absorbing foreign influence without changing their own aesthetic, recording their keen observations of nature in deft blue sketches.

The new wares, however, did not please Chinese scholars, who, in their veneration of the past, found the blue and white a vulgar departure from the subtle forms and exquisite monochrome glazes of the native Song dynasty (960–1279). For the Chinese, blue and white would be a gradually acquired taste.

[*] Yuan: "The First Beginning" or "The Original." Never before had a foreign dynasty ruled all of China, nor had a dynastic name referred to anything other than a region or place.
[†] The romantic name Silk Road (*Seidenstrassen*) was coined in the nineteenth century by Baron Ferdinand von Richthofen.[1] It is somewhat misleading, since silk was not the only cargo of the ancient East-West trade.

[‡] Cobalt had been imported into China from Persia during the Tang dynasty (618–906). It was applied as a single color and in combination with yellow, green, and white glazes. Potters gradually stopped using it, however, until its reappearance in the Yuan dynasty.

3

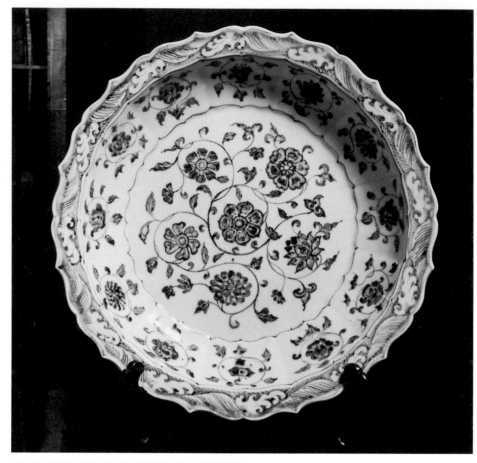

MING DYNASTY, EARLY FIFTEENTH CENTURY.
Persian-influence dish of saucer shape, decorated in underglaze
blue; the cavetto has a breaking-wave design, and the central
area displays six lotus blossoms amid vines. This is an early example
of a piece designed specifically for trade with the Near East.
Diameter: 11".
The Mottahedeh Collection.

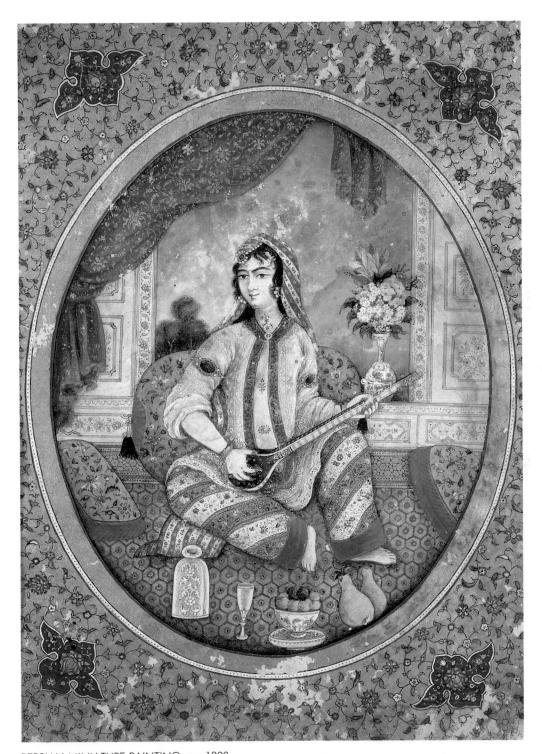

PERSIAN MINIATURE PAINTING, ca. 1800.
Gouache on vellum.
Dimensions: 6" x 8½".
The emperor Kareem Khan's favorite, Shakhunbat, is shown
playing a musical instrument. In the setting are pieces of Ming
dynasty porcelain and a Waterford crystal decanter and goblet.
The Mottahedeh Collection.

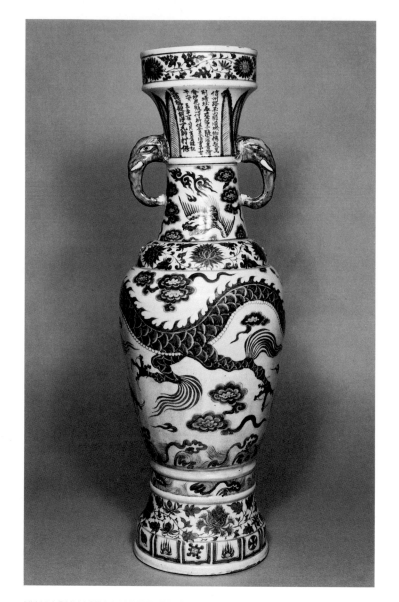

YUAN DYNASTY. MARKED BELOW NECK: 1351.
One of the two "David vases," created for presentation to a
Daoist temple (according to the mark) in the Yushan district,
southeast of Jingdezhen. Each has underglaze blue decoration of
a dragon pursuing a pearl amid stylized clouds and flames.
Height: 25".
Percival David Foundation of Chinese Art, University of London.

JINGDEZHEN,
THE PORCELAIN CAPITAL

The waterways of Jiangxi Province —large lakes connected by canals — offer easy access to Jingdezhen for the traveler and trader from the major commercial centers of Nanking, in the south, and Canton, six hundred miles to the east. Approached at nightfall from its tranquil rural surroundings, the town appeared to the French Jesuit missionary Père d'Entrecolles as if it were aflame. In a letter of 1712, he wrote, "The sight with which one is greeted on entering through one of the gorges consists of volumes of smoke and flame rising in different places, so as to define all the outlines of the town . . . the scene reminds one of a burning city."[1]

Jingdezhen is situated on a vast plain where the Chang River meets a tributary that gushes down from mountain gorges to the north and west. It has an excellent port, and the water route to the coast is largely by way of the Yangtze River. In the eighteenth century Jingdezhen was an industrial stronghold of worldwide importance, with a population of over one million people. Only Venice was larger.

The inhabitants of Jingdezhen were concerned mainly with the manufacture and distribution of ceramics — pottery had been produced continuously in the town for almost four thousand years. Since artisans and merchants worked for pay, they occupied the lowest rung on the Chinese social scale, below even peasants. Jingdezhen always retained its designation as a town and was never elevated to the more important status of city, but it had a great advantage in being an unwalled town (*zhen*), for when the potters outgrew available space, the boundaries could be easily expanded.

The town's name had originally been Jangnanzhen, but it was changed in 1004, when the Song emperor Jingde (1004–1007) honored it by establishing the imperial porcelain works there. He appointed a superintendent and inspectors to oversee the production of the palace wares (which were marked with the period name Jingde) and also their transport to the capital, Nanking, by the water route.

The high standards of the imperial factory proved to be an inspiration to the small family-owned potteries, which gradually began to produce their own distinctive ceramics independent of court domination. During the Song dynasty, superb monochrome wares with glazes of jadelike green, blue, and creamy white were produced in both private and imperial kilns. Later, the bulk of export wares, first to West Asia, and then to Europe, England, and North America, was produced in the private kilns. The Matsang Mountains to the east of Jingdezhen were a plentiful source of the raw materials of porcelain — kaolin and petuntse (porcelain stone). The raw materials were first discovered by potters around 1700 B.C. during the Shang dynasty (eighteenth to sixteenth century B.C.–1027 B.C.). Some of the earliest discoveries of kaolin in Europe were near Dresden in Saxony, near Limoges in France, and in Cornwall in England. In North America, kaolin was first found in South Carolina.

Kaolin and petuntse are minerals derived from granite in different stages of its decomposition. Kaolin, also called porcelain earth, fires white, unlike most clays, which produce a red color. Its name is derived from its earliest source, Gaoling (the name means "high ridge"). Kaolin brings plasticity to the modeling process, and petuntse is added to provide fusibility or to cement the refractory clay particles. Since petuntse contains quartz, it is the principal glaze ingredient, making a vessel hard and nonporous.

Before it can be combined with kaolin, petuntse must be pulverized and purified, done in early days by water-driven mills. It is then turned into little white briquettes or *pai tun tzu*. In combination, and with water added, kaolin and petuntse act to strengthen each other.

Recent technical findings, though, indicate far less uniformity in the composition than was long believed in the West to be the case. When their Persian customers, for instance, called for pieces of massive sizes, Chinese potters could alter the porcelain recipe by increasing the proportion of kaolin to provide additional plasticity in construction.

The transition from stoneware, which becomes vitreous (with a hard glasslike glaze) at a high temperature, to porcelain, fired at a still higher temperature, was made gradually by the Jingdezhen potters. There was always the danger — and the possibility was even greater when the heat was intensified and the baking process lengthened — that the potter would find just broken pieces or a fused mass upon opening the kiln door. Even under ideal circumstances, the proportion of loss or damage was high.

The Chinese and Westerners differ in their definition of true or hard-paste (high-fired) porcelain. The Chinese consider all hard, fine-grained wares that emit a musical ring when struck to be porcelain. They do not emphasize the whiteness and translucency that are so important to the West.

The invention of lustrous pure white porcelain in the Yuan dynasty was preceded by several earlier types of porcelain, notably the powdery blue-glazed *qingbai* of the Song dynasty and the egg-shell-glazed *shu-fu* (Privy Council), which early in the Yuan dynasty was made to order for the imperial palace. The technical ability of potters was so advanced that even in the Tang dynasty they were able to produce a high-fired translucent ware; upon seeing porcelain in Canton in 851, the Arab traveler Sulayman marveled at "cups in the fineness of glass in which the light of water can be seen even though it is of clay."[2]

The potters used the Persian method of painting directly on the unfired body. After painting, the vessel was either sprayed with the glaze through a bamboo pipe or dipped into it, and then fired. The decoration, which had been gray-black before firing, turned an intense blue, and the glaze sheathed it in a transparency as smooth as glass. The colors used for the underglaze decoration were limited to cobalt blue and copper red because of their ability to withstand high-temperature firing. Copper red was less stable and reliable, so its use was infrequent.

In the beginning, during the long period of experimentation with the new cobalt medium, the potter probably did most of the painting himself, occasionally assisted by others. Demand for the wares soon brought about the specialization of mass production and the consequent division of labor — probably the first assembly line.

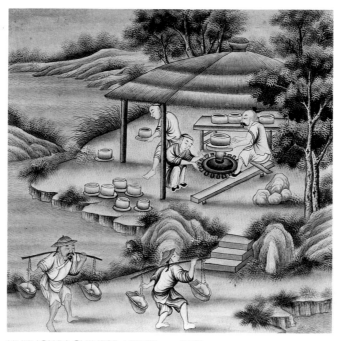

UNKNOWN CHINESE ARTIST, ca. 1800.
Watercolor on paper. *Dimensions:* 10½" x 10".
Illustration of forming porcelain on a potter's wheel.
Henry Francis du Pont Winterthur Museum, Delaware.

From early Ming times, the outlining and filling in of designs were separate operations in the imperial factory. In the private factories, where cost was more important, one painter only was assigned to the work of decoration, and therefore the export wares sometimes had a more spontaneous and individual quality. Later, in the eighteenth century, when the industry was fully developed, as many as seventy hands in each of the major factories were involved in the painting process alone. The *Zingdezhen t'ao lu,* a major source of information on the subject, says, "The draughtsmen draw but do not paint, the painters paint but do not draw. In this way the hand is concentrated and the mind is not distracted."[3] In later years, careless execution resulted in a loss of quality in the mass-produced wares.

The task of decoration always required tremendous skill and patience, for unbaked clay is like a blotter that soaks up every line, permitting neither error nor erasure.

The designs for the decorations of the imperial wares during the Ming and later dynasties came from the court's finest artists and were collected into pattern books that less skillful artists could use in their production.

The earliest documented examples of blue and white porcelain are the splendid pair of vessels known as the "David" vases, inscribed with the date 1351. Years of experimentation must have preceded them, for they represent dazzling mastery. They are a monumental twenty-five inches high, reminiscent in form of Bronze Age vessels.

The central decoration is a dragon with four claws, pursuing a pearl through clouds. In Chinese mythology, the dragon is a beneficent lord of the skies, the bringer of rain, and a symbol of fertility. It is said that the five-clawed dragon represents the goodness and power of the emperor, while three- and four-clawed dragons indicate lesser rank. Three- and four-clawed dragons are also found on sixteenth-century porcelains of imperial quality. The dragon forever pursues the flaming pearl of perfect wisdom that symbolizes the heart of Buddha as well as pure intentions, genius in obscurity, feminine beauty, and purity.

Increasing vigor and naturalism can be seen in a large storage jar, or *kuan,* clearly intended for rigorous use. The carp swimming among the waterweeds is so skillfully executed that one almost anticipates its next movement through the water.

Although the Mongol dynasty came to a violent end less than one hundred years after its self-named "First Beginning," its influence on the ceramic art of China was permanent. According to Margaret Medley, the invention of blue and white porcelain represents "the most revolutionary technical and decorative innovation of the Mongol regime in China, if not in the whole of Chinese ceramic history."[4]

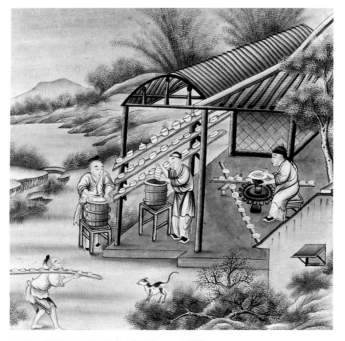

UNKNOWN CHINESE ARTIST, ca. 1800.
Watercolor on paper. *Dimensions:* 10½" x 10".
Illustration of decorating the porcelain wares.
Henry Francis du Pont Winterthur Museum, Delaware.

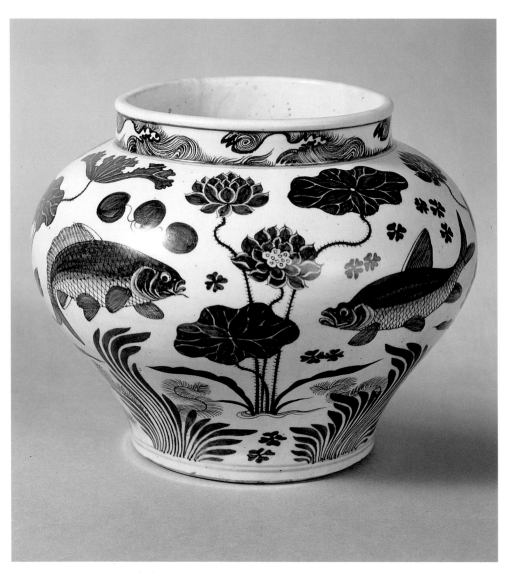

YUAN DYNASTY (1279–1368).
Kuan (storage jar) with underglaze blue carp swimming amid
lotus and water plants.
Height: 11¼".
Brooklyn Museum, New York. Gift of the executors of the estate
of Augustus B. Hutchins.

TRADE WITH THE WEST

In the early Middle Ages, knowledge of the Orient vanished almost completely from Western consciousness. Although China was larger in area and population than Europe, maps of the time exclude it completely, ending at the eastern border of India.

During the time of the Roman Empire, however, China had been well known to Westerners through extensive commerce. All this trade passed through Persian and Egyptian middlemen who exchanged Syro-Roman glass, purebred horses, silver, and gold for Oriental spices, rhubarb, and the most profitable commodity of all, silk. Curiously, there is no evidence that Chinese pottery was, at any time, part of this commerce.

Eastern luxuries drained Rome's treasury of gold and hastened the empire's final collapse. After the fall of Rome, only the countries of the Arabian Peninsula — Persia, Egypt, Syria, and Arabia — as well as Byzantium and North Africa continued to trade with the Orient. Despite frequent intervals of war and conquest, the Arabs maintained their lucrative monopoly on Eastern trade and their control over the Silk and Tartary roads and the sea route.

In the thirteenth century, Chinese ceramics were almost completely unknown in Gothic Europe. Only occasional pieces of porcelain were brought to the important trading cities of Genoa and Venice.

Marco Polo's detailed account of the exotic land he called Cathay was first ridiculed and then studied with rapt fascination. He brought back several pieces of porcelain from the court of Kublai Khan, one of which is said to be an incense burner now in the Treasury of St. Mark's Cathedral in Venice.

As rumors of the fabulous wealth of China and the Indies multiplied, early explorers were emboldened to venture into unknown waters. They set out not to discover new continents but to bring back the products of China. Christopher Columbus, who treasured Marco Polo's *Description of the World,* was the first to go west to search for ways to the East that would bypass the sea lanes dominated by the Arabs.

The Portuguese explorer Vasco da Gama took another, more dangerous route in 1497 when he sailed his caravel* around the Cape of Good Hope and then on to India. The Portuguese joined missionary zeal with commercial enterprise and ruthless conquest. "We come to seek Christians and spices," cried one of de Gama's crew as he set foot on Indian soil. De Gama returned laden with profitable Indian spices and also some pieces of Chinese porcelain, probably obtained through a Chinese trader in Malacca, since he never reached China.

Vasco da Gama's daring voyage set Europe on a new course. The wealth that had poured into Venice and Genoa from the trade with India and Asia now went to those nations with Atlantic Ocean ports. The Portuguese now gained control of the Eastern trade and established entrepôts at key points on the Indian Ocean and in Southeast Asia.

The Portuguese were the first Europeans to trade directly in China. In 1514, during the reign of Zhengde, a fleet of their merchant ships (called *kraaks,* or carracks[†]) first reached the island of Tunmen, off Canton. An Italian merchant who accompanied an early expedition wrote to Giulano de' Medici: "they are a people of great skill, and are on a par with ourselves . . . During this last year some of our Portuguese made a voyage to China.

* A vessel designed in the shipyards of the Portuguese prince Henry the Navigator. It was small, maneuverable, and fitted with lateen sails for heading into the wind.
† Merchant vessels designed for long voyages, which had as many as seven decks and carried up to eight hundred people. They were heavily armed, which enabled them to dominate the sixteenth-century trade routes.

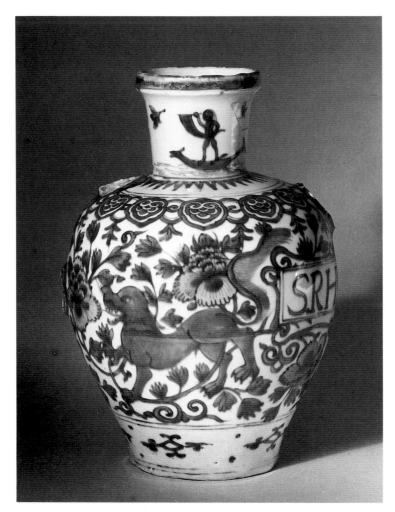

QING DYNASTY, SHUNZHI PERIOD (1644–1661).
Underglaze blue drug jar of European form, one of the earliest
made for the Western market, probably copied from a Spanish
or Portuguese majolica prototype. The handle and spout are
missing. The cartouche with scrolling border is labeled S. RHODOM,
possibly a misspelling of *Syrupus de Rhodium* (Syrup of Rosewood).
Height: 10⅜."
The Mottahedeh Collection.

They were not permitted to land; for they say 'tis against their custom to let foreigners enter their dwellings. But they sold their goods at a great gain."[1]

After a series of hostile encounters, the Zhengde emperor closed the port of Canton to all foreigners. The Portuguese, not easily dissuaded, managed to carry on a surreptitious trade with Chinese coastal towns. Blue and white porcelain became so popular in Lisbon that even when, by 1522, shipments amounted to forty to sixty thousand pieces a year, demand still outstripped supply. In 1554, the Portuguese were granted a settlement at Macao, near Canton, in exchange for their help in ridding the South China Sea of pirates.

The sixteenth century was Portugal's golden age. The products of its far-flung trading empire were funneled into the rest of Europe through Lisbon and brought enormous profits. Lisbon was a city as brilliant as Venice or Rome, with a humanistic Renaissance spirit and a taste for Oriental opulence.

The Spanish were the next to take advantage of the China trade. They took a different route east in order to avoid the South Atlantic and Indian lanes controlled by the Portuguese. Porcelain went through the Philippines to Mexico, where it was carried overland to the Atlantic Ocean and then shipped on to Spain.

Philip II, king of Spain and Portugal, closed the port of Lisbon to Dutch shipping in 1594. In reaction, the Verenigde Oost Indische Compagnie (V.O.C.), the Dutch East India Company, was created in 1602 for the purpose of trading directly with China.

The Dutch began around this time to plunder the Portuguese carracks returning from the East, taking the vessels and their cargoes of porcelain back to Amsterdam to be sold at auction. This series of international sales attracted the attention of King James I of England and also of Henry IV of France, whose agents bid successfully on a dinner set of the finest quality. Wealthy Dutch burghers were there too, eagerly replacing their heavy earthenware with plates and dishes of fine, smooth Chinese blue and white porcelain.

The Dutch named the bulk wares *kraakporselein,* thus acknowledging, without even a blush, their privateering. The word *kraak* has thus gradually come to denote all late Ming dynasty export porcelain of the Wanli period (1573–1620). Thin-walled and somewhat brittle, *kraak* ware is characteristically decorated with alternating panels, flower borders, and a central scene including flowers, deer, birds, and insects.

Kraak wares caused a sensation in Europe. Records indicate that in 1636 a fleet of six ships sailed from Batavia, the Dutch port in Indonesia, carrying over 259,000 pieces.

As trade expanded, special orders for porcelain were often accompanied by detailed drawings as well as examples of European ceramics, glass, silver, and pewter; occasionally, wooden molds were sent as patterns to be executed for the Western market.

Meanwhile, the English were waiting impatiently to enter the profitable Chinese trade. Queen Elizabeth I had affixed her seal to the charter of the London East India Company in 1600, but it was not until 1643 that the English were granted trading concessions by the Chinese. Since the Portuguese had intervened with the Chinese to exclude the English from Canton, the English were forced to conduct business at the outposts of Amoy and Formosa, as well as certain ports along the coast of India.

Then, in 1699, the Kangxi emperor opened the port of Canton to the nations of the West. The English trading ship *Macclesfield* entered the port in 1700 and loaded a "full and rich" cargo mostly of tea, with some porcelain. During the eighteenth century, world trade with China increased dramatically. In short order, the lingua franca changed from Portuguese to Pidgin (commercial) English. The English would dominate this trade until the beginning of the nineteenth century.

Although great quantities of porcelain were imported into England, the volume was small compared to that of the richest cargo of all — tea. But from the demand for tea came, eventually, a demand for teacups.

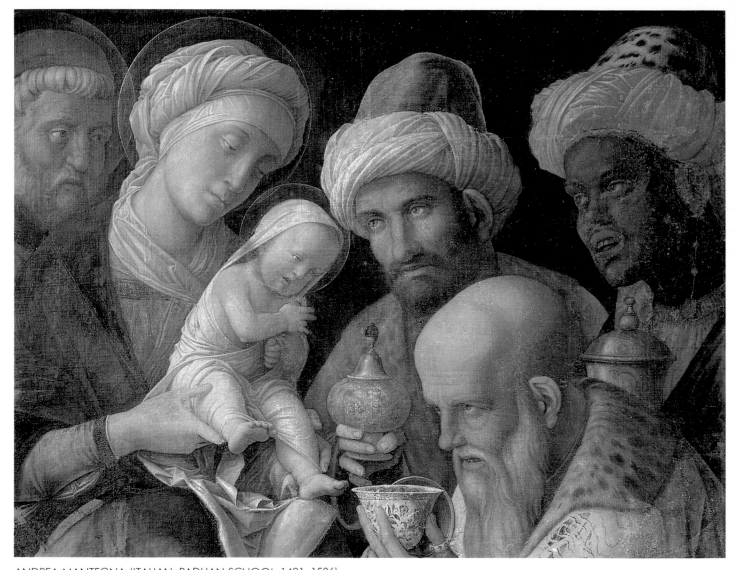

ANDREA MANTEGNA (ITALIAN, PADUAN SCHOOL, 1431–1506).
Adoration of the Magi, late fifteenth century.
Tempera and oil on linen laid down on canvas.
Dimensions: 21½" x 27 ⅜".
The cup held by the first king, Caspar, is of an unorthodox
shape, owing to artistic license. It is decorated in a contemporary
Chinese style dating to the reign of the emperor Chenghua (1465–1487).
Courtesy Christie's International.

THE MING DYNASTY
(1368–1644)

Soon after ascending the Heavenly Throne, Hongwu (1368–1398) ordered an imperial factory built in Jingdezhen at Jewel Hill and ordered twenty private kilns to work for the palace. The emperor's edict confirmed Jingdezhen as the ceramic capital of the empire; with eighty percent of domestic and foreign production concentrated there, the other ceramic centers lost their importance. The imperial potters were eager to display their command of the ceramic material and their virtuosity. They constructed pieces of enormous size, including vases six feet tall, fishbowls large enough to hold a whole school, dishes four feet across, garden seats, and even footbaths.

By the end of the Ming dynasty, "houses were covered with porcelain roof tiles and pagodas were concocted entirely of porcelain and stoneware."[1] The potters claimed that there was nothing that could not be made of porcelain, and they furnished as proof porcelain pillows and porcelain intended for decorating, for eating, and for ritual purposes, and merely for the pleasure of collecting.

Early on, the expensive imported cobalt blue (reputedly worth its weight in gold) was mixed with cobalt from native sources, or else the native cobalt was used alone. The less refined pigment was often applied with free, bold strokes from a heavily loaded brush, creating the "heaped and piled" effect imitated by eighteenth-century potters in their admiration for the earlier wares. The exact hues, ranging from a pale silver to a dark blue, depended upon the purity of the cobalt and the concentration of the glaze.

All through the Ming dynasty, the private kilns produced increasing quantities of stronger and coarser blue and white porcelain for export, as well as more refined wares for domestic use. Early in the Ming period, the design of imperial wares strongly influenced the designs that came from the private kilns.

Sheila Riddell points out that the rich ornamentation of pieces designed for Muslim taste "gradually evolved into the restrained elegance of the fifteenth century."[2] The reigns of Xuande (1426–1435) and Chenghua (1465–1487) are known as the Classical period, when porcelains of the greatest delicacy and beauty were made for the palace. Writing of these wares, A. D. Brankston said, "In Yung-lo the lotus has budded, in Hsuan-te the flower has opened in all its freshness, and by Ch'eng-hua the leaves begin to tremble in the breeze."[3]

The Zhengde emperor (1506–1521), grandson of Chenghua, was a libertine encouraged in a life of vice by the palace eunuchs, many of whom were Muslims. While the emperor caroused, they carried on the affairs of state and indulged themselves by ordering at will from the imperial porcelain factory. The fascinating "Mohammedan Wares," mostly accessories for the writing table, date from this time. They are inscribed with mottoes in Arabic, such as, "Strive for excellence in penmanship, for it is one of the keys of livelihood." Fresh supplies of Mohammedan blue arrived at this time — the best, a deep rich blue called Buddha's-head blue.

The Muslims made a hasty exit when Zhengde died and was succeeded by his cousin Shih Tsung, who took the reign name Jiajing (1522–1566). The emperor was devoted to Daoism, and many Daoist emblems appeared in the decoration of porcelain from this era. Particularly popular was the peach tree, a symbol of longevity, with trunks or branches twisted into Shou (longevity) characters. Children, sages in landscape settings, and the Three Friends of Winter (bamboo, pine, and plum) are also frequent themes.

The blue of this period is highly regarded for its quality. The potters continued to improve their methods of purifying the cobalt ore and managed

to achieve a brilliant purplish-blue. It was around this time, with an increase in mass manufacturing, that the West became acquainted with blue and white porcelain.

The Wanli emperor Zhu Yijun (1573–1620), grandson of Jiajing, ascended to the throne when he was only ten and ruled for forty-seven years. His reign, the longest and last major rule of the failing Ming dynasty, was marred by corruption and the pernicious influence of the palace eunuchs. While the emperor spent extravagant sums on his palaces, his family, and the pursuit of pleasure, the Manchus in the north threatened the empire with frequent invasions, finally taking over in 1644.

It was the Wanli emperor who, despite the Chinese xenophobia, welcomed the first Jesuit missionary to China. Father Matteo Ricci, esteemed among Chinese scholars, wore mandarin's robes, had a beard in the prescribed style, and lived in Beijing. In 1610, from his deathbed, he whispered to his Jesuit brothers, "I am leaving you on the threshold of an open door."[4]

In Jingdezhen, during the Wanli period, the potters at the imperial kilns found it difficult to meet the insatiable demands of the court for porcelain, sometimes amounting to more than a hundred thousand pieces a year. Overflow commissions were often given to the private kilns. The quality of the decoration and of the porcelain itself declined.

In addition, the Matsang Mountains were rapidly being depleted of china clay, and it was some time before another source was found two hundred *li* (about sixty-five miles) from the kilns. Hauling the clay — and the firewood needed for firing — was costly, a greater burden on the private than on the imperial kilns. Supplies of the Mohammedan blue also began to run out, but the ingenious potters conserved it by combining it with the native cobalt. The color they developed was a grayish blue with a silvery hue.

A mysterious and fascinating exception to the general deterioration of quality is the work of some artist-potters employed in the private potteries during the last hundred years of the Ming dynasty. These artist-potters added new styles and a new aesthetic dimension with their mastery of landscape painting and their use of light and dark washes. They greatly influenced the wares of the Transitional period and succeeding generations.

MING DYNASTY, CHENGHUA PERIOD (1465–1487).
Underglaze blue palace bowl, decorated outside and inside with scrolling lily design.
Diameter: 5½".
Percival David Foundation of Chinese Art, University of London.

MING DYNASTY, WANLI PERIOD (1573–1620).
Large dish with underglaze blue decoration of pheasants
on rocks in a landscape.
Diameter: 12½".
Courtesy Ralph M. Chait Galleries.

MING DYNASTY, XUANDE PERIOD (1426–1435).
Kuan painted in underglaze blue with a dragon and clouds.
The *kuan* is marked below the rim.
Height: 19".
Metropolitan Museum of Art, New York. Gift of Robert E. Tod, 1937.

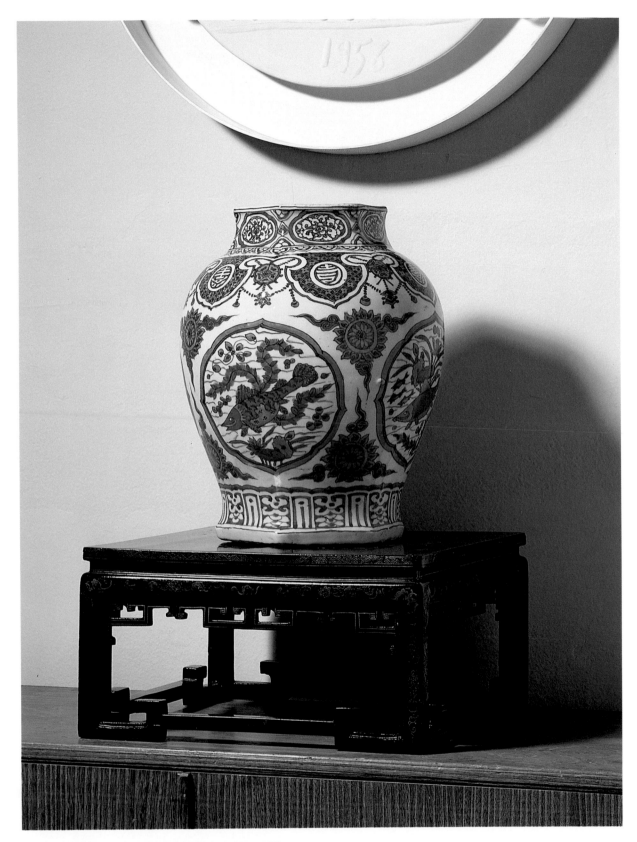

MING DYNASTY, LONGQING PERIOD (1567–1572).
Kuan painted in underglaze blue with central medallions
containing fish swimming among aquatic plants.
Height: 12⅜".
Courtesy Ralph M. Chait Galleries.

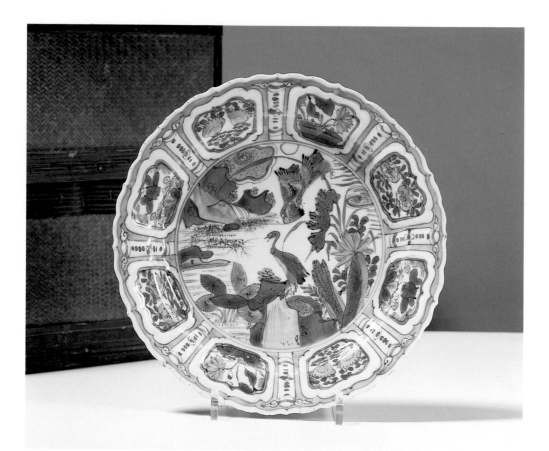

MING DYNASTY, WANLI PERIOD (1573–1620).
Plate with a foliated rim and divided panels, a typical example of
fine-quality *kraak* ware. In the center is a watery landscape with
a pair of geese among rocks and lotus plants.
Diameter: 8¼".
The Mottahedeh Collection.

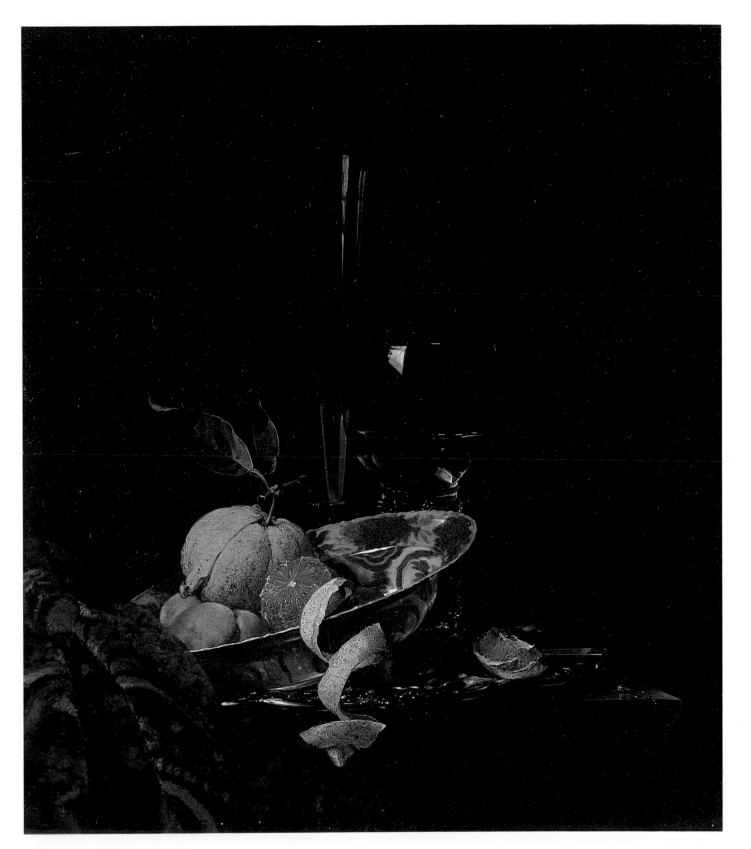

WILLEM KALF (Dutch, 1619–1693).
Still Life, 1659. Oil on canvas.
Dimensions: 23″ × 20″.
Another dish similar to the one in this painting was recovered
from the wreck of the Dutch ship *Witte Leeuw.* The *Witte Leeuw*
sank in 1613 off the coast of St. Helena.
Metropolitan Museum of Art, New York, Maria DeWitt Jessup Fund.

MING–QING DYNASTY, TRANSITIONAL PERIOD
(1620–1683).
Three Dutch-inspired shapes.
LEFT: Bottle with *rolwagen* form decorated with a royal
personage under a parasol in a landscape—probably
a scene from a play or popular novel.
Height: 17".
Courtesy Michael B. Weisbrod.
CENTER: Bottle with long flaring neck, underglaze blue
with floral decoration.
Height: 14".
Courtesy Michael B. Weisbrod.
RIGHT: Ewer in underglaze blue with a royal personage
under a parasol in a landscape.
Height: 14¾".
Courtesy Ralph M. Chait Galleries.
Eighteenth-century European needlework carpet
courtesy Doris Leslie Blau, Inc.

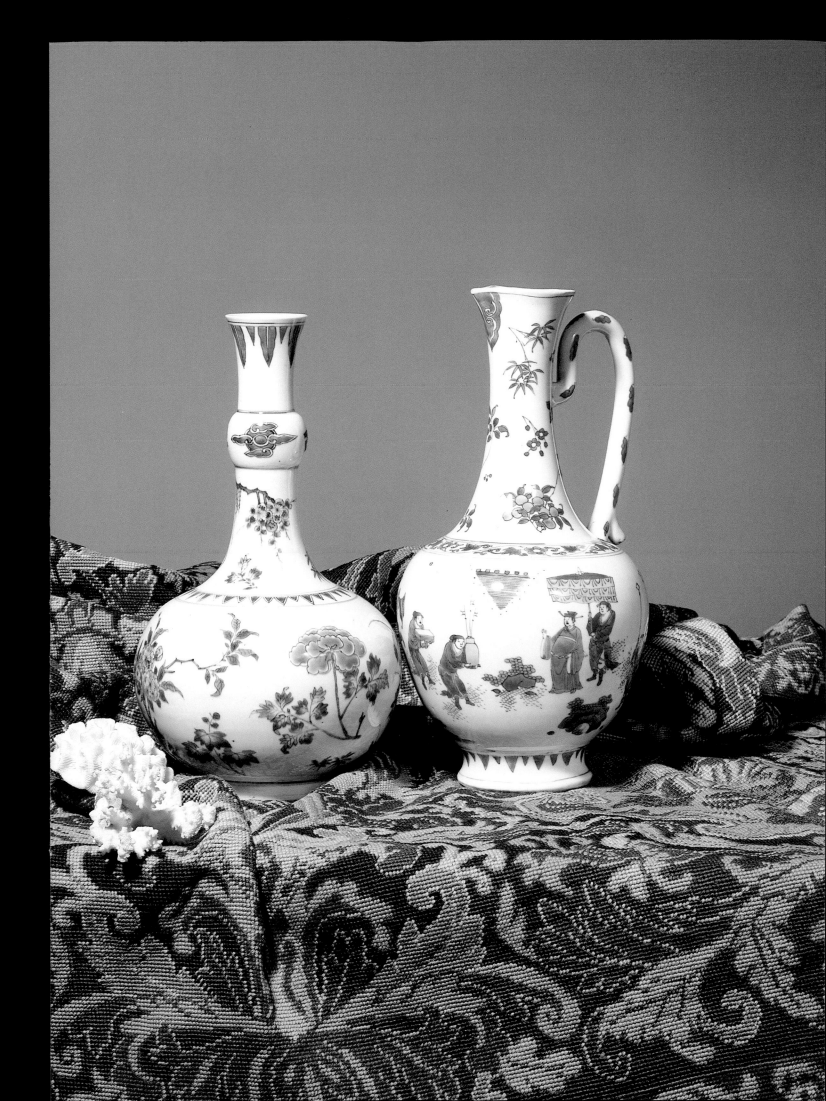

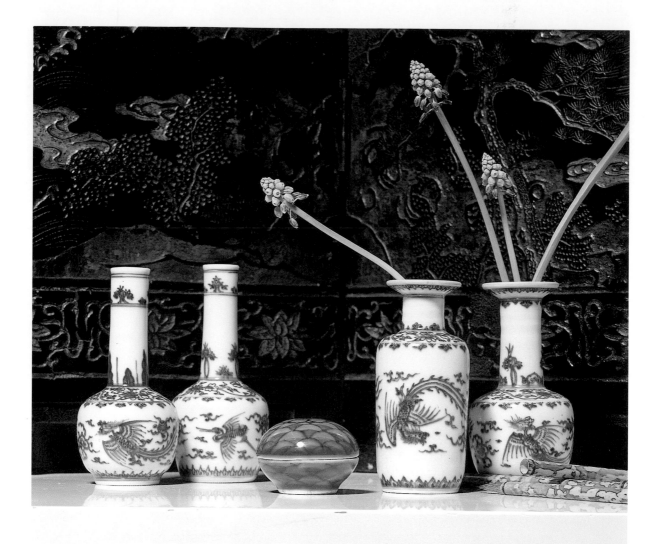

MING–QING DYNASTY, TRANSITIONAL PERIOD (1620–1683).
Four bottles with underglaze blue designs of mythical birds with
cloud scrolls; a box and cover with fish-scale design. Part of a
cargo salvaged in 1983 by Captain Michael Hatcher from the
wreck of a Chinese junk off the Malaysian coast.
Height of largest piece: 4¾".
All, courtesy Ralph M. Chait Galleries.

TRANSITIONAL PERIOD
(1620–1683)

Devastating warfare erupted soon after the death of the Wanli emperor as the armies of the Mings and Qings clashed all across the land in a fearful contest for power. In porcelain manufacture, this chaotic time extended twenty years into the reign of Kangxi, ending with the appointment of Zang Yingxuan as superintendent of the rebuilt imperial factories in Jingdezhen. The mysterious "Transitional" period of sixty-three years — largely unknown in the West until recently — is now recognized as a brief and sudden flowering of the arts that is unique in the continuous flow of Chinese history.

So preoccupied with survival were the last three Ming emperors that they were unable to concern themselves with matters at the imperial porcelain works or with the placing of orders. The loss of the long patronage released the potters from the stifling authority of the palace, but also left them without means of livelihood. In order to survive, the potters had to search elsewhere for customers, and they found them in the expanding markets of Japan, Southeast Asia, and Europe, where the most popular ceramics were blue and white.

Since the familiar Chinese religious and folk symbols — fabulous beasts such as dragons, phoenixes, and *qilins* — meant little or nothing to foreigners, it was necessary for the potters to find new design sources. From early Ming times, export wares had been decorated with universally translatable motifs derived from the natural world — birds, insects, animals, plants, and figures. Now, for the first time, the potters turned to classic literature as well as the popular arts, including paintings and woodblock illustrations from novels depicting contemporary life, for pictorial ideas as well as styles of drawing. A distinct break with the dull formality of the past became evident almost at the beginning of the Transitional period. Stephen Little observes that "by the mid-1620s the wide range of styles and experimentation that characterize the Transitional period as a whole had appeared. Because there were no imperial supervisors present to dictate which shapes and decorative designs were to be produced, the potters had considerable artistic freedom. As a result, the Transitional ceramics of the late seventeenth century reveal a fresh and novel range of style unique in Ming and Qing ceramic history."[1]

The story-telling landscape and riverscape scenes of the Transitional period are painted with sensitivity and reveal a delicate handling of the brush. Perspective compositions of people and animals are extended and joined on round wares such as vases and bowls by the devices of precipitous cliffs, jagged rocks, waterfalls, distant mountains, and swirling clouds. Borders are characteristically decorated with stiff leaves, foliage scrolls, and tuliplike plants.

The highly refined "blue" of this period, probably derived from local sources, is a bright violet; under a thick, bubbly glaze its effect on the pure white porcelain prompted the description "violets in milk."

Westerners were delighted by the exotic painting on the export wares but they quickly became dissatisfied with the limited shapes available, mainly bowls, flasks, and dishes. Soon after the Dutch entered the China trade in the seventeenth century, they sent samples and wooden models of tablewares for the Chinese potters to copy — salt cellars, mustard pots, tankards, bottles, candlesticks, and dishes with flat rims called *clapmutsen*.

When tea drinking became fashionable, enormous quantities of cups were ordered. At first, they were the traditional handleless Chinese cups that had been used in Europe for brandy and other beverages. Cups with single and double handles as well as saucers to hold the cups were introduced by Turkish merchants and were intended for the drinking of coffee. This entire category of specially ordered wares is generally superior in quality to the ordinary export ware that the Dutch named *kraakporselein.*

In the Chinese domestic market, the preference was for ornamental objects rather than tablewares. Pieces of great elegance and simplicity were produced: brush-pots, covered boxes, and vases, including cylindrical ones known as *rolwagen* or *rouleau* types, with rounded shoulders and short flaring necks.

Following the restoration of imperial patronage by the Kangxi emperor, the Transitional period of experimentation and unrestrained artistic expression came to an end. The great achievements of this time would influence the brilliant period ahead; but still, one wonders, as does Richard Kilburn, "what new heights the decoration of porcelain might have reached if it had not reverted at this moment . . . to a court-dominated art."[2]

MING—QING DYNASTY, TRANSITIONAL PERIOD, ca. 1650.
Oviform jar, decorated in underglaze blue with mythical animals in a landscape with rocks and trees.
Height: 10¼".
Courtesy The Chinese Porcelain Company.

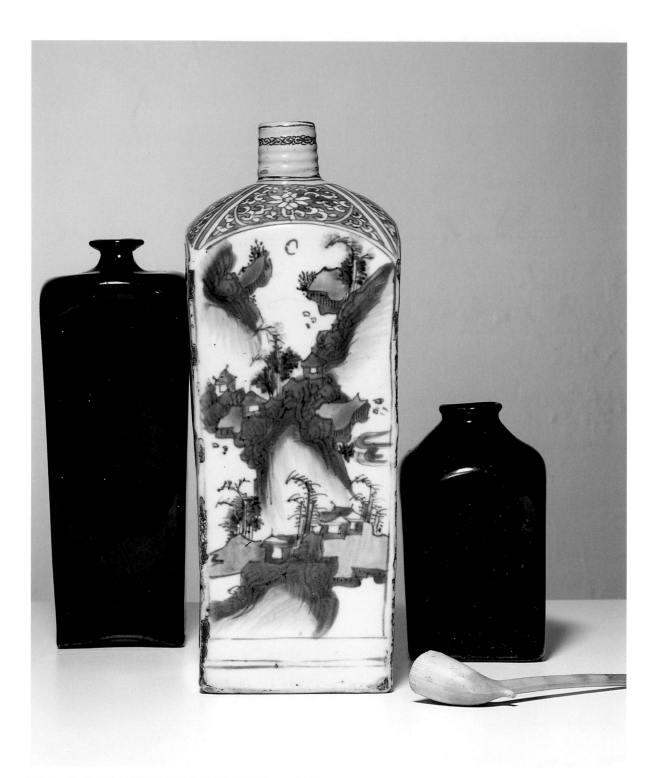

MING–QING DYNASTY, TRANSITIONAL PERIOD, ca. 1650.
Square bottle with underglaze blue decoration of a mountain
landscape. The shape of the bottle was copied from a Dutch gin
or schnapps bottle.
Height: 11½".
Courtesy Sylvia Tearston.

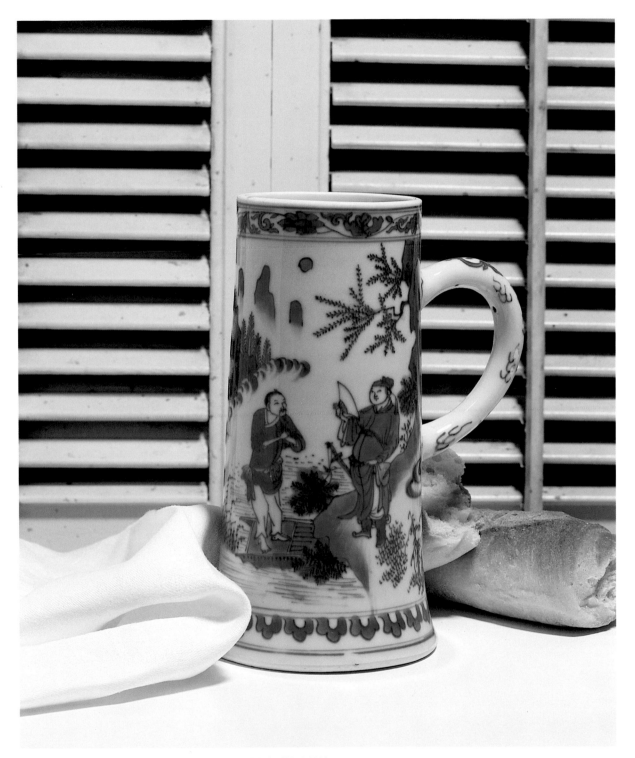

MING–QING DYNASTY, TRANSITIONAL PERIOD (1620–1683).
Tankard with a loop handle decorated in underglaze blue with
the figures of a dignitary and an attendant in a landscape.
Height: 7½".
Courtesy Ralph M. Chait Galleries.

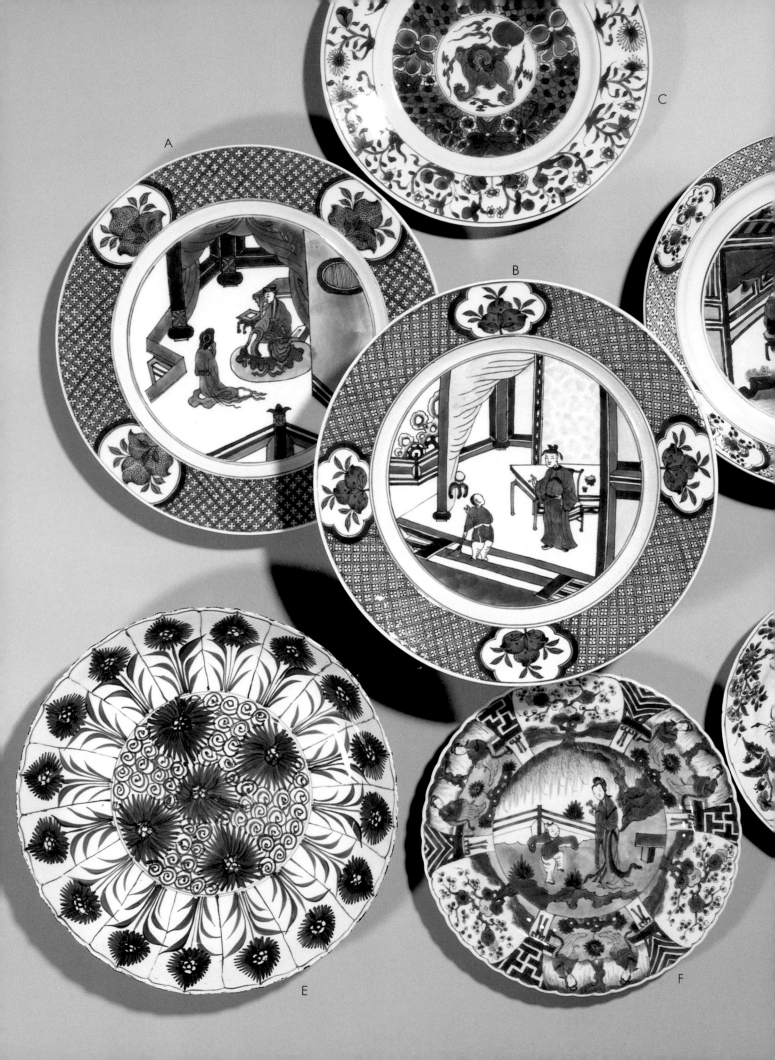

A

B

C

E

F

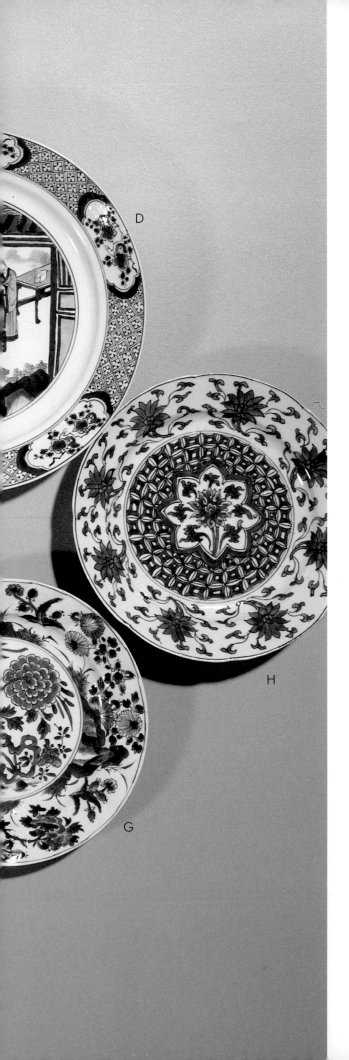

QING DYNASTY, KANGXI PERIOD (1662–1722).
Plates with underglaze blue decoration in various patterns, made for export to the West.
A & B: Dignitaries in various pursuits in garden pavilions; fretwork border with inserted medallions.
Diameter: 10½".
The Mottahedeh Collection.
C: Center medallion with Fu dog; border of blossoming flowers.
Diameter: 9½".
Courtesy Ralph M. Chait Galleries.
D: Two seated dignitaries with an attendant in a garden pavilion; fretwork border with medallions.
Diameter: 9".
Courtesy The Chinese Porcelain Company.
E: Plate with "Aster" pattern, once part of the Herbert Hoover collection.
Diameter: 10½".
Courtesy Ralph M. Chait Galleries.
F: Woman with a child in a garden; fretwork and flower border.
Diameter: 10".
The Mottahedeh Collection.
G: Flower pattern in the center; border with flowers and rocks.
Diameter: 8½".
Courtesy Ralph M. Chait Galleries.
H: Formalized flower spray in the center; floral-pattern border.
Diameter: 8½".
Courtesy The Chinese Porcelain Company.

THE QING DYNASTY
(1644–1911)

The Kangxi Emperor

In its spirit of enlightenment and worldliness, the period of the Kangxi emperor (1662–1722) is similar to that of his grand contemporary Louis XIV of France. Both were devoted patrons of the arts and ardent collectors of porcelain.

The Kangxi emperor of the Qing, or Manchu, dynasty inherited a country torn by internal dissension, to which he was able to bring peace and prosperity only after several decades. His accomplishments were many. "He ruled firmly but compassionately, fathered fifty-six children, fought a winning war against civil uprisings and was known as an indefatigable hunter, a brilliant politician, a poet, scientist, philosopher and bon vivant."[1]

So great was Kangxi's interest in the arts that he gathered together the finest painters, architects, and artisans of his vast realm within the palace walls so he could oversee their work. He had many studios built, including some for carving jade and ivory and making glass, lacquer, and enamel.

Jesuit missionaries who were expert mathematicians, mapmakers, and astronomers soon won the emperor's respect and were invited to work within the palace. The influence of the Jesuits was so strong that when they proposed the use of the Western calendar, the emperor decreed that it be adopted, despite the furor this caused throughout the kingdom.

After Jingdezhen had been leveled by fire during civil disturbances in 1673 and 1675, and the imperial kilns destroyed, Kangxi wanted to install new potteries within the palace precincts. Later, the emperor had Jingdezhen rebuilt and Zang Yingxuan appointed supervisor of the imperial factories in 1683. During Zang's administration, working conditions improved, wages were raised, and the morale of the potters was higher than it had ever been. It was said of Zang that when he was at work "the god laid his finger on the design and protected the porcelain in the kiln so that it naturally came out perfect."[2]

Kangxi decided that it would benefit the economy to open the port of Canton to trading ships of all the European nations. His decision, made at the end of the seventeenth century, frustrated the Portuguese, who had enjoyed an exclusive trade privilege for almost 150 years.

During the Kangxi period, "a profusion of exciting new wares appeared; colors assumed a peacock brilliance and shapes were as complicated as potters could invent."[3] Kangxi blue and white was prized above the wares of all other reigns until the late 1940s, when specimens of the rare, early Ming ware won the favor of connoisseurs.

The body of fine-quality Kangxi porcelain is a perfect white, free of impurities and in complete harmony with the blue decoration. The color is a pure sapphire of great depth and fire. It was repeatedly refined "until the very quintessence had been extracted from the cobaltiferous ore."[4]

The decoration is invisibly outlined, and grada-

QING DYNASTY, KANGXI PERIOD (1662–1722).
Charger in underglaze blue with a woman and child in a landscape with a willow tree; wide fretwork border.
Diameter: 15".
Courtesy Charles R. Gracie and Sons.
BACKGROUND: home of Mr. J. Hyde Crawford.

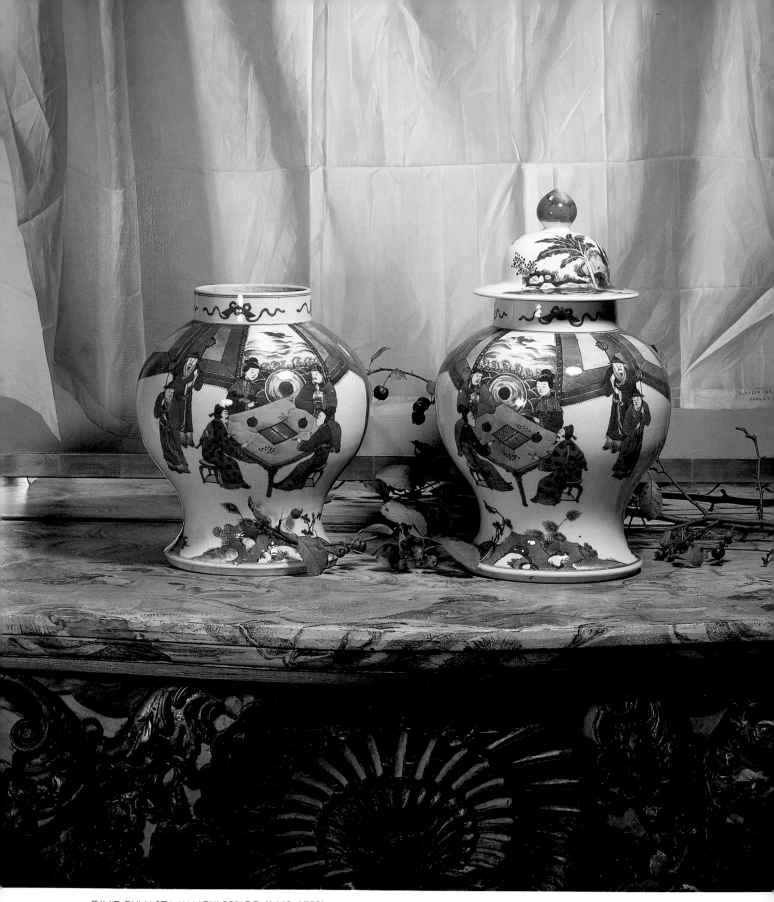

QING DYNASTY, KANGXI PERIOD (1662–1722).
Underglaze blue jars with covers depicting people in a pavilion
seated at a gaming table.
Height: 17½".
Courtesy Charles R. Gracie and Sons.
BACKGROUND: home of Mr. J. Hyde Crawford.

QING DYNASTY, KANGXI PERIOD (1662–1722).
Underglaze blue jar with four inserted panels decorated with
mythical beasts; jar has a teak replacement cover.
Height: 8".
Courtesy Charles R. Gracie and Sons.
BACKGROUND: home of Mr. J. Hyde Crawford.

tions of color are then applied. A subdivision of labor is practiced, in which "one workman is solely occupied with the ring which one sees on the border of the ware; another outlines the flowers, which a third paints; one does the water and the mountains, another the birds and animals."[5]

There was a profusion of decorative motifs, including scenes taken from poetry, mythology, and history and landscapes inspired by Song and Ming paintings. "The noblest of all Chinese blue and white patterns," according to Hobson, the prunus or plum blossom (often mistakenly called hawthorn) appeared against a dark blue background simulating cracking ice and heralding the coming of spring. The jars were customarily filled with gifts, such as ginger or fragrant tea, and delivered to friends at the New Year. Usually the jar was later returned to the giver.

Kangxi was succeeded by his son Yongzheng, who took a personal interest in the porcelain works during his brief reign (1723–1735). At this time the potters were imitating early Ming blue and white, showing reverence for the achievements of their predecessors.

Yongzheng was followed by his son Qianlong (1736–1795). Vowing that he would not rule longer than his illustrious grandfather, he resigned after the end of his sixty-year cycle, at the age of eighty-five. Like his grandfather, he was a friend to the arts, a poet, a calligrapher of great ability, and a collector of bronzes. The emperor was fascinated by all manner of European inventions, and ordered a pavilion built in imitation of Versailles. He owned a collection of European timepieces and ordered copies of Limoges enamels, Delftware, Italian majolica, Meissen, and even Wedgwood jasperware.

Fine blue and white objects imitating fifteenth-century imperial wares were made early on in the Qianlong reign, but there was a noticeable deterioration of quality toward the end of the eighteenth century as the decoration lost its spontaneity and became mechanical. Although blue and white remained an important export commodity, the palace and the home market showed an increasing preference for multicolored enameled wares.

QING DYNASTY, KANGXI PERIOD (1662–1722).
Three underglaze blue jars of different shape and design.
Heights, from left: 8"; 10"; 13".
Courtesy Charles R. Gracie and Sons.
BACKGROUND: home of Mr. J. Hyde Crawford.

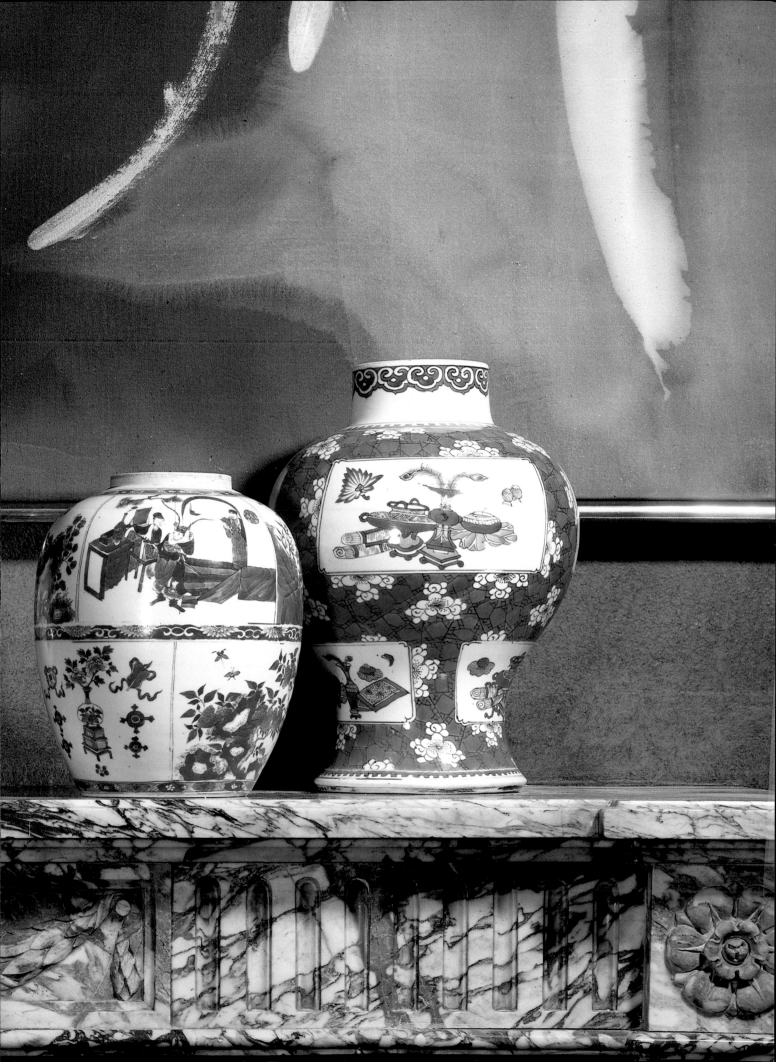

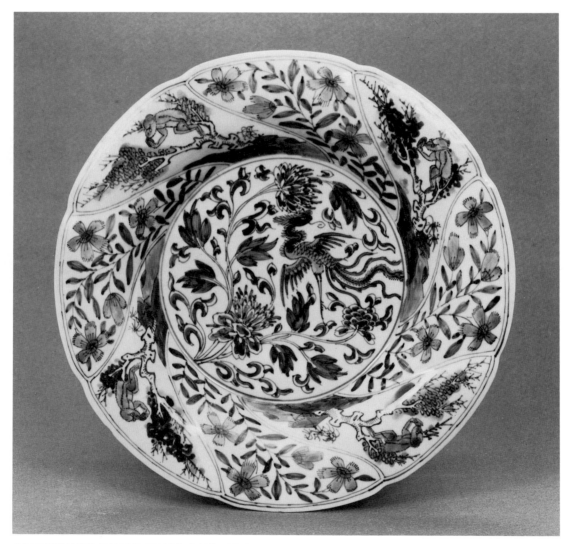

QING DYNASTY, KANGXI PERIOD (1662–1722).
Underglaze blue plate with a phoenix and
a peony spray in the center. The plate imitates a common
European silver form.
Diameter: 11¼".
The Mottahedeh Collection.

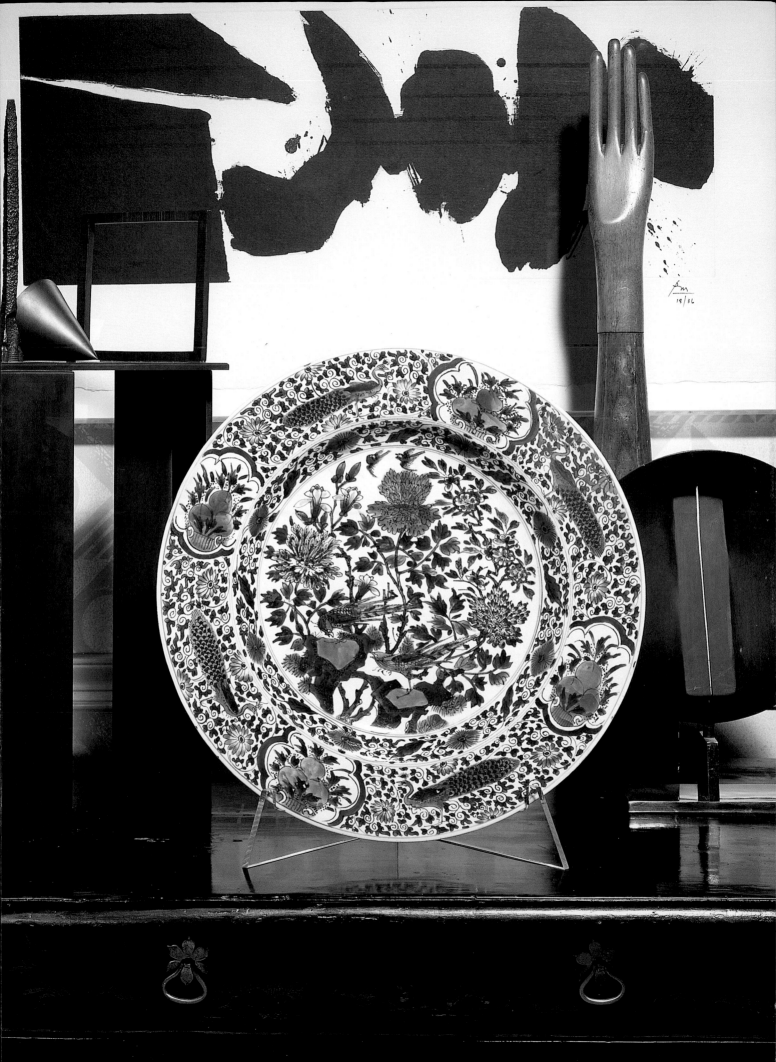

QING DYNASTY, KANGXI PERIOD (1662–1772).
Underglaze blue double gourd bottle with *T'ao T'ieh*
(monster mask) designs.
Height: 9½".
Courtesy Ralph M. Chait Galleries.

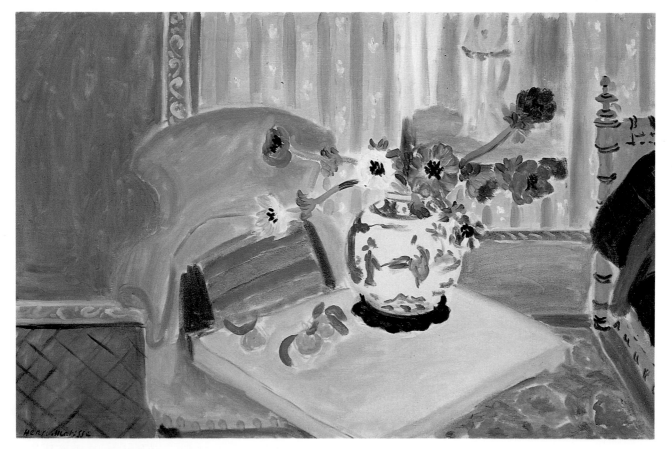

HENRI MATISSE (FRENCH, 1869–1954).
Anemones and Chinese Vase, 1922. Oil on canvas.
Dimensions: 23 ⅝" × 36¼".
The jar depicted is underglaze blue with figures in a landscape,
possibly of the Kangxi period.
Baltimore Museum of Art, Maryland. Cone Collection formed by
Dr. Claribel Cone and Miss Etta Cone.

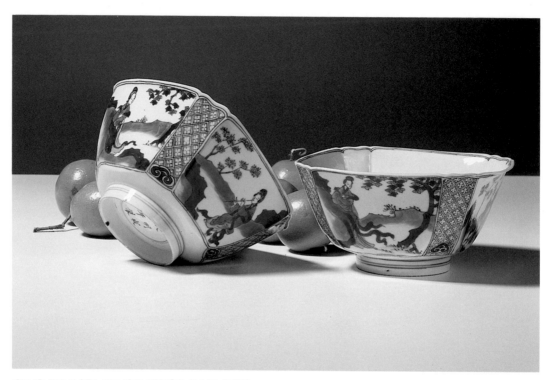

QING DYNASTY, KANGXI PERIOD (1662–1722).
A pair of octagonal bowls, underglaze blue with four divided
panels with figures in a landscape; the bottom is marked with the
Chenghua reign mark as a gesture of deference to the skill of
the earlier potters.
Diameter: 6".
The Mottahedeh Collection.

QING DYNASTY, KANGXI PERIOD (1662–1722).
Underglaze blue plates with a woman and a child in a garden
scene in the center and a fretwork border.
Diameter: 10".
Courtesy Nuri Farhadi, Inc.
English trumpet wine goblets ca. 1820;
English cut-glass decanter ca. 1790.
Courtesy Bardith, Ltd.
BACKGROUND: home of Mr. Carl Steele.

QING DYNASTY, KANGXI PERIOD (1662–1722)
A group of underglaze blue porcelains.
LEFT: Covered jar with figures in a landscape, with gilded lion
on lid and gilded elephant handles.
Height: 8½".
CENTER: Jar with cover, decorated with medallions with flower-
spray inserts.
Height: 8½".
RIGHT: Bowl with sides decorated with figures in a landscape.
Diameter: 7¾".
All, courtesy Ralph M. Chait Galleries.

JAMES McNEILL WHISTLER (AMERICAN, 1834–1903).
Group of Four Porcelains, before 1878. Gray wash on paper.
Dimensions: 7⅝" × 6⅝".
Collection of Munson-Williams-Proctor Institute, Utica, New York.

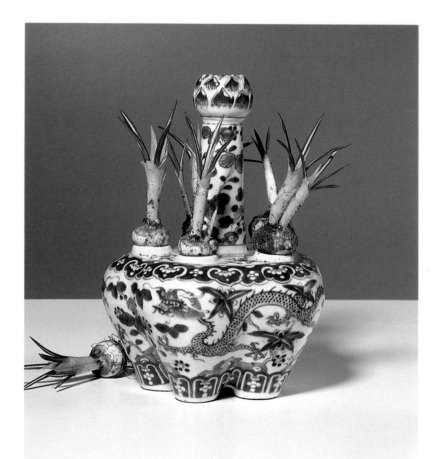

QING DYNASTY, KANGXI PERIOD (1662–1722).
Underglaze blue crocus pot decorated with a four-clawed
dragon surrounded by plant forms.
Height: 10".
The Mottahedeh Collection.

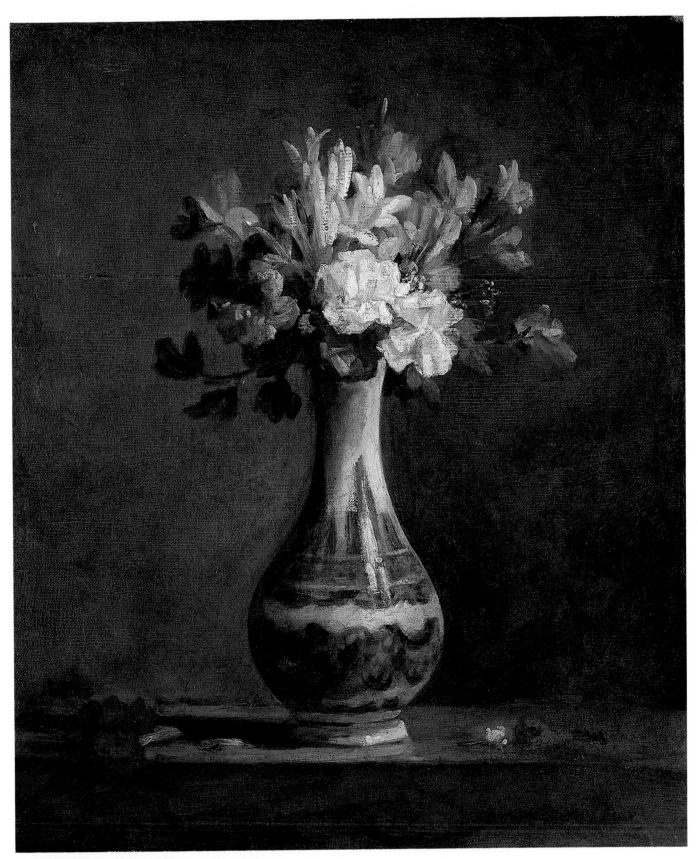

JEAN BAPTISTE CHARDIN (FRENCH, 1699–1779).
Vase of Flowers, 1760. Oil on canvas.
Dimensions: 19⅜″ x 14³⁄₁₆″.
The bottle in the painting is probably of the Kangxi period.
National Gallery of Scotland, Edinburgh.

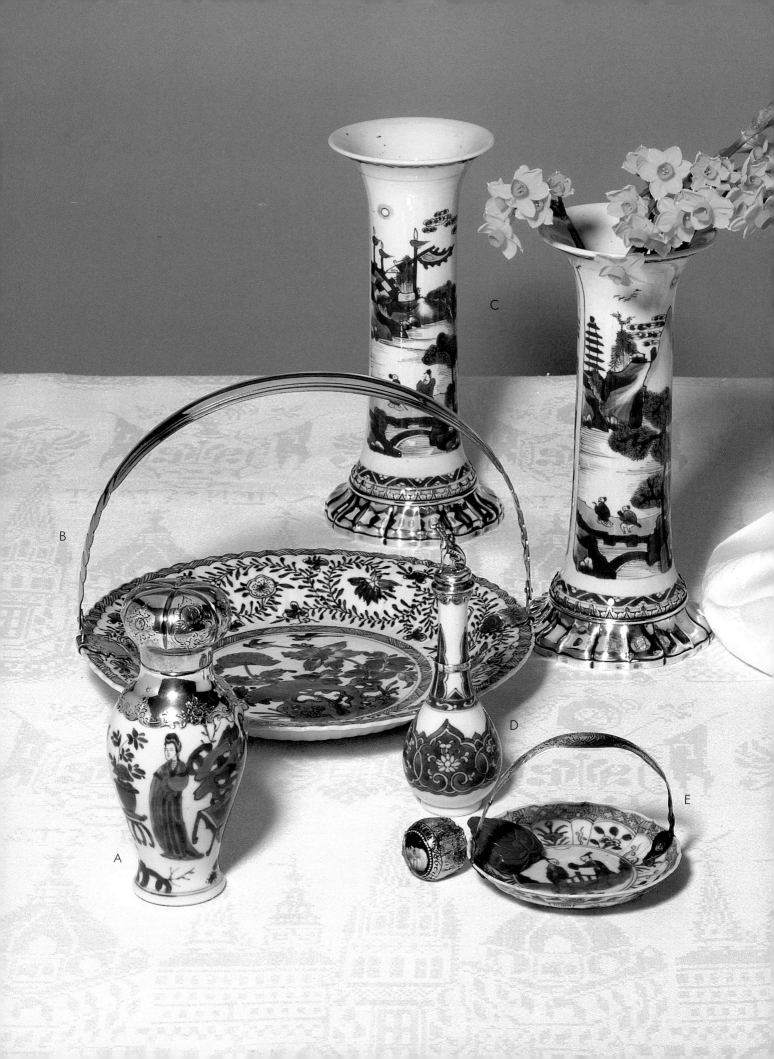

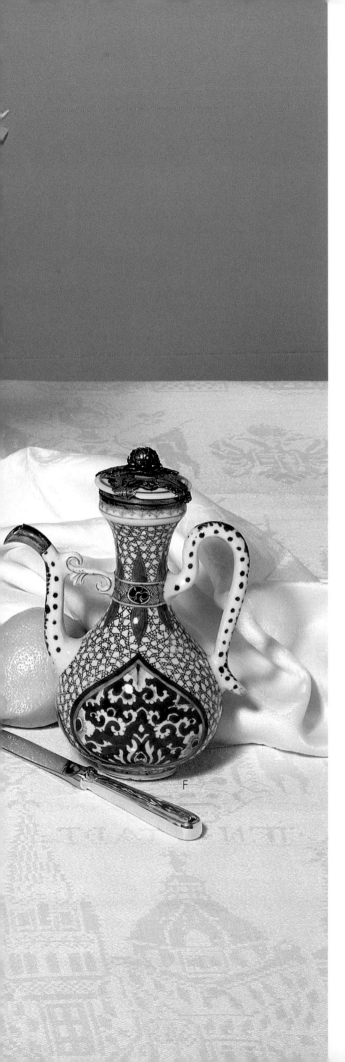

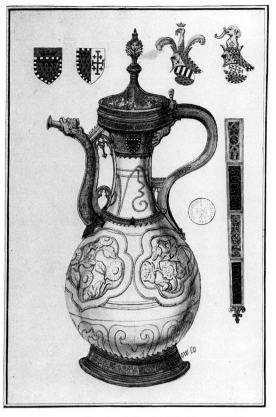

ROGIER DE GAIGNIÈRES (FRENCH, 1642–1715).
The Gaignières-Beckford Ewer, ca. 1713.
Watercolor on paper.
Dimensions: 9″ × 13½″.
A detailed rendering of the porcelain bottle mounted as
a ewer with silver gilt and enamel. Also illustrated are
the armorial bearings of its royal owners. This Yuan
dynasty (1279–1368) bottle is the most important
surviving example illustrating the early method of
mounting porcelain.
The Bibliothèque National, Paris.

QING DYNASTY, KANGXI PERIOD (1662–1722).
Group of underglaze blue mounted porcelains intended
for the Dutch market.
A: Oviform bottle with figures; the neck was mounted
ca. 1700 in engraved silver with a fitted
knob-shaped stopper.
Height: 6¾″.
B: Plate decorated with plant forms, mounted for use
as a cake stand.
Diameter: 8½″.
C: Slender beakers with figures in a landscape;
the bases are mounted in silver with gadrooning.
Height: 10⅜″.
D: Condiment bottle; mounted with a silver stopper with
a hound on top.
Height: 6½″.
E: Small dish with figures; mounted with
a swing handle.
Diameter: 4″.
F: Ewer with traditional Persian-influence shape and
decoration; silver-gilt hinged lid mounted with oak leaf
and bud finial.
All, The Mottahedeh Collection.

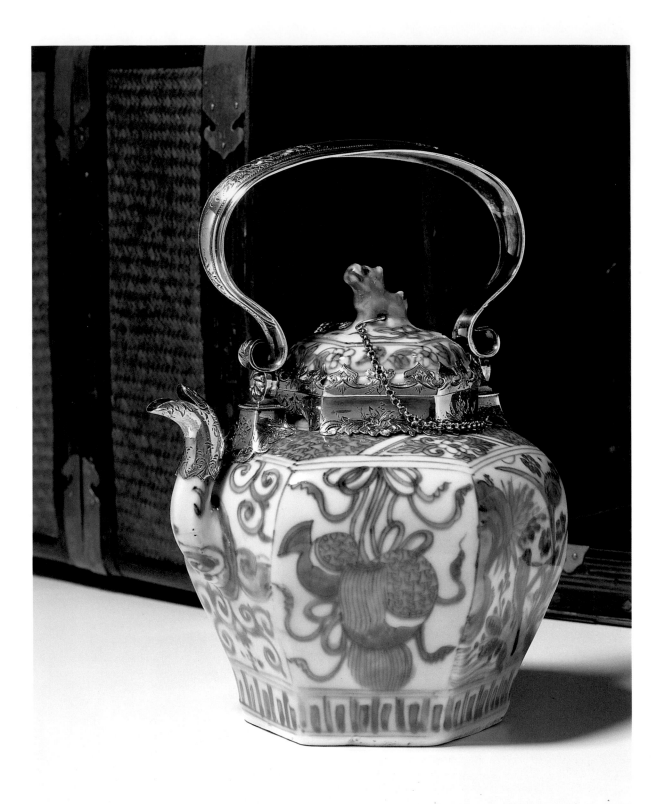

MING DYNASTY, WANLI PERIOD (1573–1620), DUTCH MOUNTED.
Underglaze blue hexagonal wine pot or kettle with Dutch silver
mounts, decorated with auspicious emblems tied in ribbons
and with birds and insects.
Height with handle: 8¼".
The Mottahedeh Collection.

EUROPEAN-MOUNTED CHINESE PORCELAIN

Chinese porcelains were so rare in Europe in the fourteenth century that they were mounted like jewels in gold or silver settings that were then enameled or embellished with pearls and garnets. Even when Chinese porcelain became more readily available during the baroque and rococo periods, the custom of mounting porcelains, now with ormolu and gilt bronze, continued throughout Europe, most particularly in France, where it became a new decorative art form.

To Western eyes, there was nothing incongruous in this embellishment of porcelain; on the contrary, the mount seemed to emphasize the exotic nature of the object. From medieval times there had been a tradition of mounting precious and religious objects for the treasuries of great cathedrals. St. Mark's in Venice was the repository of "bowls and goblets of classical and Byzantine origin, mounted in gold, silver and silver-gilt, partly to emphasize their rarity and also to adapt them for ecclesiastical use as chalices, patens and so on."[1]

The earliest known piece of Oriental porcelain that was once mounted is the so-called Gaignières-Beckford ewer. A white Chinese porcelain bottle with incised floral decoration, made in Jingdezhen around 1300, during the Yuan dynasty, the bottle is believed to have been a present from the last Yuan emperor to Pope Benedict XII. It was acquired by Louis the Great of Hungary, who was probably the one who converted it into a ewer by the addition of enameled and silver-gilt mounts. The mounts disappeared mysteriously after the death in 1849 of the last owner, William Beckford.

In its earlier history the ewer appeared in three major collections: that of Charles III, king of Na-ples, that of the Grand Dauphin, son of Louis XIV and one of the earliest connoisseurs of Chinese porcelain in Europe, and that of the antiquarian Rogier de Gaignières.

Elizabeth I of England possessed more than fifteen hundred blue and white porcelain pieces — enough certainly to set a banquet table. She presented a mounted Ming dynasty bowl to her godchild Thomas Walsingham as a baptismal gift. The bowl has a silver-gilt band with a sawtooth edge around the rim; the band is engraved with Elizabethan-style flowers and is connected to the base by five undecorated strips. This bowl may possibly have been one of the pieces brought back to England in 1580 by Sir Francis Drake.

During Drake's circumnavigation of the globe, he is said to have captured a Spanish ship and taken its porcelain cargo. When he later anchored at what is now called Drake's Bay, north of San Francisco, to clean and repair his ship, a case of late Ming dynasty blue and white porcelain may have fallen overboard and later been recovered by the Miwok Indians. Another explanation for the arrival of the first porcelain in America has it that the crew took broken pieces ashore and traded them to the Indians, who used the blue and white shards to ornament the graves of their dead.

At the beginning of the seventeenth century, Dutch silversmiths began mounting some of the Chinese porcelain in simple and elegant settings. An accurate record of those mounted pieces can be found in contemporary Dutch still-life paintings, most notably in the works of Willem Kalf. The Dutch mounted existing Chinese shapes — teapots, bowls, ewers — as well as shapes they commissioned — tankards, mustard pots, plates — to ac-

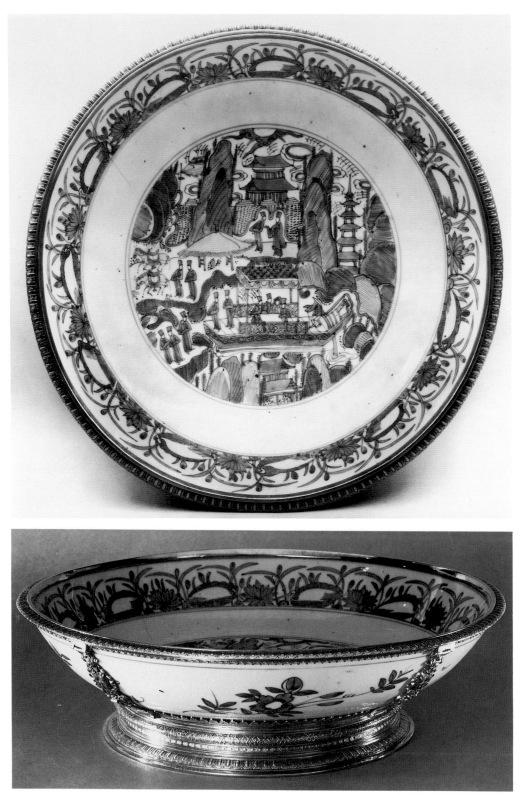

MING DYNASTY, WANLI PERIOD, ca. 1585, ENGLISH MOUNTED.
Underglaze blue dish with silver-gilt mounts, decorated on
the inside with a circular scene of a pleasure boat on a river.
A pagoda and mountains are in the background. The dish is
one of a group of blue and white mounted porcelains that
belonged to William Cecil, Lord Burghley (1520–1598), Lord
Treasurer to Elizabeth I of England; they are among the
earliest surviving English-mounted pieces.
Height: 4". Width: 14⅜".
Metropolitan Museum of Art, New York, Rogers Fund, 1944.

commodate their functions as utilitarian objects.

The French sense of style quickly added a new exuberance to the craft of mounting porcelain. King Louis XIV would begin his day by drinking his breakfast bouillon from a Chinese bowl mounted with golden handles. Not one to do things in a small way, the Sun King had a pleasure pavilion, the Trianon de Porcelaine, built at Versailles; it was completely faced with faience tiles in imitation of Chinese blue and white porcelain. It was a gift for his favorite mistress, the marquise de Montespan. Everyone at the court was charmed by *lachinage* — the term "chinoiserie" had not yet been coined.

Louis XIV was the first French monarch to consider seriously a proposal for the domestic manufacture of porcelain. Nothing came of it, but his interest may have sparked that of his great-grandson Louis XV. In 1753, Louis XV granted the title of Manufacture Royale de Porcelaine to the works at Sevres, where outstanding pieces were being produced in *pate tendre,* or soft-paste (low-fired) porcelain.

Louis XV and his mistress, the marquise de Pompadour, were so devoted to the royal factory that they constantly importuned their courtiers to buy its products, suggesting that they might be considered unpatriotic if they refused. The marquise also had an insatiable appetite for Chinese porcelain, especially the mounted kind; it is recorded in the sales book of the *"marchand-mercier"* * Lazare Duvaux that she purchased more than 150 pieces of mounted Oriental porcelain from his shop.[2]

More Chinese porcelain was mounted in Paris between 1740 and 1760 than at any other time anywhere else. Objects continued to be mounted up to the French Revolution and on into the nineteenth century, but when tastes changed to the simple neoclassic style, as a result of the excavations at Pompeii and Herculaneum, the vogue for ornately mounted porcelains came to an end.

* Literally translated, a "merchant-merchant," a middleman who bought the porcelains and then employed *fondeurs* (bronze casters) and *doreurs* (gilders) to execute the mounts the *marchand-mercier* himself had probably designed.[2]

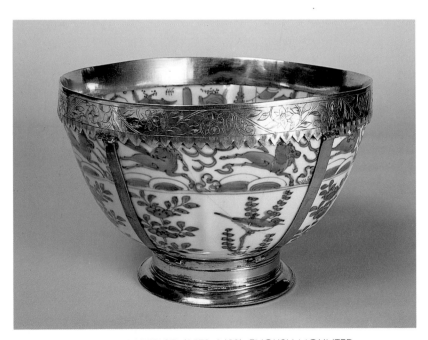

MING DYNASTY, WANLI PERIOD (1573–1620), ENGLISH MOUNTED.
Underglaze blue bowl ca. 1580–1600. This is the baptismal bowl of the Burghley family; it was a gift from Queen Elizabeth I to her godchild Thomas Walsingham.
Height: 5⁷/₁₆".
Courtesy The Burghley House Collection, England.

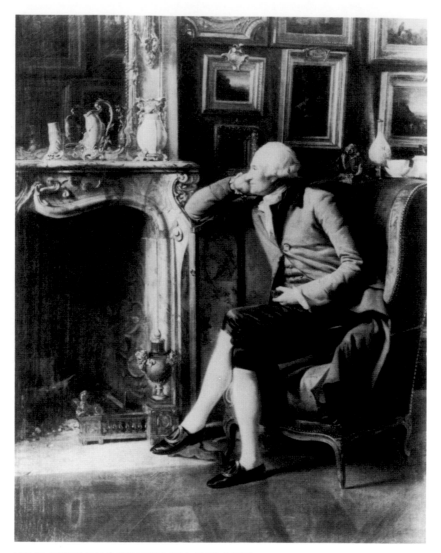

HENRI-PIERRE DANLOUX (FRENCH, 1753–1809).
Portrait of Pierre Victor, Baron de Besneval, 1791. Oil on canvas.
Dimensions: 23⅝" x 19¹¹⁄₁₆".
De Besneval (1722–1791) was a member of the inner circle of the
queen, Marie Antoinette, and a collector of Chinese porcelain.
Part of his collection of mounted porcelain is included in the
painting, on the chimneypiece and on the shelf behind him.
Private collection Princesse Amédée de Broglie, Paris.

QING DYNASTY, KANGXI PERIOD (1662–1722), FRENCH MOUNTED.
Underglaze blue porcelain brush-pot, decorated with a
landscape with rocks and mountains. Mounted in Paris with
bronze d'oré sometime during the reign of Louis XV.
Height: 7½".
Courtesy Sylvia Tearston.
BACKGROUND: home of Mr. Carl Steele.

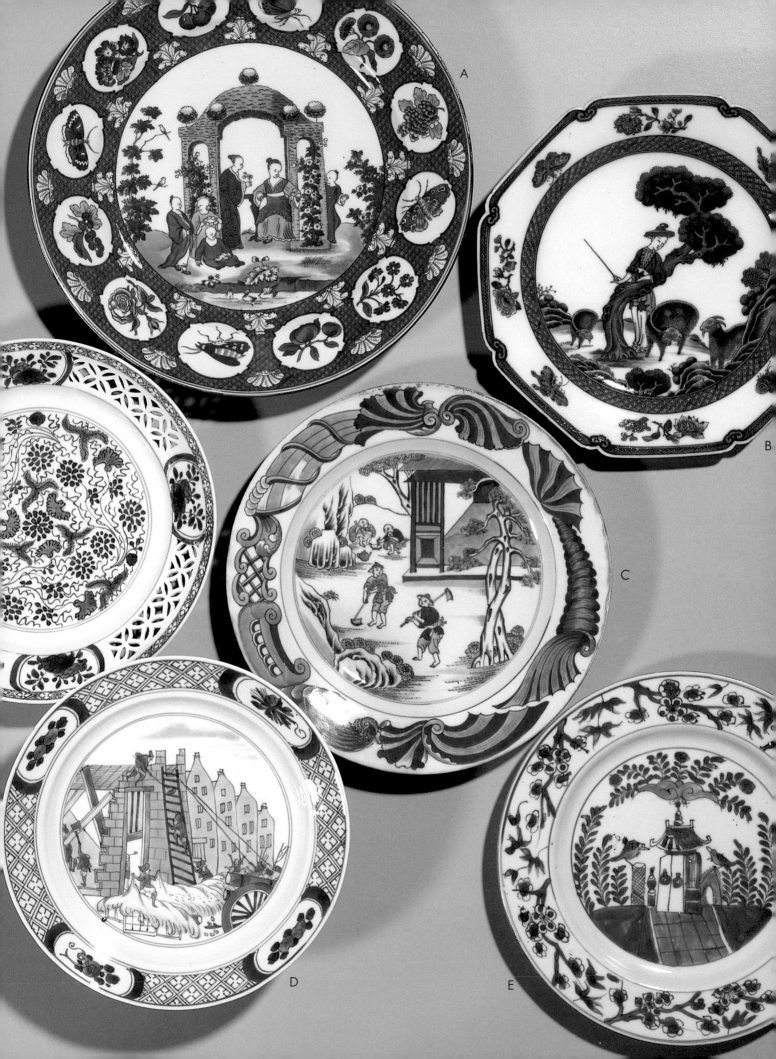

PORT OF CANTON

The Chinese had much disdain for the European traders; they called them *Fan Kwae,* or foreign devils. They restricted the traders to a quarter-mile strip of land along the waterfront of Canton, where the factories, or hongs, were located.* The trading nations — England, France, the Netherlands, Denmark, Sweden, Spain, Greece, and the United States, the last to arrive — were all required to follow the same procedure.

Canton had been a trading center from the fourth century B.C. Its Bureau of Trading Junks was established during the Tang dynasty to regulate ocean commerce and collect taxes. All the varied and rich products of the eighteen provinces of the empire, from tea, silk, and porcelain to ivory, lacquer, and rare woods, flowed into Canton. During the trading season, the Pearl River bustled with Chinese vessels of all shapes and colors.

The hong buildings, rented only for the two- to

* Factory, derived in this sense from *factor* (agent), denotes a trading post and warehouse, not a place of manufacture.

three-month trading season, each flying the flag of a different European nation, were an exotic sight for a first-time visitor. In his memoirs, the English diarist William Hickey wrote of Canton in 1769, "The magnitude and novelty of the architecture must always surprise strangers . . . the scene upon the water is as busy a one as the Thames below London Bridge."[1]

A European ship would first reach Macao, eighty miles down the Pearl River from Canton, and be boarded by a licensed Chinese pilot who would guide it to the Bogue Forts, a station at the mouth of the river, near the narrow entrance rocks called the *Bocca Tigris,* or Tiger's Mouth. Here the ship's captain would meet the agents of the Imperial Commissioner of Customs, known as the Hoppo, and pay two port taxes. The first tax was based on the size of the ship; the second tax was a tribute that was offered to the emperor, following an established custom, but which actually ended up in the hands of local officials.

The ship would then be permitted to move to

QING DYNASTY (1644–1911).
Group of underglaze blue plates with designs commissioned for the European market.
A: Qianlong period (1736–1795). The center, painted after a Cornelis Pronk design, shows six figures in a landscape, called "In the Arbor"; the wide, patterned border with medallions contains flowers, fruits, and insects.
Diameter: 9¼".
Courtesy Ralph M. Chait Galleries.
B: Qianlong period (1736–1795). A shepherdess and sheep in a landscape. The plain octagonal border has flower sprays and insects.
Diameter: 7⅞".
Courtesy The Chinese Porcelain Company.
C: Qianlong period (1736–1795). The illustration depicts the process of tea culture. The border has a shell and scroll design.
Diameter: 8¼".
Courtesy Ralph M. Chait Galleries.

D: Kangxi period (1662–1722). An illustration of a group of rioters attacking the house of Jacob van Zuylen van Nyevelt. The subject was struck from a popular medal commemorating the riots in Rotterdam in 1690.
Diameter: 7⅞".
Courtesy Ralph M. Chait Galleries.
E: Kangxi period (1662–1722). This plate illustrates the popular legend of the cuckoo and the house; flowering branches compose the rim.
Diameter: 8".
Courtesy The Chinese Porcelain Company.

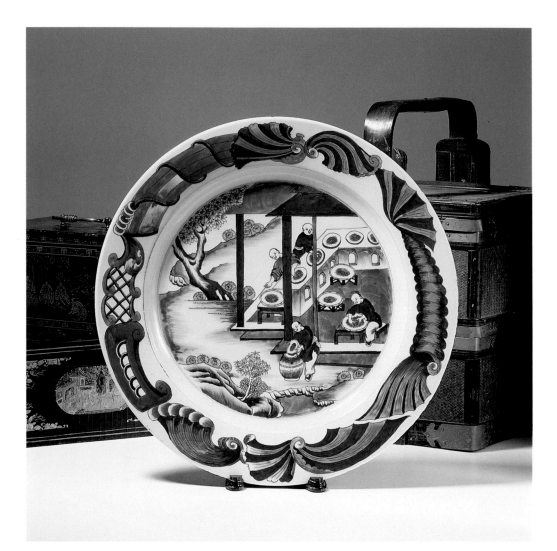

QING DYNASTY, QIANLONG PERIOD, ca. 1740.
Underglaze blue plate with decoration showing the process of
sampling and packing tea for shipment. The shell and cornucopia
design of the border was clearly taken from a European pattern.
Diameter: 15⅜".
The Mottahedeh Collection.

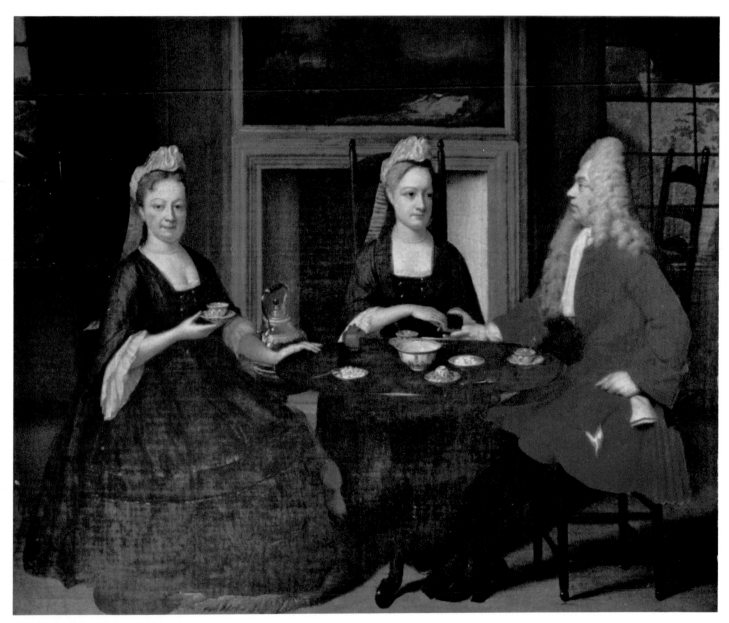

JAN VERKOLJE (DUTCH, 1650–1693).
Painting of Europeans drinking tea from Chinese porcelain.
Oil on canvas.
Dimensions: 25″ x 30″.
Victoria and Albert Museum, London.

QING DYNASTY, ca. 1770–1870.

A group of underglaze blue tea and coffee pots made for the European market.

A: Coffee pot with riverscape scene, ca. 1770. This shape was probably derived from a Dutch or English silver coffee-pot model.
Courtesy Sylvia Tearston.

B: Drum-shape teapot with overglaze enamel and gilt, ca. 1790, with unknown coat of arms.
Courtesy Scarborough Fair.

C: "Lighthouse"-shape coffee pot, ca. 1790, with overglaze blue flower-sprig decoration on the sides.
Height: 9".
Courtesy Scarborough Fair.

D: Teapot, ca. 1790, with a Fitzhugh post-and-spear border with a riverscape scene.
Courtesy Sylvia Tearston.

E: Teapot, ca. 1785, with a Nanking butterfly-and-scale border with a riverscape scene, and with a gilt-heightened knob.
Courtesy Sylvia Tearston.

F: Teapot, ca. 1870, with a spiraling dragon-and-cloud decoration, with replacement handles.
Courtesy John Rosselli, Ltd.

G: Teapot, Canton pattern, ca. 1820.
Courtesy Scarborough Fair.

H: Teapot, ca. 1860, with a man in a landscape setting, with replacement handles.
Courtesy John Rosselli, Ltd.

J: Drum-shape teapot, Canton pattern, ca. 1825.
Courtesy Scarborough Fair.

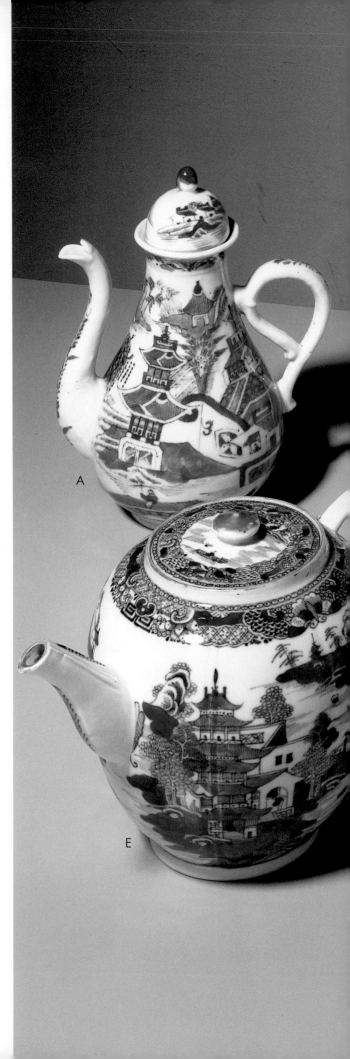

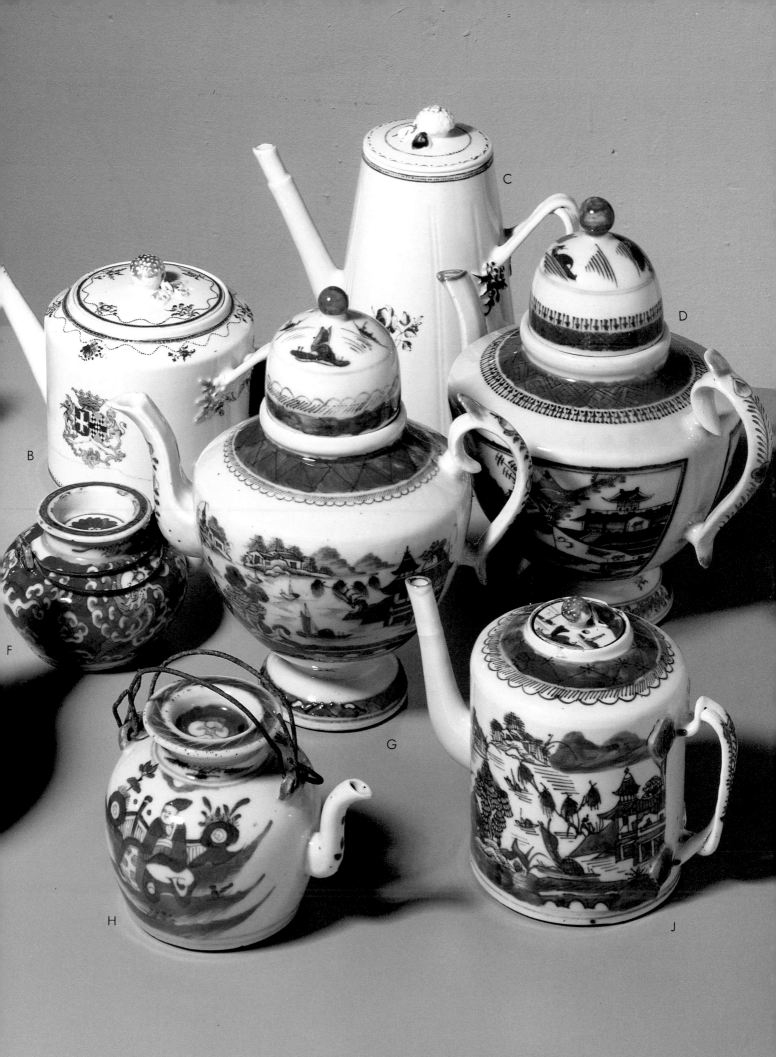

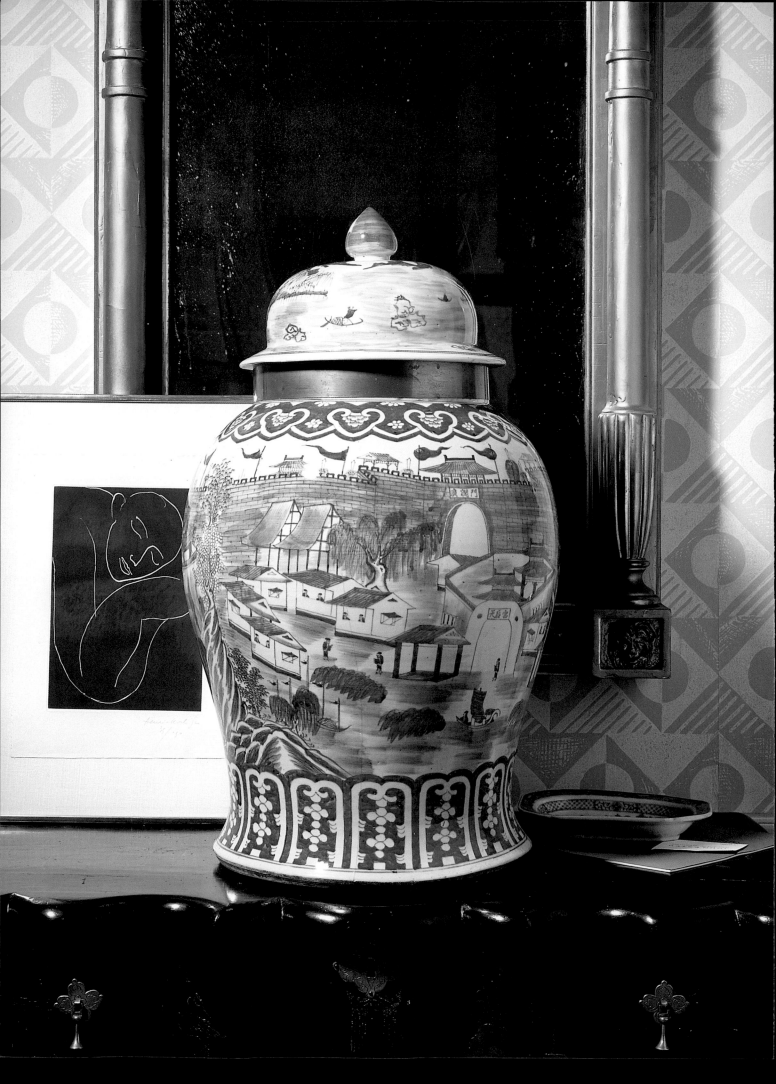

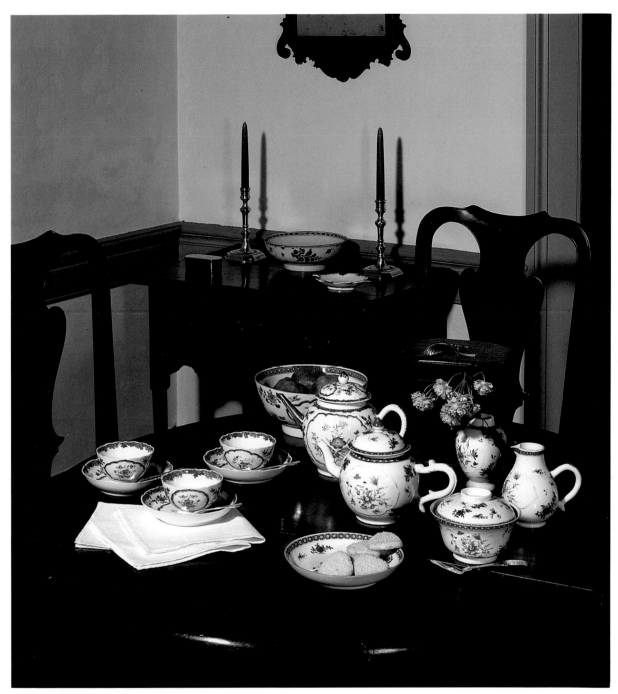

QING DYNASTY, QIANLONG PERIOD, ca. 1750.
Underglaze blue tea set with overglaze color enamel of flowers
and insects. The large teapot has been repaired with a silver
spout. Two teapots were sometimes ordered to accommodate
green as well as black tea.
Height: 6½" (large teapot); 5¾" (small teapot).
Private collection, Philadelphia.

QING DYNASTY, QIANLONG PERIOD, ca. 1750.
Large underglaze blue jar with cover. A brass mount was added
in England so the jar could be locked for the storage of tea.
The jar shows a view of Chinese life outside a walled city.
Height: 26".
Private collection Mr. Carl Steele.

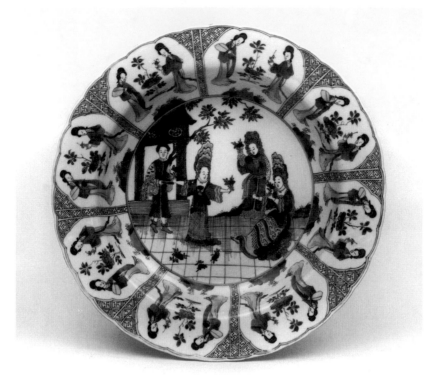

QING DYNASTY, KANGXI PERIOD (1662–1722).
Underglaze blue plate decorated with figures of Europeans in
fashionable dress of the period, from an unidentified print
illustrating "the sense of smell."
Diameter: 13⅞".
Courtesy Earle D. Vandekar of Knightsbridge.

QING DYNASTY, QIANLONG PERIOD (1736–1795).
Partial set of garniture with underglaze blue decoration
of sprigs of flowers and gold trim.
Height: 12".
Courtesy Philadelphia Society for the Preservation of Landmarks.
Given by Henry Danby in memory of his brother John.
Photographed at the Powel House, Philadelphia.
Samuel Powel purchased the house in 1769 from its first owner,
Charles Stedman, just five days prior to his marriage to Elizabeth
Willing. Powel is known as the "patriot mayor," the last mayor of
Philadelphia under British rule and the first in the new republic.
Mrs. Powel was renowned as a hostess, and receptions at
the Powel House were unrivaled in elegance and the distinction
of the company. Washington, Adams, Lafayette, and other lumi-
naries of the day dined and danced at the Powel House.

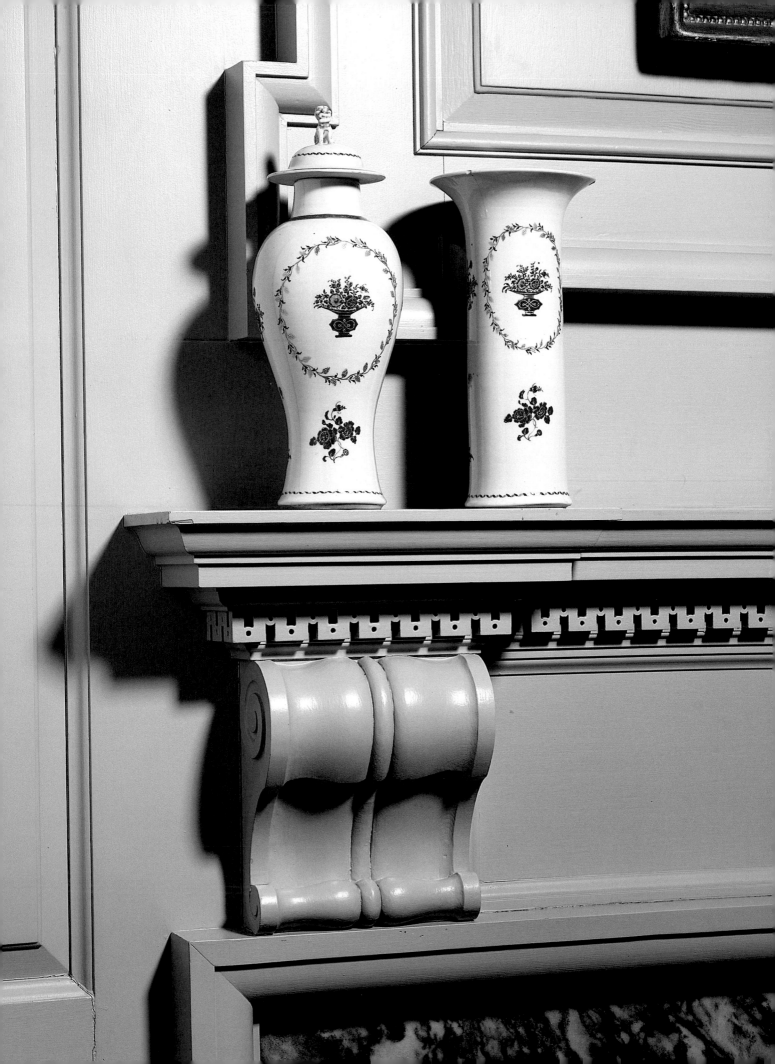

QING DYNASTY, QIANLONG PERIOD ca. 1785.
Underglaze blue and gilt bough pot with handles, decorated with
raised panels with the traditional riverscape pattern.
Height: 7".
The Mottahedeh Collection.
Photographed at the Nathaniel Irish House, Philadelphia.
The Nathaniel Irish House, now the home of Mr. and Mrs. John
F. Hunt, was built in 1762 by Nathaniel Irish, a carpenter and builder.

QING DYNASTY, QIANLONG PERIOD, ca. 1785.
Underglaze blue octagonal platter with a peony and bamboo
design in the foreground and a river scene in the distance.
Width: 12".
Private collection Mr. Inman Cook.
Needlepoint pillow courtesy Woolworks, Inc.

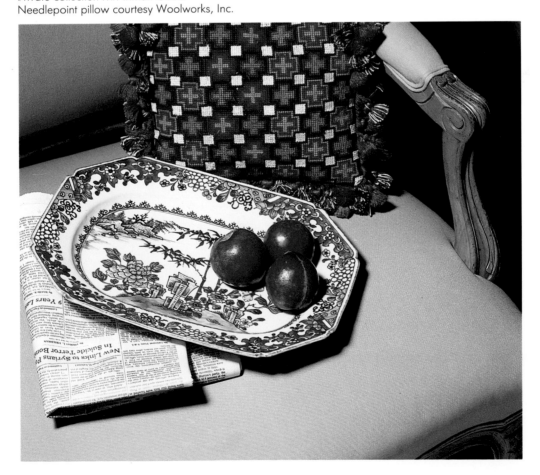

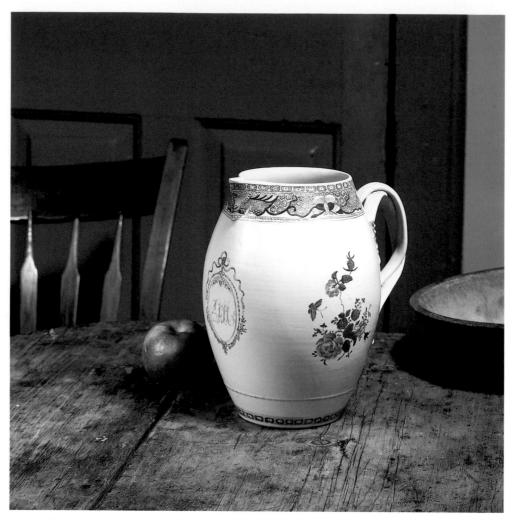

QING DYNASTY, QIANLONG PERIOD, ca. 1790.
Underglaze blue pitcher with modified Fitzhugh border overglaze,
with a cipher of colored enamel surrounded by ribbons and flowers.
Height: 9".
Private collection Mr. and Mrs. John F. Hunt.

QING DYNASTY, QIANLONG PERIOD, ca. 1770–1785.
From left, underglaze blue Nanking-pattern tankard.
Height: 4½".
Private collection, Philadelphia.
Underglaze blue Nanking-pattern tankard with a river scene.
Height: 4".
The Mottahedeh Collection.
Underglaze blue Fitzhugh-pattern tankard.
Height: 5".
Private collection, Philadelphia.
Underglaze blue tankard with inserts of colored enamel overglaze.
Height: 4½".
Courtesy Bardith, Ltd.

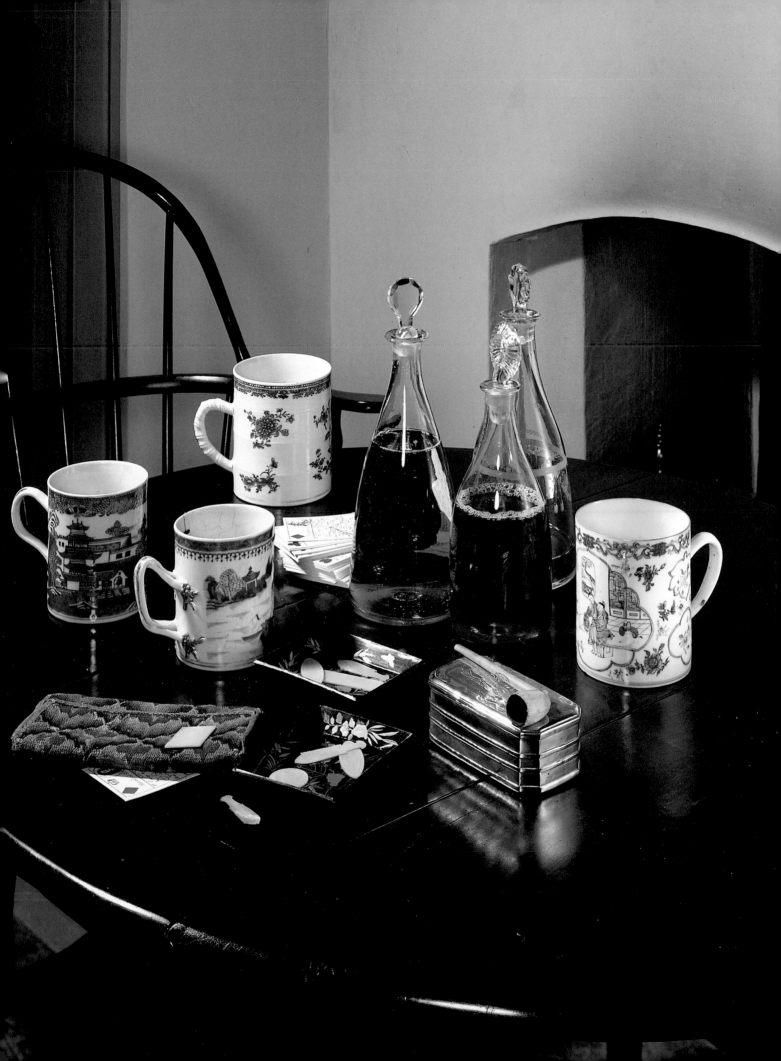

Whampoa, twelve miles below Canton. Ships would anchor and remain at Whampoa until the final loading at the end of the trading season. The supercargo (a businessman at sea), the ship's captain, and the incoming cargo would be carried upstream to Canton proper in small river craft known as chop boats.

Not far from the European factories in Canton were those belonging to the hong merchants. Each nation dealt with an assigned hong merchant, who was responsible for receiving incoming cargo and fulfilling outgoing orders. He was answerable to the Chinese government for all behavior and business dealings of the Europeans during their stay in China. Negotiations between the hong merchant and the supercargo were usually carried on through a "linguist," or interpreter—the Chinese were forbidden to teach their language to foreigners.

Loading the ship for the return voyage was done with great care. The porcelain wares would be carefully placed in the bottom of the hold, along with pig iron, tin, or any other available heavy items, serving as a base on which the main cargo —tea — would remain dry. This base or ballast would also act as a counterweight for the masts and sails, holding the vessel steady in the open sea. Raw silk, textiles, lacquer, spices, and drugs would be stored anywhere space could be found on board.

Ships of the East India companies, first the Dutch and then the British, brought blue and white porcelain as well as tea to the New World. In New Amsterdam, Dutch people shared the fondness of their relatives at home for blue and white china. The 1696 will of Margharita van Varick refers to "three East India cups, three East India dishes, three Cheenie pots, one Cheenie pot bound in silver, two glassen cases with thirty-nine pieces of small

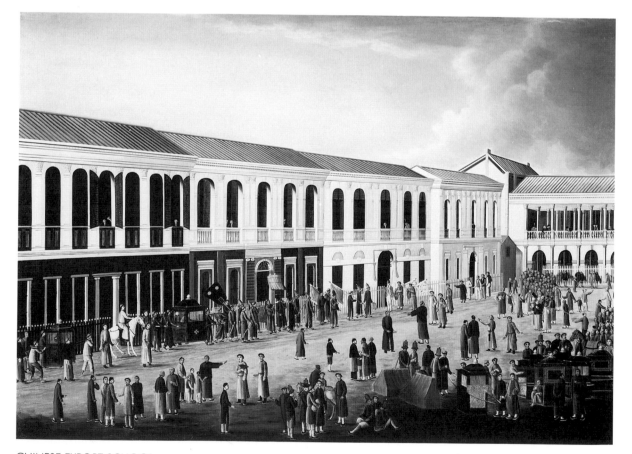

CHINESE EXPORT SCHOOL.
View of the British Hong in Canton from the Land,
early nineteenth century. Oil on silk.
Dimensions: 28⅜" x 39⅝".
The view is from the land side of the hongs. The procession of a mandarin with attendants has come to a halt before the British factory.
Henry Francis du Pont Winterthur Museum, Delaware.

china ware, eleven India babyes."[2]

Until they won their independence, Americans were forced to buy Chinese products only through the British company. Just weeks after the ratification of the Treaty of Paris, Americans exercised their right of free trade by sending the Boston-built *Empress of China* on her maiden voyage to Canton.

The ship was captained by John Green and the voyage backed by Robert Morris of Philadelphia, the "Financier of the American Revolution," and Daniel Parker & Company of New York City. The supercargo of the *Empress of China* was the young and able Samuel Shaw. He, along with Captain Green and several other officers, was a member of the recently organized, elite Society of the Cincinnati. Among the benefits of membership was a network of business connections for men who had the daring to seek their fortunes in the China trade.

The *Empress of China* cost her investors $119,000, including the ship itself and a cargo that consisted mostly of ginseng and Spanish silver dollars. (Ginseng, an aromatic root found plentifully in the American wild, prized by the Chinese as a medical panacea and aphrodisiac, was one of the few Western products — fur pelts being another — the Chinese were interested in trading.)

The *Empress of China* sailed across the Atlantic Ocean, around the Cape of Good Hope, and across the Indian Ocean to Macao. Six months later, on the morning of August 24, 1784, when the ship reached Whampoa, the Americans fired a thirteen-gun salute, and the greeting was returned by the European vessels anchored in the harbor.

The Americans were given a warm welcome by Chinese officials eager to have them replace the Europeans, for whom the China trade was no longer profitable. Samuel Shaw, able at both diplomacy and busi-

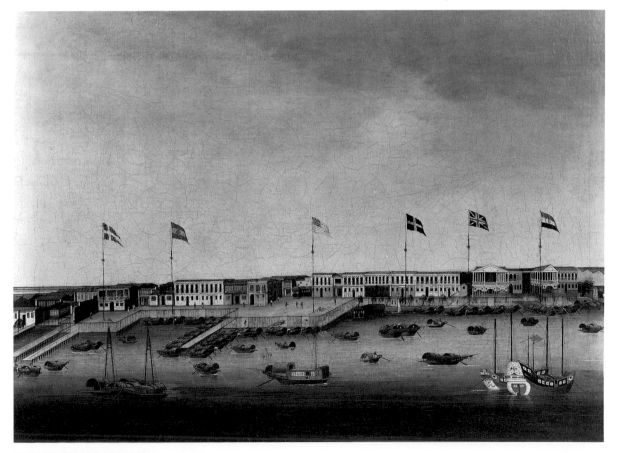

CHINESE EXPORT SCHOOL.
The Hongs of Canton, ca. 1810. Oil on canvas.
Dimensions: 18" x 23".
A view of the hongs in Canton, along the Pearl River, with the American hong in the center.
Courtesy Berry-Hill Gallery.

ness, negotiated a cargo that returned a profit to its investors.

Ships from Boston, Providence, and Salem soon joined the trade, unhampered by the regulations of an East India company. Captains were given free rein by the owners to trade in any port en route, and as many as forty ships a year brought tea, textiles, and porcelain to the United States during the fifty years of trade with China. So successful were the American traders and their "streamlined" ships that from 1795 on the Americans made a greater profit than the British East India Company.

During the nineteenth century, Americans desired porcelain as much as had Europeans before them. But vases, punch bowls, and prunus-decorated ginger jars were never as popular as the almost endless number of cups, teapots, plates, platters, bowls, and saucers that crossed the oceans to Eastern seacoast ports. There were services for breakfast, dessert, dinner, evening, and tea. These services often contained an extraordinary number of pieces: a dinner service could run to two hundred or even, occasionally, four hundred pieces. The major decorative styles produced for the American market were labeled by Westerners as Nanking or Nankeen, Canton, and Fitzhugh. Also, there were costly services made to special order.

After fifty years, American trade with China began gradually to decline. The ceramic industries of Europe and England and the development of less expensive native porcelain in the United States reduced the demand for Oriental wares. For several generations, Americans lost interest in Chinese porcelain. By the end of the nineteenth century, when interest was revived, Europeans and Americans preferred the superb pieces the Chinese had originally intended for themselves to the everyday export ware.

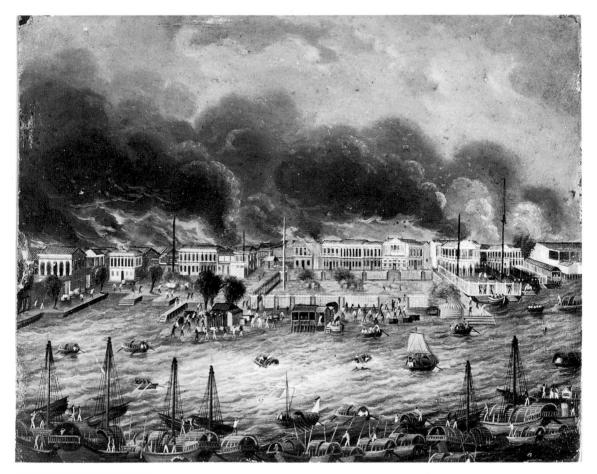

CHINESE EXPORT SCHOOL.
The Burning of the Hongs at Canton, ca. 1856.
Oil on copper.
Dimensions: 4¾" x 6⅜".
This unusual painting graphically records the destruction of the
Western hongs in 1856.
Metropolitan Museum of Art, New York.

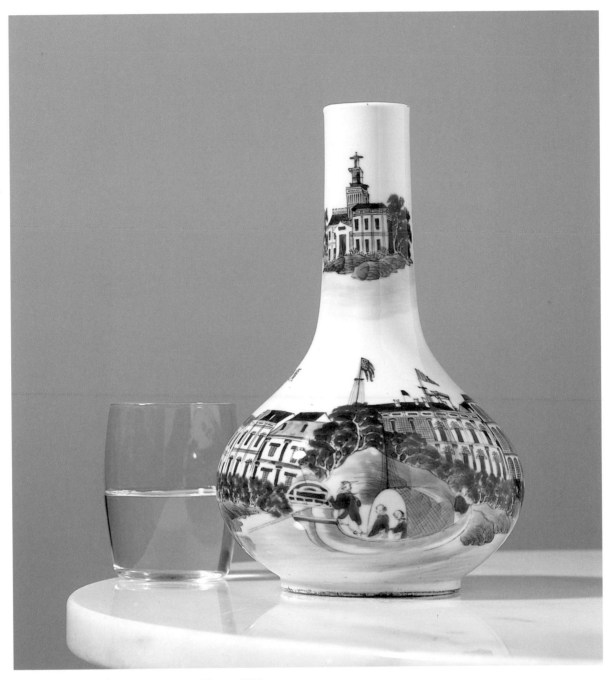

QING DYNASTY, DAOGUANG PERIOD, ca. 1830.
Underglaze blue water-bottle with a continuous scene of hong
buildings in Canton around the base. Below the neck two
Western churches are depicted. On the shoulder is an inscription
in Chinese characters: "The thirteen factories of Kuangtung
Province." The bottle is also marked underneath with an
unrecorded painter's mark. The Chinese inscription and freer style
of painting may indicate that the bottle was made for the
Chinese market.
Height: 8½".
The Mottahedeh Collection.

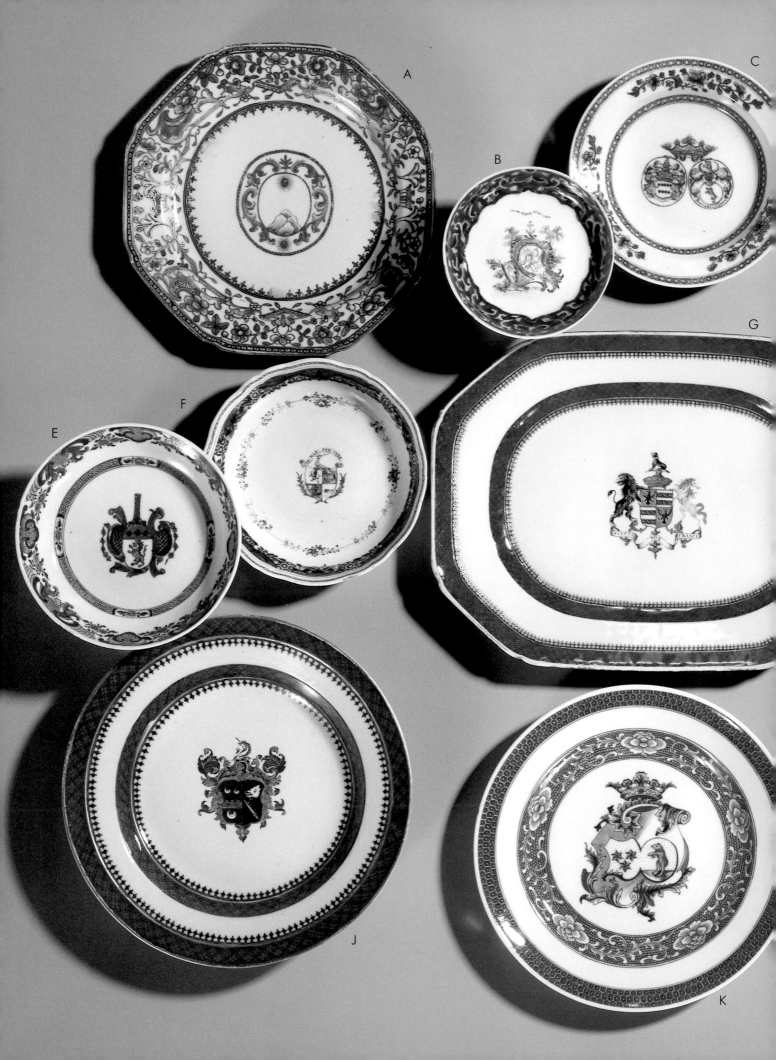

A

B

C

E

F

G

J

K

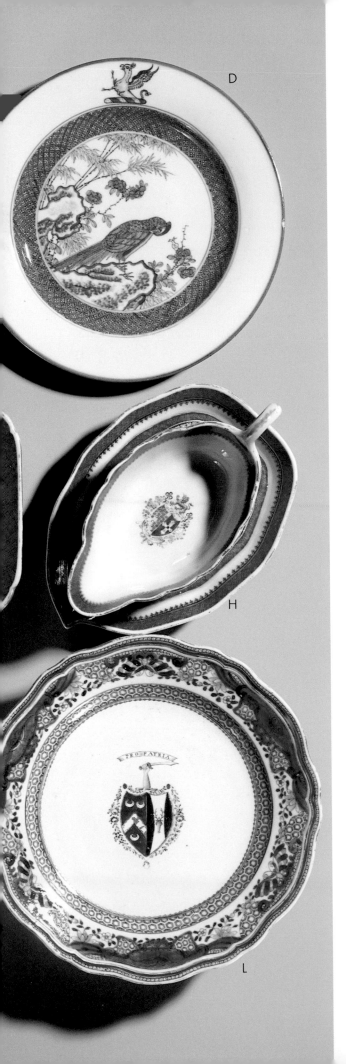

QING DYNASTY, QIANLONG PERIOD (1736–1795).
A group of underglaze blue porcelains for the European market.

A: Octagonal plate (ca. 1755) with overglaze enamel with the arms of Sunnbank of Oxfordshire.
Diameter: 8⅞".
Courtesy Earle D. Vandekar of Knightsbridge.

B: Saucer with overglaze enamel (ca. 1770). The decoration is possibly of the arms of Taaffe; the motto is *"In hoc signo spes mea"* ("In this sign is my hope").
Diameter: 4⅝".
Courtesy Earle D. Vandekar of Knightsbridge.

C: Saucer (ca. 1750) with double crest, origins unknown.
Diameter: 6¼".
Courtesy Ralph M. Chait Galleries.

D: Plate with pheasant design: on the rim are the arms of Charles Peers (1703–1781) of Chiselhampton, Oxfordshire.
Diameter: 8¾".
Courtesy Ralph M. Chait Galleries.

E: Saucer (ca. 1755) with the arms of Crichton, possibly made for John Crichton, a private trader in Canton.
Diameter: 6".
Courtesy Earle D. Vandekar of Knightsbridge.

F: Saucer (ca. 1780) with the arms of William MacDonald of Perthshire.
Diameter: 6¼".
Courtesy The Chinese Porcelain Company.

G: Hexagonal platter (ca. 1785) with the arms of Palmerston; the service was made for the second viscount, the father of the prime minister Lord Palmerston.
Width: 12¼".
Courtesy Earle D. Vandekar of Knightsbridge.

H: Sauceboat and stand (ca. 1790) with the arms of Warren impaling Humphrey.
Width: 7⅞".
Courtesy Earle D. Vandekar of Knightsbridge.

J: Soup plate (ca. 1790) with the arms of Oliphant impaling Brown.
Diameter: 9½".
Courtesy Earle D. Vandekar of Knightsbridge.

K: Plate (ca. 1760) with the arms of Peer of Bavaria *accollée* with Mareschal of Forez.
Diameter: 9".
Courtesy The Chinese Porcelain Company.

L: Plate (ca. 1790) with the arms of Martin impaling Parker, from a service made for Sir Henry Martin, M.P.
Diameter: 9⅝".
Courtesy The Chinese Porcelain Company.

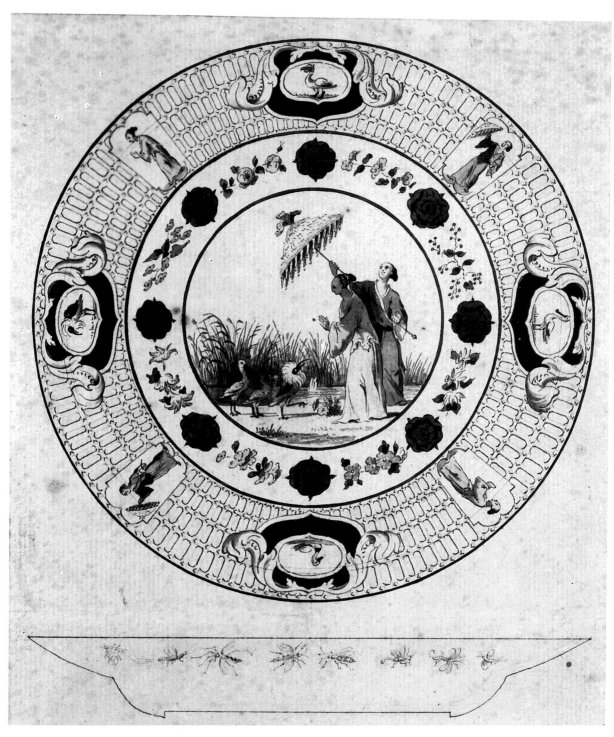

CORNELIS PRONK (DUTCH, 1691–1759).
1734. Watercolor on paper.
Dimensions: 6 ⅜" x 7½".
Design for a plate, decorated with "the parasol ladies."
Rijksmuseum, Amsterdam.

SPECIAL ORDERS

Almost from the moment foreign traders made direct contact with China, they began to impose their own tastes and aesthetics on the Chinese when ordering porcelain to send home. Shipping records, company invoices, and detailed family inventories referring to these specially ordered wares offer a reliable method of dating export porcelain.

During the Yuan dynasty, some of the first Chinese blue and white porcelain was made to order for the Persians. It is likely that Persian merchants provided samples of their own underglaze blue earthenware for the Jingdezhen potters to copy. Muslims continued to order special wares, and during the Jingde reign porcelains decorated with interlaced arabesques, vine scrolls, verses from the Koran, and Arabic mottoes were probably made for Muslims living at the Chinese court as well as for export to wealthy Egyptians, Syrians, and Persians.

The Western traders brought samples, models, and drawings of their requirements to Canton merchants who then carried them to the potteries at Jingdezhen. All of the East India companies hired artists to do the designs. One of these artists, Cornelis Pronk, created for the Dutch East India Company the charming "Parasol Ladies," based on an earlier Chinese motif. Paintings by famous

QING DYNASTY, QIANLONG PERIOD, ca. 1740.
Underglaze blue coffee cup and saucer; the design incorporates the Pronk design of "the parasol ladies."
Diameter of saucer: 4½".
The Mottahedeh Collection.

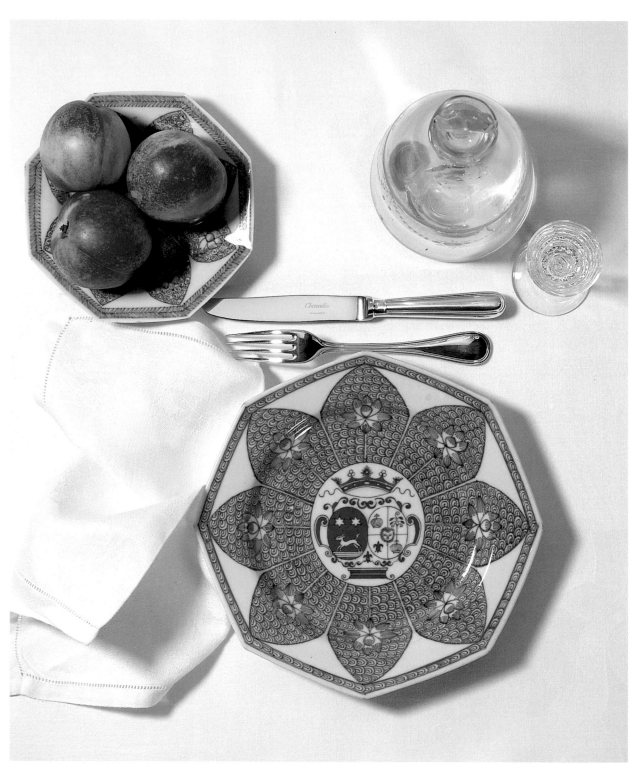

QING DYNASTY, QIANLONG PERIOD, ca. 1745.
Octagonal plates with underglaze blue design of lotus petals,
each petal containing a flower on a scroll background. The arms
have not been identified, but the lotus design would have been
popular in the Persian and Indian markets.
Diameter: 8¼".
The Mottahedeh Collection.

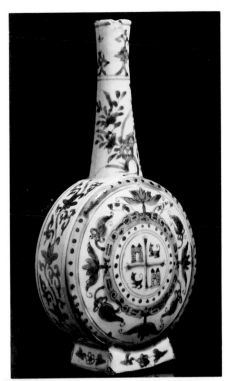

MING DYNASTY,
WANLI PERIOD (1573–1620).
Underglaze blue bottle. On one side
are the arms of Philip II of Spain, no
doubt copied from a coin.
Height: 12".
The Mottahedeh Collection.

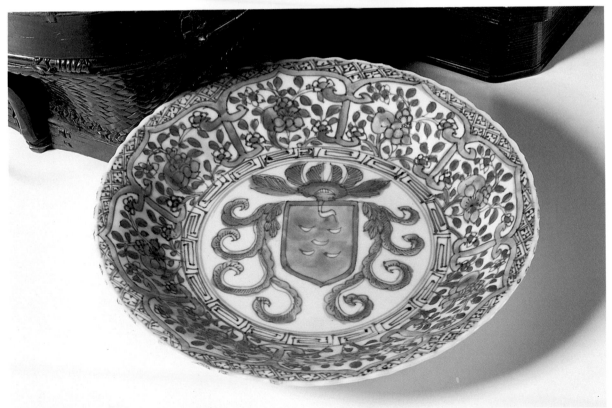

QING DYNASTY, KANGXI PERIOD, ca. 1695.
Underglaze blue plate displaying the Portuguese arms of de Pinto
of the Hague, encircled by wide, paneled band. An example of the
continuing taste for carrack decoration long after the Wanli period.
Diameter: 8⅜".
The Mottahedeh Collection.

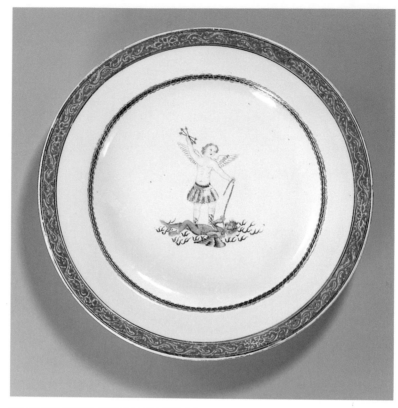

QING DYNASTY, QIANLONG PERIOD, ca. 1740.
Underglaze blue dish with enamel and gilt; in the center is an
illustration of an angel or Saint Michael, holding in his right hand
a sheaf of arrows, in his left a cord tied around the neck of the
Devil, who lies among flames. The piece is possibly intended to
depict Chapter XII, 7–9, of Revelation.
Diameter: 11¼".
The Mottahedeh Collection.

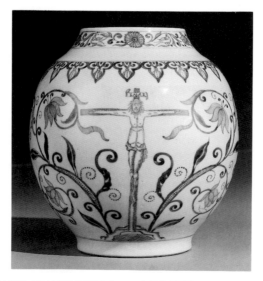

QING DYNASTY, KANGXI PERIOD, ca. 1690–1700.
Underglaze blue jar with crucifixion in the center, surrounded by
scrolled flowering branches. The style of drawing may have been
derived from the embroidered cover of a European prayer book.
Height: 8¾".
Metropolitan Museum of Art, New York.

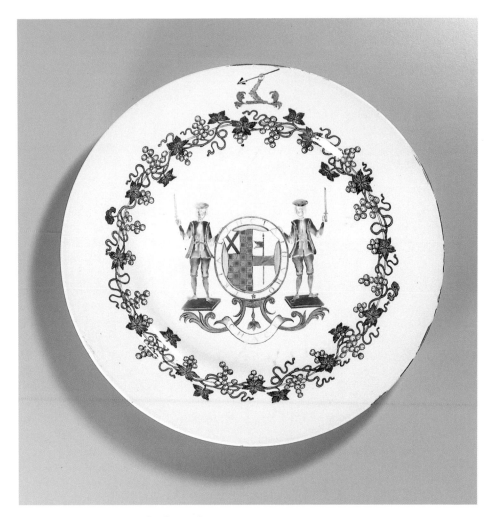

QING DYNASTY, QIANLONG PERIOD, ca. 1748.
Underglaze blue plate with color enamel overglaze. The border
consists of vine leaves and grapes encircling the arms of
Warren of Ireland impaling another (unidentified) coat, all with
the ribbon of the Order of the Bath.
Diameter: 13¾".
The Mottahedeh Collection.

Dutch, French, and Italian artists as well as engravings and even coins and medals were faithfully copied in underglaze blue. Biblical subjects, marine scenes, mythological tales, sports, erotica, political figures, and the fables of La Fontaine were used as design sources.

The Dutch called this made-to-order category *Chine de Commande;* the French, *Porcelaine de la Compagnie des Indies.* In America, such wares were once referred to as Lowestoft in the mistaken belief that they were decorated at the Lowestoft factory in England. The term used now is Chinese Export Wares.

Soon after their arrival in China in 1516, the Portuguese too began to commission special pieces. Almost every carrack leaving Canton for Lisbon carried blue and white with Portuguese motifs and inscriptions. Wares emblazoned with a royal coat of arms or a cipher (monogram) called an armorial were also ordered. The ewer of King Manuel I made during the Jingde reign displays the king's emblem, an armillary sphere. Armorial pieces were also made for Spanish royalty. Charles V, king of Spain and Holy Roman Emperor, ordered an entire dinner set displaying his arms and cipher.

In the seventeenth century, when the Dutch dominated the China trade, demand for special pieces increased and was expanded to include many European forms and decorations as well. The first complete *Chine de Commande* dinner service designed by Pronk was commissioned by the Dutch East India Company in 1736. In all, forty-six services were ordered, each containing 371 pieces.

The design for the rare "Riots of Rotterdam" plate is derived from a Dutch commemorative coin, with a border of Chinese design elements. The subject, which puzzled experts for years, concerns an unjust execution in Rotterdam in 1690.

Porcelain decorated with biblical subjects was ordered by early missionaries active at the imperial court and is known as Jesuit China. Christian subjects are often incongruously combined with Buddhist motifs such as the symbolic pearl in flames and clouds. In a letter of 1712, Père d'Entrecolles writes: "From the debris at a large emporium they brought me a little plate which I treasure more than the finest porcelain made during the last thousand years. In the centre of the plate is painted a crucifix between the Virgin and St. John."[1]

England shared the enthusiasm of the Portuguese for armorial wares. These were the finest of made-to-order porcelains, often taking as long as two years from order to completion. During the 1700s, of the five thousand dinner and tea services with armorial decoration that were shipped to Europe, four thousand went to England. Orders for armorials were placed either with the East India Company or with specialized English merchants in London who were called "chinamen."

The most famous of American armorial wares are those of the Society of Cincinnati. The American supercargo Samuel Shaw ordered the first examples of this ware in Canton during the initial voyage of the *Empress of China.* He and the Canton enamelers worked out the decoration, which is based on a medal designed by Major Charles L'Enfant. The Cincinnati-decorated porcelains were an immediate success with the members of the Society.

George Washington bought one of the earliest Fitzhugh services with the Cincinnati insignia from a merchant in New York during the summer of 1786. The set contained 302 pieces and cost $150, not a modest price for the time.

In Canton, orders for armorial wares were handled by the supercargoes. The supercargo dealt directly with "outside" porcelain merchants, of whom there were more than a hundred, and whose shops were to be found in the streets and alleyways behind the hongs.

Armorial decoration was applied in workshops in and around Canton; it was painted on wares from Jingdezhen that were blank or only partially adorned. Up to a hundred people, including children and the very old, worked at the sketching and final painting, which was done in underglaze blue and/or enamel colors and then refired (muffled) at a lower temperature.

QING DYNASTY, QIANLONG PERIOD, ca. 1785.
Underglaze blue teapot with enamel overglaze and gilding, with a Fitzhugh pattern containing the cipher of Sir Joshua Reynolds, president of the Royal Academy. The cipher, hieroglyphic in design, spells out the artist's name in full and was probably designed by Reynolds himself. The teapot is of a drum shape with a litchi finial on its cover and a crossed-branch handle terminating in flowers and leaves.
Height: 5½".
Courtesy Earle D. Vandekar of Knightsbridge.
The matching cup is part of a tea service commissioned by Sir Joshua Reynolds in the early 1780s.
Height: 3".
The Mottahedeh Collection.

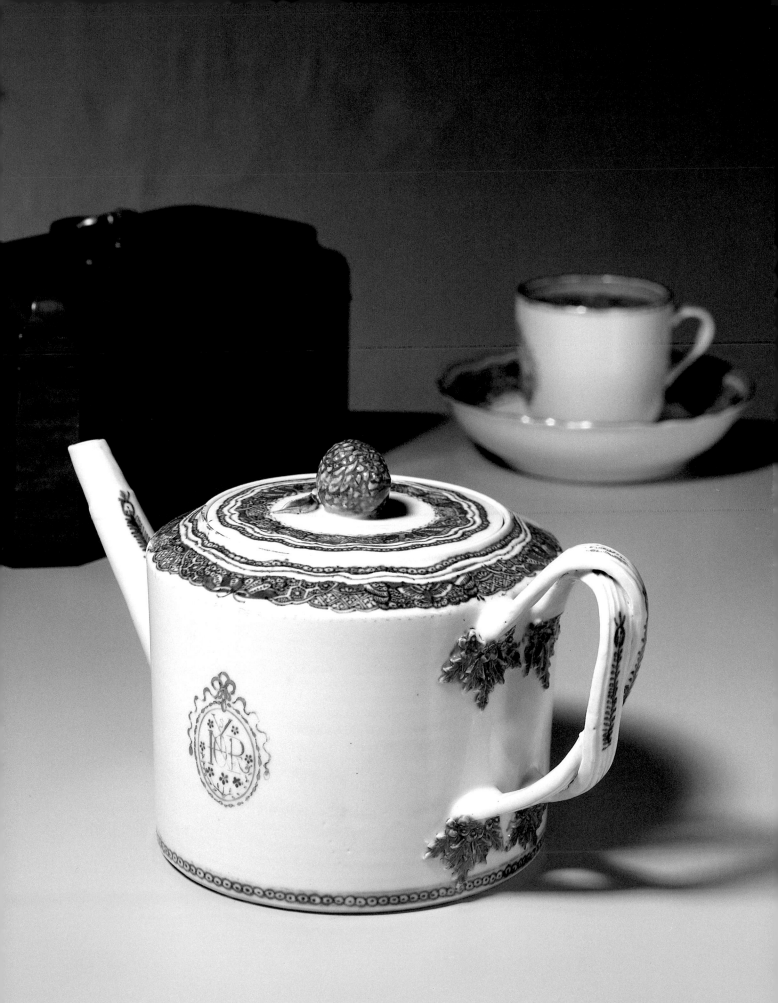

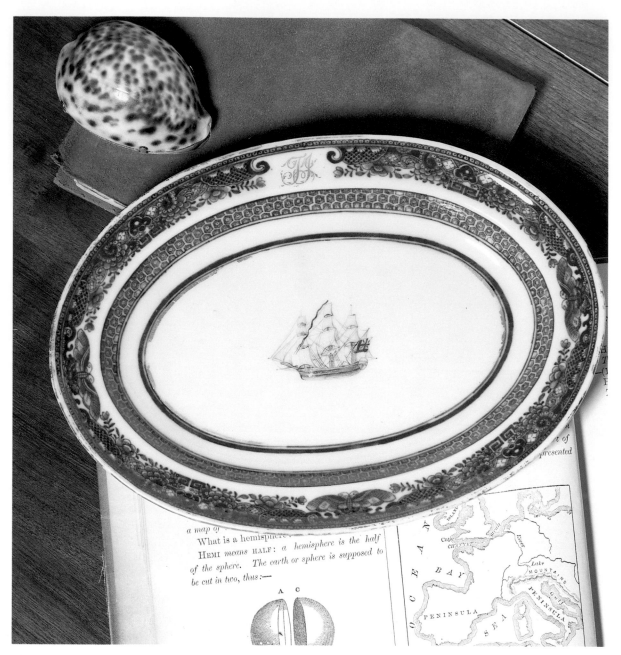

QING DYNASTY, JIAQING PERIOD, ca. 1800.
Underglaze blue oval dish with Fitzhugh border containing a gilt
cipher. The center contains a rendering of a vessel in overglaze
enamel, with rigging of a British East Indiaman.
Width: 8⅝".
The Mottahedeh Collection.

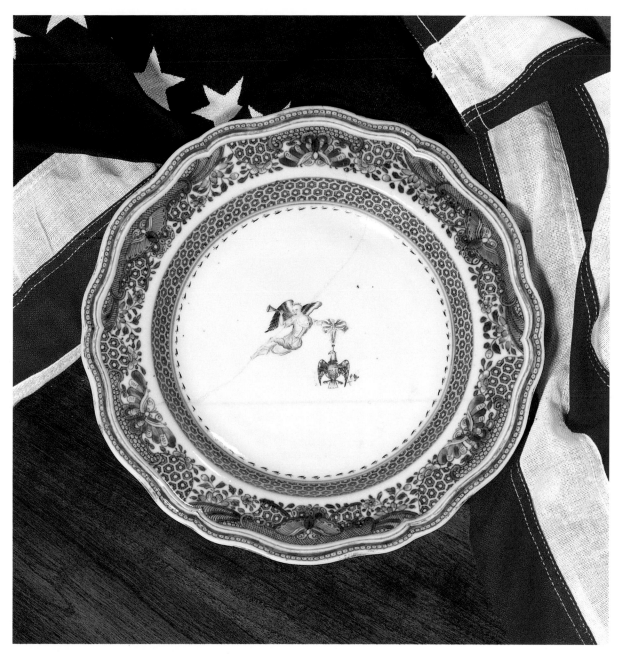

QING DYNASTY, QIANLONG PERIOD, ca. 1785–1790.
Underglaze blue soup plate with overglaze color enamel, gilt,
and Fitzhugh border. The center displays the emblem of the
Order of the Society of the Cincinnati. From a dinner service
purchased by George Washington in 1786.
Diameter: 9½".
The Mottahedeh Collection.
Flag courtesy Gates Flag Company.

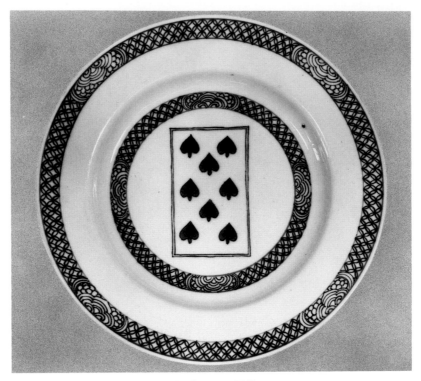

QING DYNASTY, QIANLONG PERIOD, ca. 1760.
Underglaze blue saucer decorated with the eight of spades in the
center, surrounded by decorative bands. The significance of the
particular card is unknown. The plate was possibly part of a
card-party dessert service.
Diameter: 8½".
Kasteel-Museum Sypesteyn, Loosdrecht, the Netherlands.

QING DYNASTY, QIANLONG PERIOD, ca. 1745.
Underglaze blue plates, part of a service made for the French
market. The border cartouches contain an eagle, the symbol of
Louis XV, and a carplike fish, the emblem of Mme. de Pompa-
dour, whose maiden name was Poisson.
Diameter: 9".
Courtesy Earle D. Vandekar of Knightsbridge.
English cut-crystal decanter, ca. 1720, and square-based English
crystal wine goblets, ca. 1820.
All, courtesy Bardith, Ltd.
A selection of French Mennecy soft-paste porcelain boxes, ca. 1750.
Courtesy the Antique Porcelain Company.

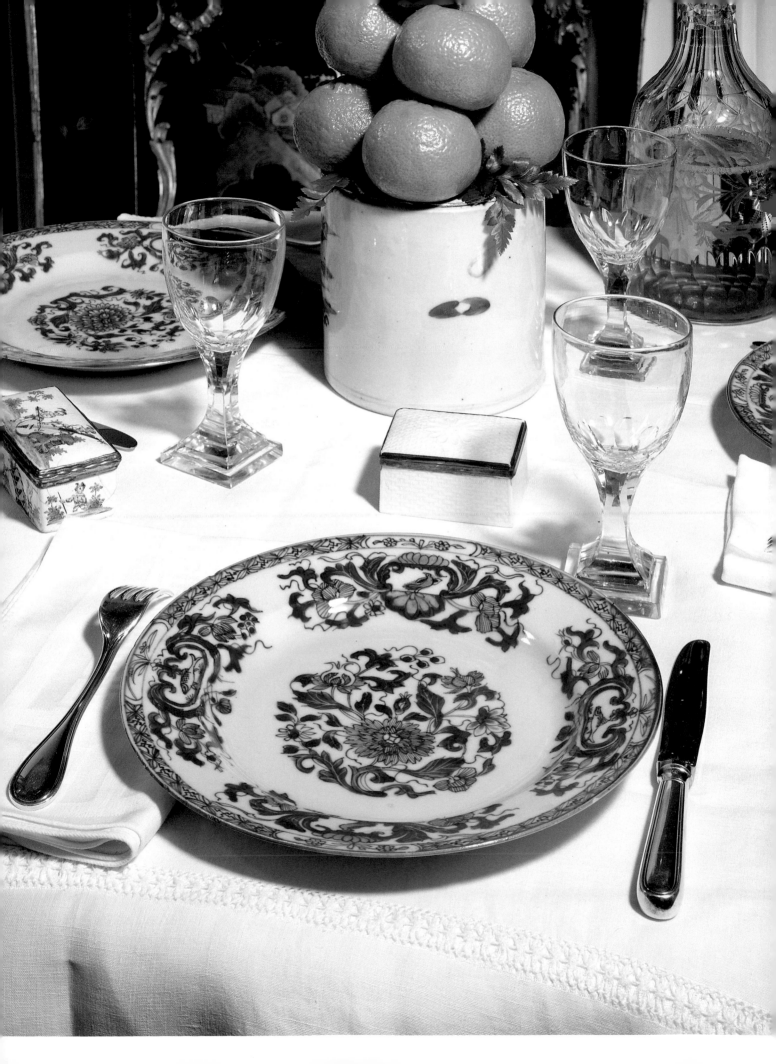

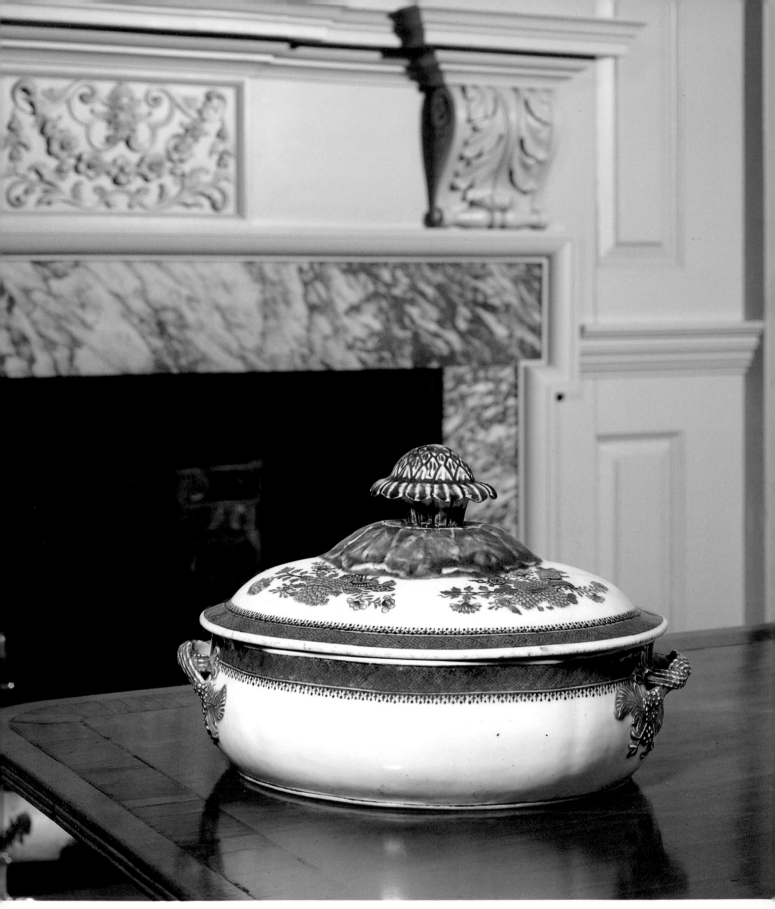

QING DYNASTY, QIANLONG PERIOD, ca. 1790.
Covered tureen in underglaze blue with Fitzhugh pattern. This
large serving piece has double strap handles. The finial on the
cover is in the form of a torch-ginger flower.
Width: 12".
Philadelphia Museum of Art.
Photographed in the dining room at the Powel House, Philadelphia.

FITZHUGH WARE

Three generations of the Welsh family FitzHugh were involved in the English China trade. Thomas FitzHugh was president of the English factory or hong from 1779 to 1781 and sent home porcelain services consisting of hundreds of pieces in the family's own design. His diary records personal orders of chinaware by the boxload, along with chests of different varieties of tea.

The Fitzhugh pattern is most safely identified by its unique design of a central medallion surrounded by four separate floral groups representing the Chinese arts. Its lattice or honeycomb border includes butterflies in flight, split pomegranates, and flowering branches connected by fretwork. There are many and confusing variations of border details, including the post-and-spear or Nanking border.

The Chinese hong merchants often placed stock orders in Jingdezhen for the Fitzhugh pattern with the centers blank and only the borders decorated. Specially ordered emblems such as American eagles or personal devices such as ciphers were then enameled over the glaze in Canton, and the object was refired. Blue was the most popular, but Fitzhugh was also ordered in green, red, brown, and other colors.

The Fitzhugh-pattern wares were first encountered by American traders when they arrived in Canton in the 1780s and placed orders to be shipped home. One of the most famous Fitzhugh-bordered services was the one owned by George Washington with the Cincinnati insignia. The pattern was widely sold and distributed in the port cities of New York, Salem, Boston, and Philadelphia. The Fitzhugh pattern was so popular in the United States that it is now identified with this country, although, as D. F. Lunsingh Scheurleer notes, the pattern "occurs in pieces for the English and American markets in the last thirty to thirty-five years of the eighteenth century, and in the beginning of the nineteenth, and from time to time one comes across it on blue and white dinner services exported to the Netherlands."[1]

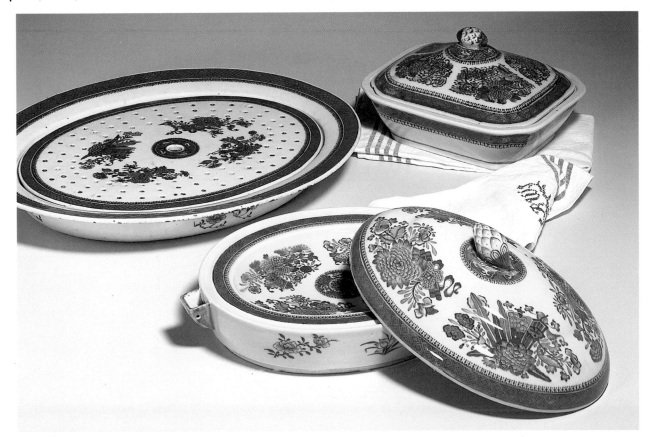

QING DYNASTY, QIANLONG PERIOD, ca. 1790.
Three serving pieces in underglaze blue with Fitzhugh pattern.
Large oval dish with draining insert (mazzarine). *Width:* 19½".
Covered dish with cassia-flower finial. *Width:* 10½".
Covered hot-water dish with cassia-flower finial. *Width:* 12½".
All, courtesy Sylvia Tearston.

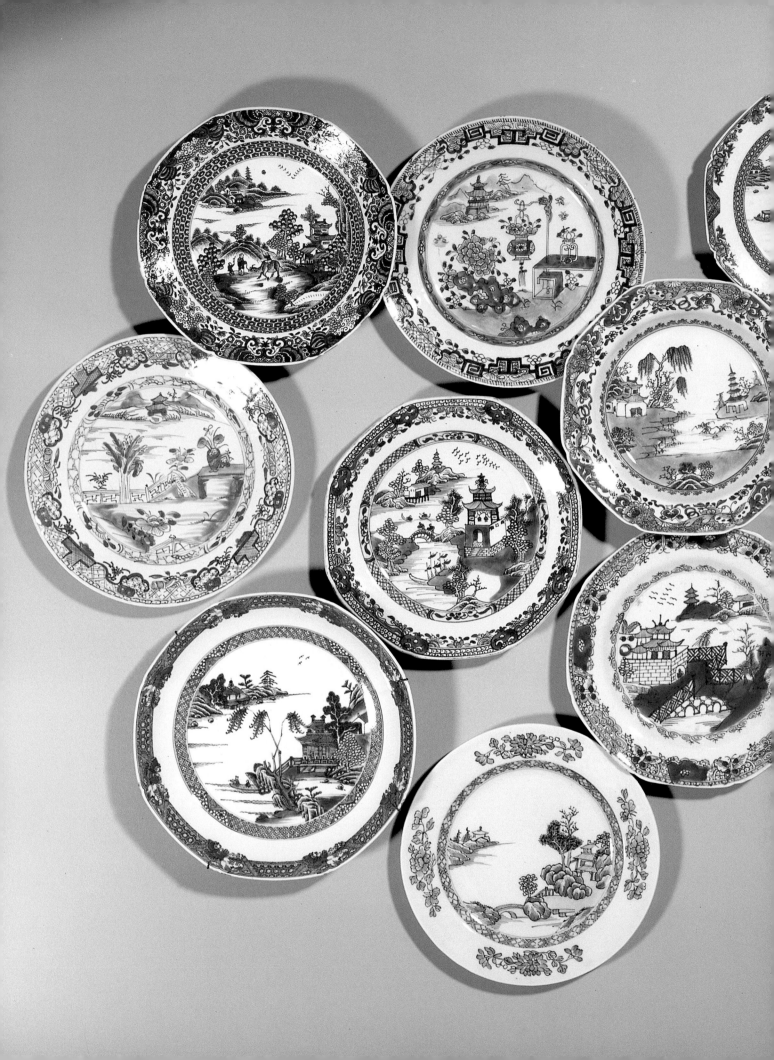

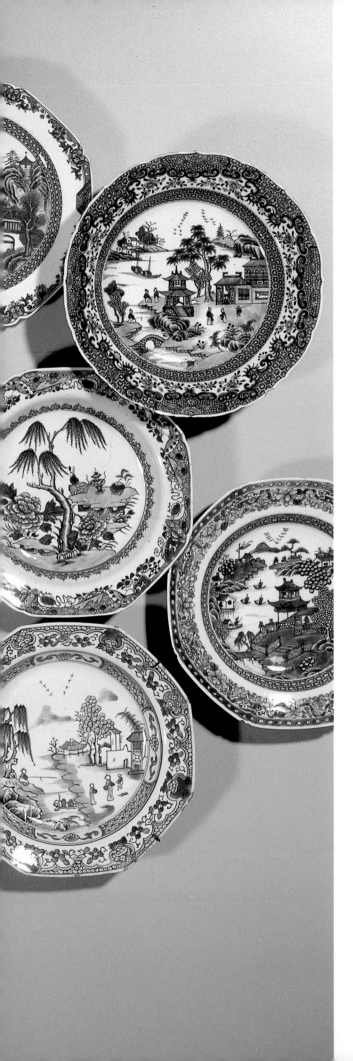

JIN DYNASTY (1115–1234).
Traditionally attributed to Liu Sung-nien
(active 1174–1210).
Ink and color on silk.
Height: 9½". Width: 10⅜".
Fan-shaped painting of a cottage by a river in autumn.
Museum of Fine Arts, Boston.

QING DYNASTY.
The riverscape was a popular theme painted in
underglaze blue on export porcelains manufactured in
Jingdezhen. This group of plates, dating from the mid-
eighteenth to the first quarter of the nineteenth century,
illustrates many variations of the Chinese decorative
elements that directly influenced English potters.
All, courtesy John Rosselli, Ltd.

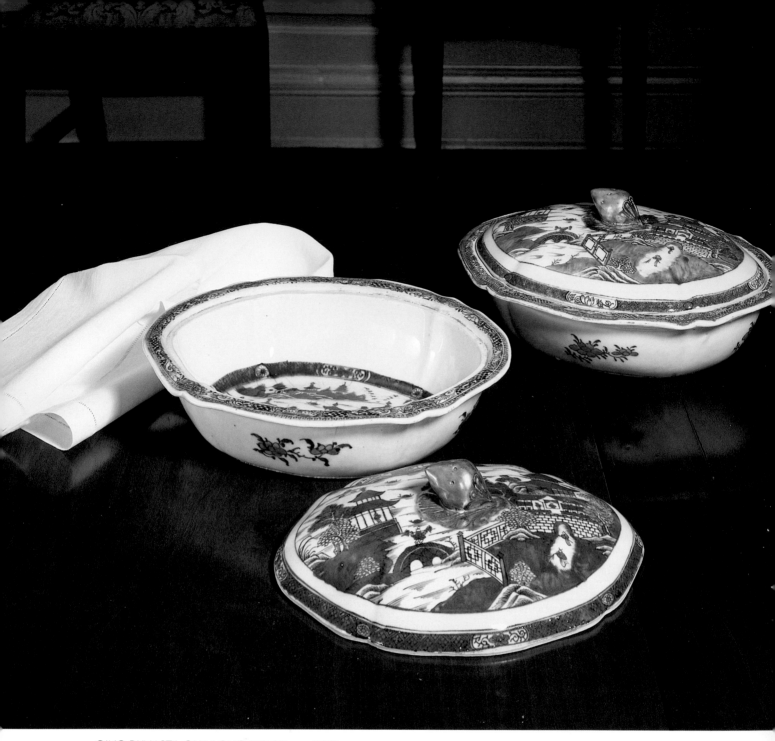

QING DYNASTY, QIANLONG PERIOD, ca. 1790.
Pair of underglaze blue covered dishes with gilded finials and
borders. These are part of a set given to Mayor and Mrs. Samuel
Powel by General Washington. This set does not have the "true"
Nanking border, but is referred to as Nanking because
of its gilded edges.
Width: 11".
On loan to the Powel House from the Mount Vernon Ladies Association.
Photographed in the dining room of the Powel House, Philadelphia.

NANKING WARE

anking — sometimes known as Nan-keen or Nankin — is the name both of the Yangtze River port north of Canton and of one of the major decorative patterns of blue and white export porcelain. Millions of pieces of Nanking ware were shipped to the West after the mid-eighteenth century. In the earlier Portuguese trade, the ware was called Macao.

Nanking ware is of high quality, consistently well potted, with a rich blue color and careful decoration. Look closely at its characteristic island and river scene and you may discern a figure on a bridge carrying an open umbrella. This small detail is not found on other patterns with similar island and river scenes.[1]

The latticework border most often associated with Nanking ware is meticulously painted and is usually encircled by a post-and-spear motif reminiscent of the fleur-de-lis. An attractive border variation combines butterflies in flight, split pomegranates, and flowering branches, much in the style of the Fitzhugh border. Gilding was often applied to rims and other areas of Nanking ware, generally by decorators in Canton, although sometimes this work was done in England.

Like Canton and Fitzhugh wares, Nanking was manufactured at Jingdezhen and decorated there by painters who specialized in export porcelains. After it was glazed and fired, it was shipped by river to Nanking, where it was transshipped in ocean-going junks to Canton. When the rivers dried up, as sometimes happened, the porcelain was painstakingly carried overland by coolie bearers.

Nanking ware got its name because of a misunderstanding. As a matter of convenience, the Canton hong merchants often stopped first at Jingdezhen to drop off samples and model drawings before they headed north to Nanking, an important marketplace. Not knowing about the Jingdezhen stop, Western supercargoes assumed that Nanking was also a place of porcelain production. The English *Gentleman's Magazine* was the first to circulate this misconception, in 1776.[2]

During the last quarter of the eighteenth century, the competitive production of English earthenware potteries seriously reduced the demand for Chinese blue and white export porcelains in Europe. America, however, continued to enjoy the quaint Nanking decorations, with their superficial glimpse into an exotic place and its people, long into the nineteenth century.

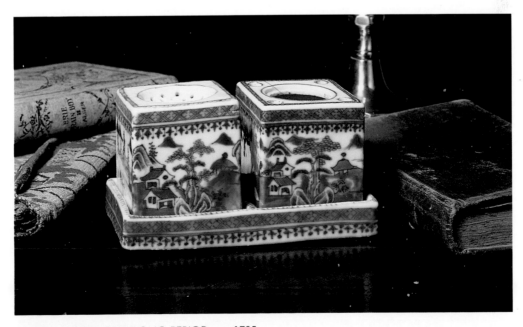

QING DYNASTY, QIANLONG PERIOD, ca. 1785.
Underglaze blue inkwell and "sander" with stand in the
Nanking pattern. The lid of the inkwell is missing.
Width: 5". Height: 2½".
Private collection, Philadelphia.

MARY CASSATT (AMERICAN, 1845–1926).
Lady at the Tea Table, 1883–1885. Oil on canvas.
Dimensions: 29" x 24".
A portrait of Mrs. Robert Moore Riddle, a first cousin of the
artist's mother. She is serving tea from a Nanking tea set
that was, in all probability, a cherished family heirloom.
Metropolitan Museum of Art, New York. Gift of Mary Cassatt, 1923.

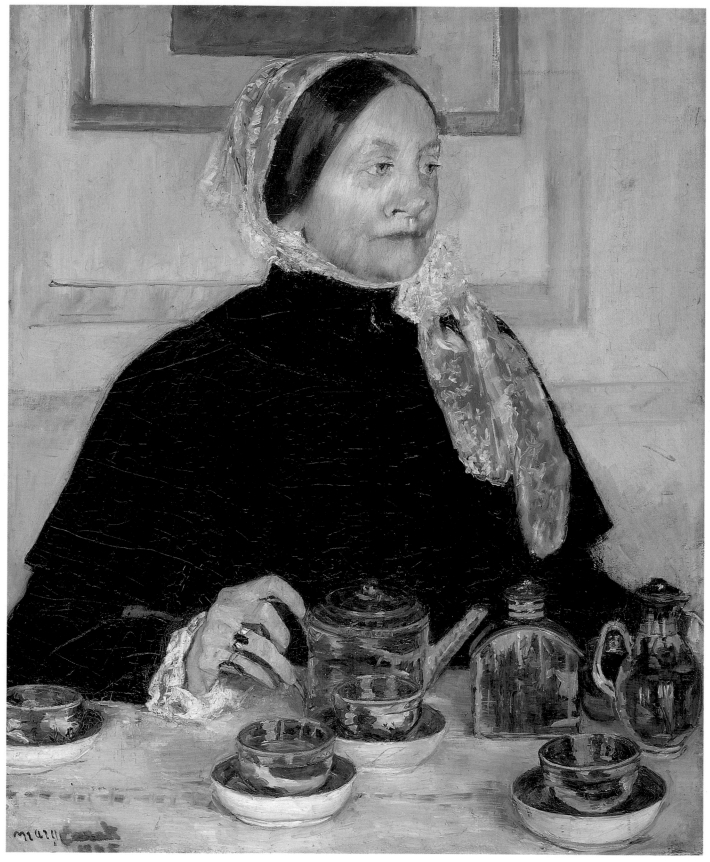

QING DYNASTY, QIANLONG PERIOD, ca. 1785–1790.
Underglaze blue assembled tea service in the Nanking pattern,
with gilt. The cream pitcher, (slop) bowl, and dish are true
Nanking pieces; the teapot, tea bowls, and saucers are not
"true" Nanking. The unifying factor is the gilding, which was
probably in each case added in England.
Height of teapot: 6".
Private collection Mr. Carl Steele.

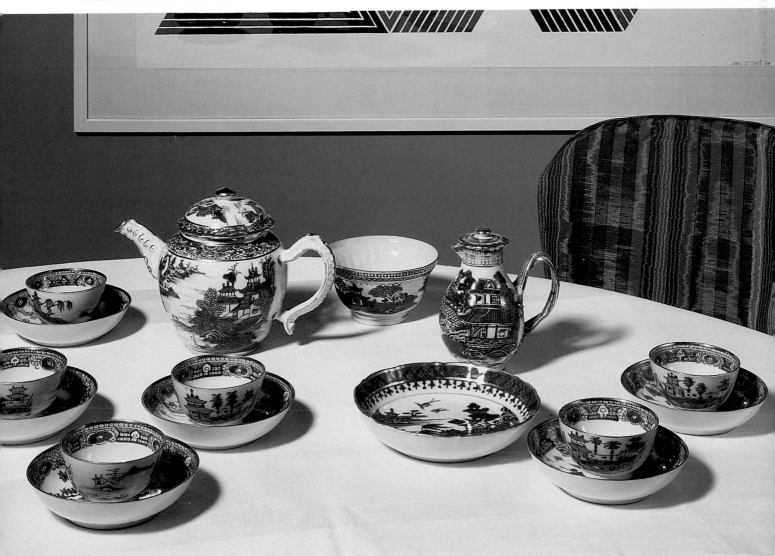

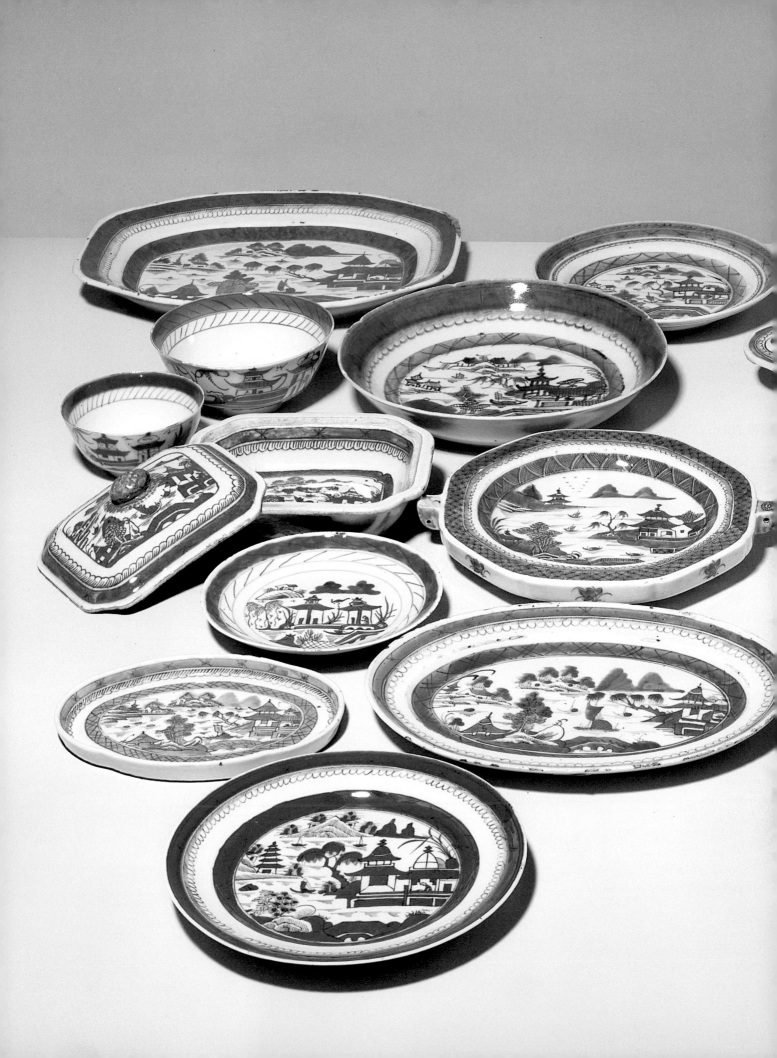

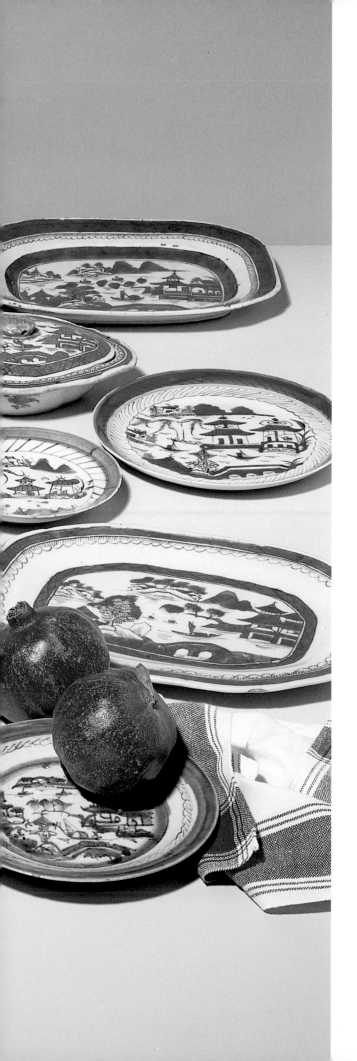

QING DYNASTY, QIANLONG PERIOD, ca. 1785–1790.
A selection of Canton-pattern serving pieces. Note the variety of shades in the underglaze blue and the differences in the execution of the riverscape.
Width of largest piece: 12".
Courtesy Flores and Iva, Antiques.
Private collection Mr. William Glasgow Thompson.

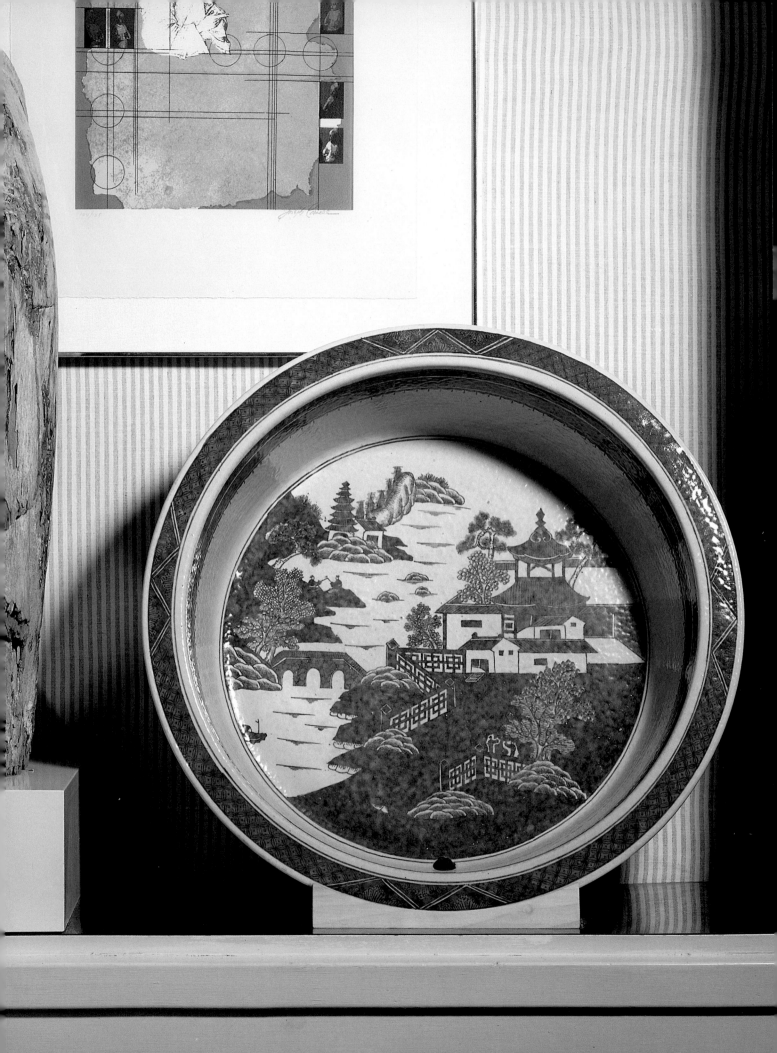

CANTON WARE

From the beginning of the American China trade, much of the porcelain imported into the United States was of a type known as Canton ware, named for the port of export rather than the place of decoration. Canton was used in homes throughout the new United States, from small farms to George Washington's home at Mount Vernon. It has often been referred to as "everybody's china," and because so much was brought over by the traders, great quantities of Canton have survived.[1]

Canton ware has a wide latticework border with a scalloped inner edging. The central design of Canton, like that of Nanking ware, consists of a meticulously rendered teahouse by a river, surrounded by pines and willows with distant mountains. Sometimes there is a figure in the window of the teahouse.[2]

The quality of Canton varied greatly from the very beginning of its manufacture. Some of it was as fine as the better trade porcelains, and some was coarse and carelessly potted and decorated. There is a wide range in the blues used on Canton wares, from pale or gray-blue to midnight shades. By the end of the nineteenth century, the designs were executed in a bolder, freer technique —almost calligraphic in style.

The trade in Canton ware began in the last quarter of the eighteenth century and continued through the nineteenth and into the twentieth century. It is difficult to date Canton because it was traded in such quantities over a long period of time and was never considered as valuable as the other Chinese porcelains. After 1894 in America, all porcelains were marked *China* because of a Congressional order that all imports be stamped with the country of their origin, but Hiram Tindall notes that great quantities arrived after that date with gummed labels only.[3]

Accurate trading-company records indicate that all exported porcelain was used as ballast in the tea trade. The lesser-grade Canton ware, however, is the only porcelain that retains the pejorative term "ballast China." Canton ware was not fully appreciated until the end of the nineteenth century; Alice Morse Earle wrote: "it has been crushed grievously under foot in Salem attics; it has been sold ignominiously to Salem junkmen."[4]

Times have changed, though, and the "humble" Chinese wares are now avidly sought by discerning collectors.

QING DYNASTY, JIAQING PERIOD (1796–1820).
Underglaze blue cistern in Canton pattern. This piece has been variously described as a fishbowl or a footbath. We have called it a cistern here; it was undoubtedly designed to hold water, as evidenced by the drainage hole on the side, and may have been used as a washbasin by a sea captain.
Height: 5¼". *Diameter:* 21¼".
Private collection Mr. Carl Steele.

QING DYNASTY, DAOGUANG PERIOD (1830–1880).
Underglaze blue soup plates and other tableware
in the Canton pattern.
Diameter of soup plates: 8".
Courtesy Nuri Farhadi, Inc.

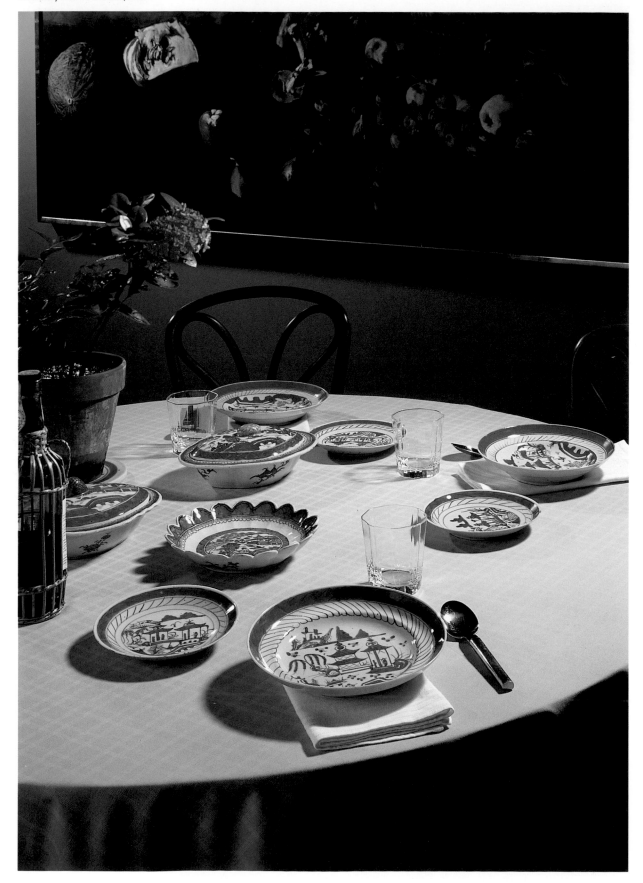

QING DYNASTY, DAOGUANG PERIOD (1830–1880).
Underglaze blue ginger or sweetmeat jars in the Canton pattern.
These jars were produced in great quantities for the shipment of
various delicacies to the West. Note the coarse potting and the
differences in application of the underglaze blue. The jars
originally had flat lids.
Height: 7".
Private collection, Philadelphia.

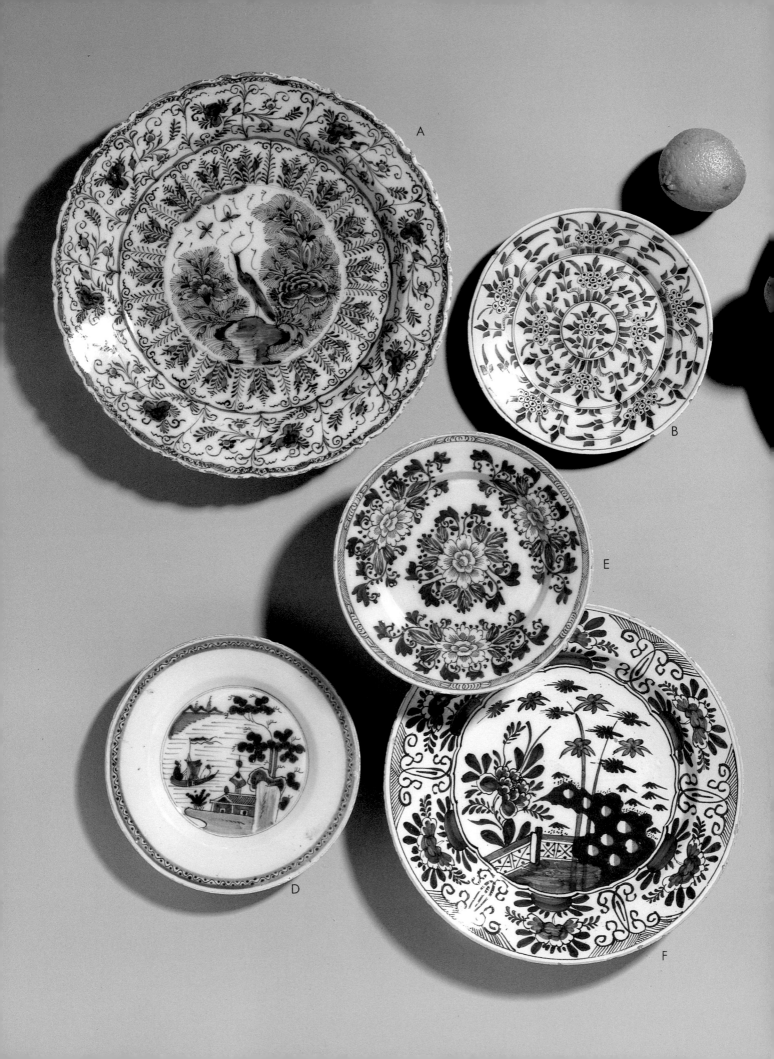

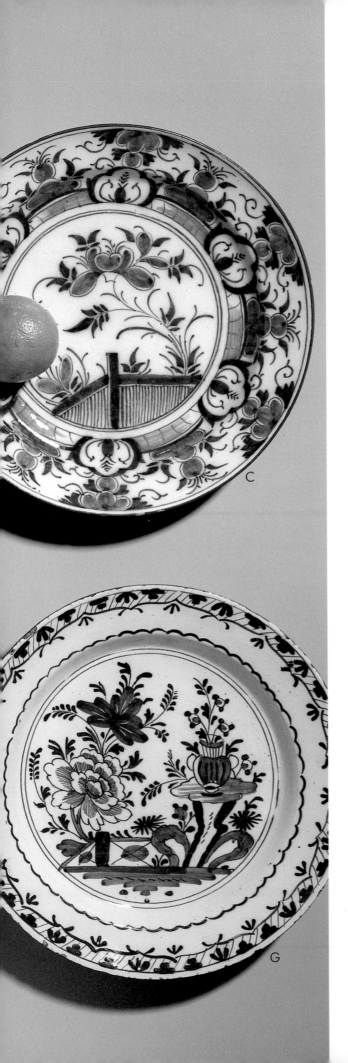

DUTCH DELFT, ca. 1730–1780.

A selection of tin-glazed earthenware pieces.

A: Charger (ca. 1750) with a peacock in the center. There is a clawmark on the bottom.
Width: 14".

B: Dish (ca. 1730) with a geometric flower pattern.
Width: 8½".

C: Charger (ca. 1740) depicting a fence with a peony branch.
Width: 13½".

D: Dish (ca. 1760) with a river scene.
Width: 9".

E: Dish (ca. 1780) with a stylized flower pattern. Marked van Beeck.
Width: 9".

F: Charger (ca. 1760) displaying a rock with a fence and trees. The charger has a clawmark on the bottom.
Width: 12½".

G: Charger (ca. 1750) with peony and vase.
Width: 13½".

All, courtesy Bardith, Ltd.

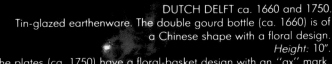

DUTCH DELFT ca. 1660 and 1750.
Tin-glazed earthenware. The double gourd bottle (ca. 1660) is of
a Chinese shape with a floral design.
Height: 10".
The plates (ca. 1750) have a floral-basket design with an "ax" mark.
Diameter: 9".
The decanter and wineglasses are late eighteenth-century English.
All, courtesy Bardith, Ltd.
BACKGROUND: home of Mr. Inman Cook.

DELFTWARE

oward the end of the sixteenth century, roving bands of Italian potters brought the technology of maiolica from one European country to another. A certain Guido da Savino is credited with setting up the Netherlands industry in Delft, a small town near Rotterdam. There, the decline of the breweries provided the space needed for the potteries, which retained the buildings' former names, such as The Three Bells, At the Sign of the Greek A, and The Golden Flowerpot.[1]

Dutch maiolica was covered on the back with a "waterproof" lead glaze and, on the front, with a tin glaze that produced an opaque white surface.*

* Oxide of tin (ashes) was added to the glaze material to cause the chemical reaction.

It is probable that the Dutch potters would have indefinitely continued to decorate their maiolica in dark colors and with simple incising. By 1602, though, their wares began to seem crude and old-fashioned. At auctions that year and two years later, prosperous Dutch burghers fell in love with the delicate, gleaming, blue-painted Chinese porcelain that was part of the plunder from the Portuguese ships.

During the next fifty years, over three million pieces of what were called Blue Nankin tablewares flooded into Europe, much of it destined for the Dutch market.

Unable to sell their own tablewares, the Dutch potters turned to making wall and stove tiles decorated, of course, in underglaze blue. Skilled artists

J. J. VAN GOYEN (DUTCH, 1596–1656)
View of Delft, 1652. Pencil on paper.
Dimensions: 7½" × 4½".
Rijksmuseum, Amsterdam.

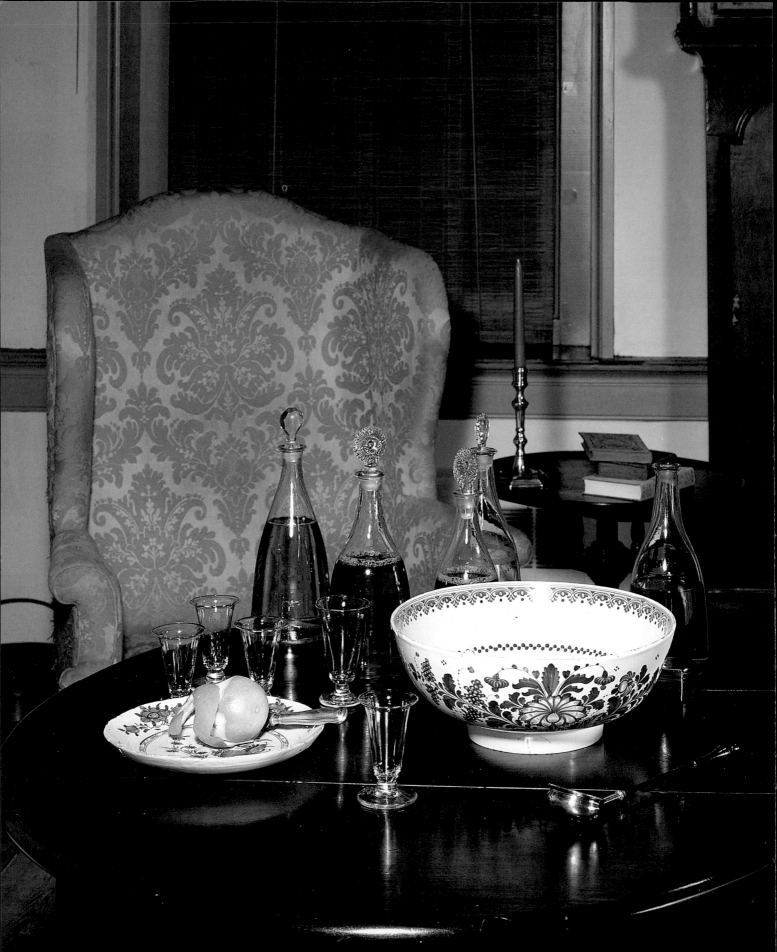

DUTCH DELFT, ca. 1770.
Punch bowl with stylized flower design.
Diameter: 12".
Private collection, Philadelphia.

DUTCH DELFT, ca. 1760.
Tin-glazed earthenware charger with stylized flowers in a bowl.
Diameter: 13½".
Courtesy Bardith, Ltd.

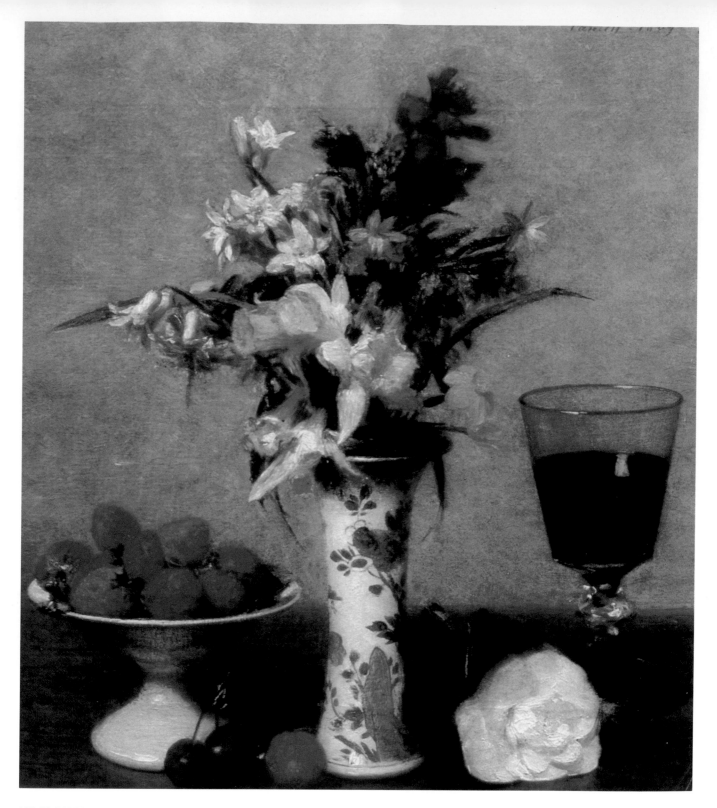

HENRI FANTIN-LATOUR (FRENCH, 1836–1904).
The Betrothal Still Life, 1869. Oil on canvas.
*Dimensions:*12½" x 11½".
The beaker vase in the still life is part of a set of Delft garniture.
Museum of Painting and Sculpture, Grenoble, France.

DUTCH DELFT, ca. 1760.
Tin-glazed earthenware beaker-shaped vase, part of a set of
garniture with a design of stylized flowers. *Height:* 10".
Charger with fence and peony branch design. *Width:* 12¼".
Courtesy Bardith, Ltd.
BACKGROUND: home of Mr. Inman Cook.

were often hired to paint masterful landscapes, portraits, marine and biblical scenes, and flowers on individual tiles as well as panels.

The production of tablewares started up again when the Dutch East India Company's trade with China halted abruptly in 1644. Word came that the civil war between the Mings and the Qings had caused "great mortality among the porcelain makers."[2]

Now the Dutch began to manufacture a new, refined type of ware called faience, which bore a closer resemblance to Chinese porcelain. Not only the front but the entire surface of faience was covered with the opaque white tin glaze. The warm, brilliant blue color was achieved with relative ease in the low-temperature firing.

By the last quarter of the seventeenth century, the famous "blue Delft" was being made not only in Delft, but also in Haarlem and Dordrecht, among other cities.[3]

At first, the decoration of Delftware closely followed that of the *kraakporselein* and later Transitional wares before moving further and further into an imaginative chinoiserie. Gradually, Dutch fig-ures, landscapes, and religious themes began to appear, along with European baroque decoration.

In addition to tablewares, the Dutch potters made superb and intricate garnitures, vases, flower pyramids, and garden urns. A new and passionate popular interest in botany had brought about the importation of rare plant specimens. The tulip, which had come to Holland from Turkey around 1575, inspired special vases for its display. Tulips were painted on tiles and wares and often appeared on the Delft models sent by the East India Company to China for copying.[4] During the reign of William III, who would later rule England with his wife, Mary, Delft wares went to English country houses and in turn influenced potters in Bristol.

The fortunes of the Dutch potters languished again in 1729, when the East India Company entered into direct trade with Canton. Imports of Chinese blue and white rose astronomically, as did those of the newly fashionable cream-colored English earthenware. After 1813, of the thirty factories, which had employed two thousand people at the height of Delft's production, only one survived.

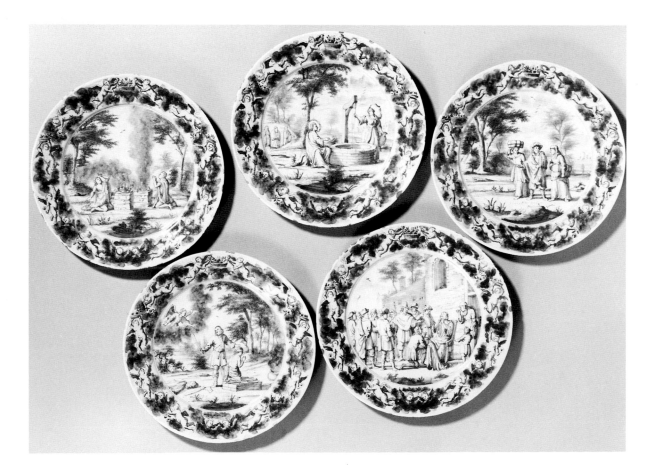

DUTCH DELFT, ca. 1765–1780.
Part of a set of garniture, with a decoration illustrating Jacob's
dream. Probably based on an engraving by Lucas van Leyden.
Height: 10".
Private collection, Philadelphia.

DUTCH DELFT, ca. 1765–1780.
Tin-glazed earthenware plates, underglaze blue, with cherubs
and clouds as the rim motifs, and marked De Roos Factory.
The individual designs of the plates were probably based on
Lucas van Leyden's 1509 circle-shaped engravings of biblical scenes.
UPPER LEFT: the sacrifice of Cain and Abel. UPPER MIDDLE: Christ and
the Samaritan woman. UPPER RIGHT: Lot and his daughters.
LOWER LEFT: the binding of Isaac. LOWER RIGHT: Christ before Annas.
Diameter: 9".
Courtesy Earle D. Vandekar of Knightsbridge.

DUTCH DELFT, ca. 1800.
A pair of tin-glazed covered jars, with a design of peacocks and
stylized flowers.
Height: 18".
The Fantin-Latour drawing of a male nude was once in the
collection of James McNeill Whistler.
Private collection Mr. J. Hyde Crawford.

DUTCH DELFT, ca. 1690–1700.
Tin-glazed earthenware flower pyramid, used to display cut
flowers of all kinds, not exclusively tulips. Manufactured at the
Greek A factory of Adriaen Kocks, marked with monogram AK.
Height: 51".
Dyrham Park—The National Trust (Blathwayt Collection).

113

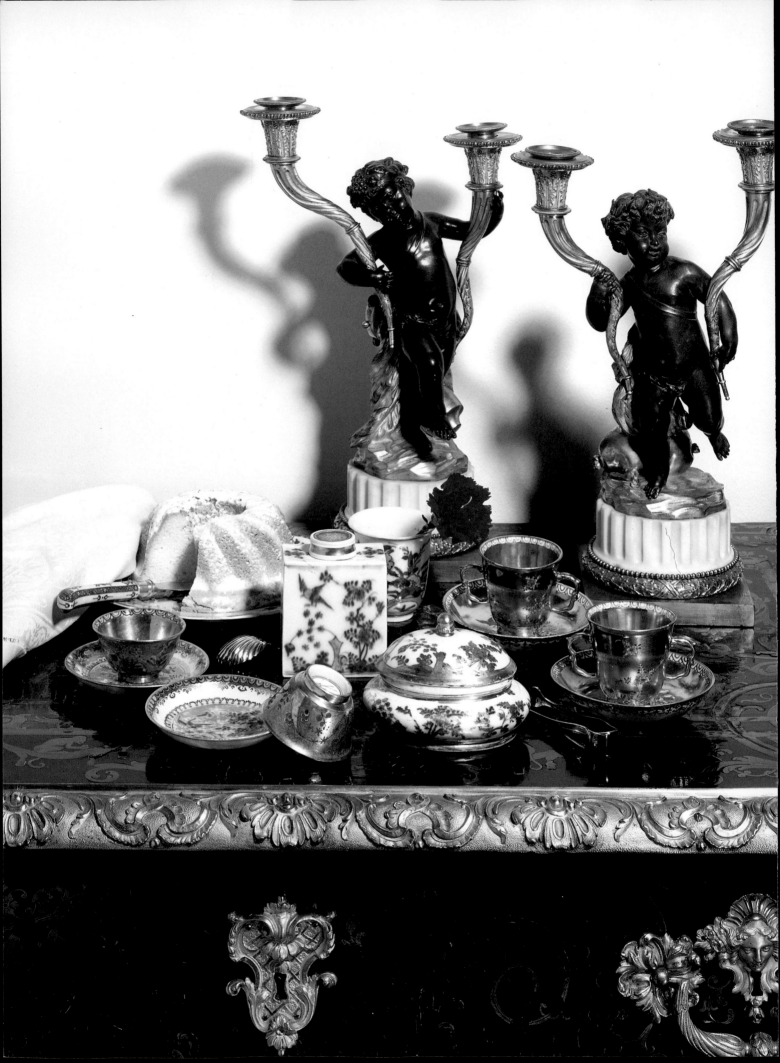

MEISSEN WARE

Admiration for Chinese porcelains, as well as for the Dutch ceramic achievements at Delft, inspired potters in Germany to refine their earthenware and emulate the Chinese shapes and decoration. This ware was referred to as *porzellan,* although it was, of course, faience rather than true porcelain.

Augustus the Strong, Elector of Saxony and King of Poland, assembled thousands of pieces of Chinese porcelain and once exchanged a regiment of dragoons for forty-eight Chinese vases. In the early eighteenth century, when Germany — and, indeed, all of Europe — was in the grip of porcelain fever and every palace had its porcelain room, the notorious extravagances of Augustus led all the rest. His expenditures so concerned the Saxon nobleman and scientist Erenfried Walthers von Tschirnhaus, a believer in the national policy of economic self-sufficiency, that he determined to manufacture porcelain at home in Germany and to do away with the fiscally draining import trade. Tschirnhaus persuaded Augustus to subsidize him in a joint research effort with Johann Friedrich Bottger, the king's alchemist. The unfortunate Bottger had been a virtual prisoner of Augustus, assigned to the task of producing gold. There were many disappointments, but finally, in 1709, a year after Tschirnhaus's death, Bottger produced the first porcelain, with kaolin from Colditz as a base. The secret of hard-paste porcelain had been, at last, revealed.

In 1710, a royal factory was established at Meissen, where Augustus spared no expense to achieve a level of quality equal to that of his Chinese treasures.

He hired master potters, painters, and sculptors to create extraordinary, life-size animals, stylized figure groups, centerpieces, and splendid tablewares. The successes at Meissen were admired and imitated everywhere, even to the famous crossed-swords factory mark in underglaze blue adopted in 1724.

Meissen porcelain became renowned throughout Europe. At first, the Meissen factory produced copies of Chinese blue and white porcelain, but it was not long before the potters of Jingdezhen became adept at imitating the imitations. Today even an expert has difficulty in distinguishing between genuine Meissen and Chinese Meissen.[1]

From about 1723 on, the rococo period's fanciful

MEISSEN, ca. 1722–1750.
A selection of early underglaze blue wares for serving tea and chocolate. From far left, tea bowl and saucer, heavily gilded. Tea caddy, rectangular shape, with replacement top. *Height: 4".*
Beaker cup, painted by David Kohler, who worked with Johann Friedrich Bottger at Dresden about 1720.
Bell-shaped chocolate cups with double handles and saucers, heavily gilded. Sugar box painted by an unknown *hausmaler* (an outside decorator).
All, courtesy The Antique Porcelain Company.

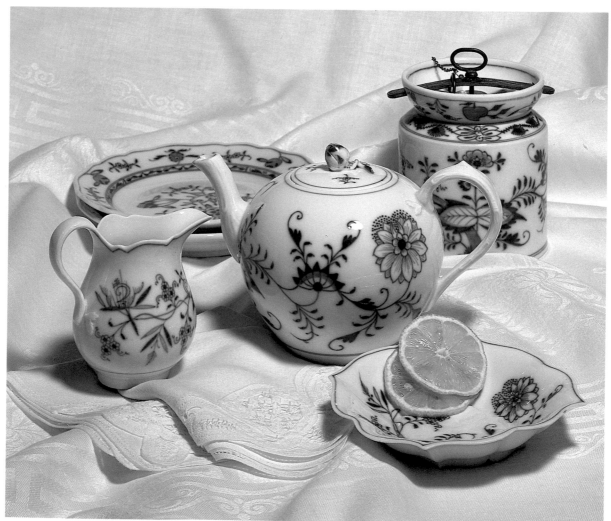

MEISSEN, NINETEENTH CENTURY.
A group of underglaze blue porcelains in the traditional Onion
pattern. At the top right is a tea caddy with metal fittings.
Height of tea caddy and pot: 4½".
Courtesy David Seidenberg Antiques.

theme opened up delightful new areas of invention for the porcelain painters at Meissen. There is a vase from this time in the Tower Room of the Residenz-Schloss at Dresden, decorated with scenes of Augustus the Strong, dressed as a Chinese emperor, viewing the Albrechtsburg, or royal porcelain works, at Meissen.[2]

Meissen's greatest period, 1733–1756, followed Augustus's death. During this time, large table sets were produced not only for royalty but also for the wealthy, who had transformed the taking of meals into an elaborate ritual lasting many hours. In addition to the usual pieces, the sets included sweet-meat dishes, mustard pots, tankards, and wonderful tureens topped by fruit, vegetable, and animal shapes. There were also ornate services for tea, coffee, and chocolate.

The Zweibelmuster, or Onion pattern, with underglaze blue decoration, was originally introduced in tablewares about 1735. The design was taken from a Chinese pattern of flowers, foliage, and fruit; in the stylistic translation, the fruit motif became an onion. The pattern continues to be produced today at Dresden and other factories. The English versions were called Meissen Onion, Immortelle, and Copenhagen pattern.

AFTER BERNARDO BELLOTTO (ITALIAN, EIGHTEENTH CENTURY)
View of Dresden from the Right Bank of the Elbe, below the Augustusbruck, 1748(?). Oil on canvas.
Dimensions: 37" x 64".
© 1987 Sotheby's, Inc.

MEISSEN, NINETEENTH CENTURY.
Underglaze blue floral pattern with gilt trim; the bottom
of the cup in the foreground has the traditional Meissen
mark of crossed swords.
Height of tureen: 12".
Courtesy David Seidenberg Antiques.
BACKGROUND: designed by Daniel Park of Donghia, Inc.

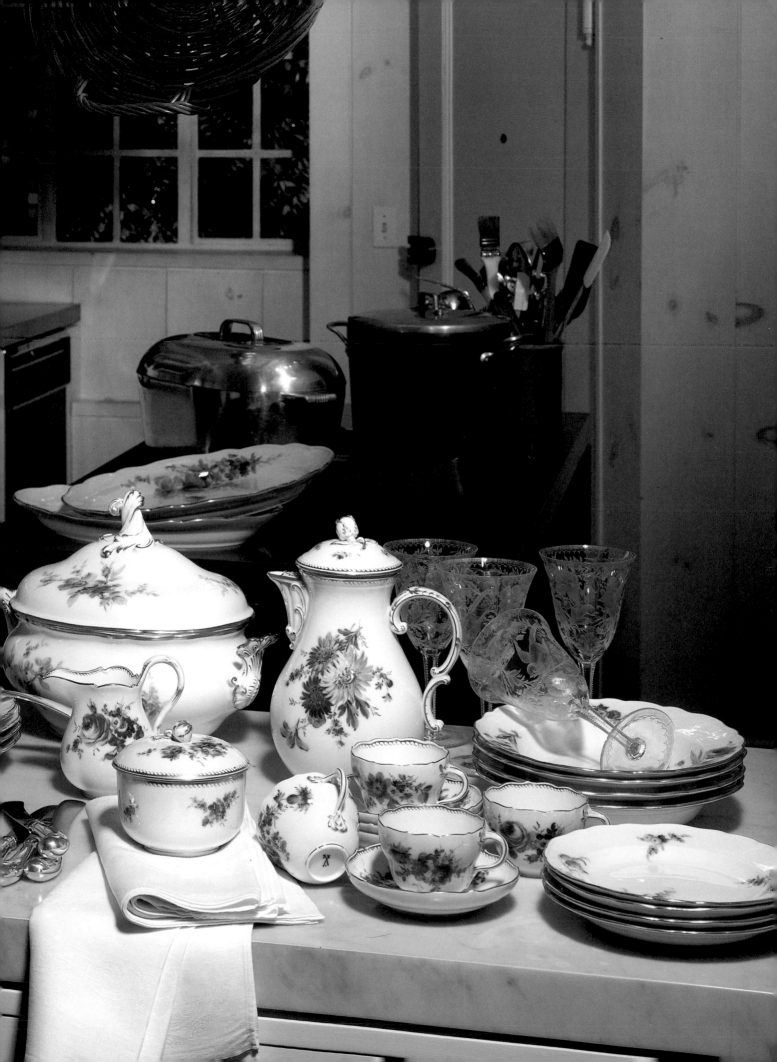

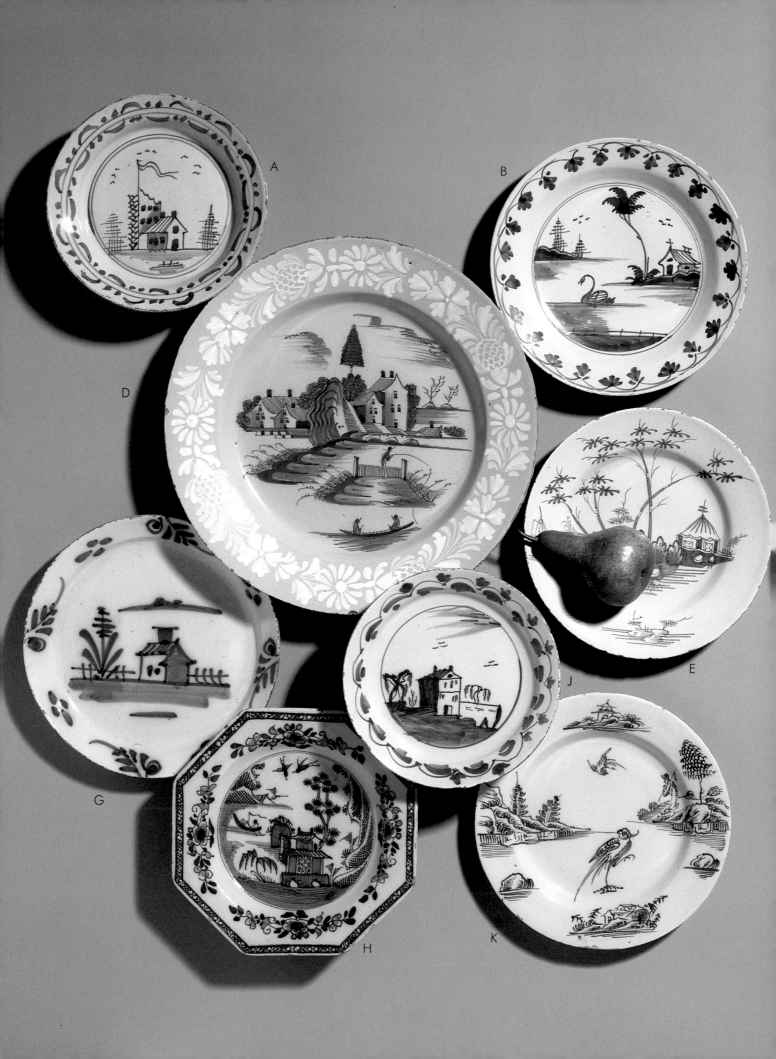

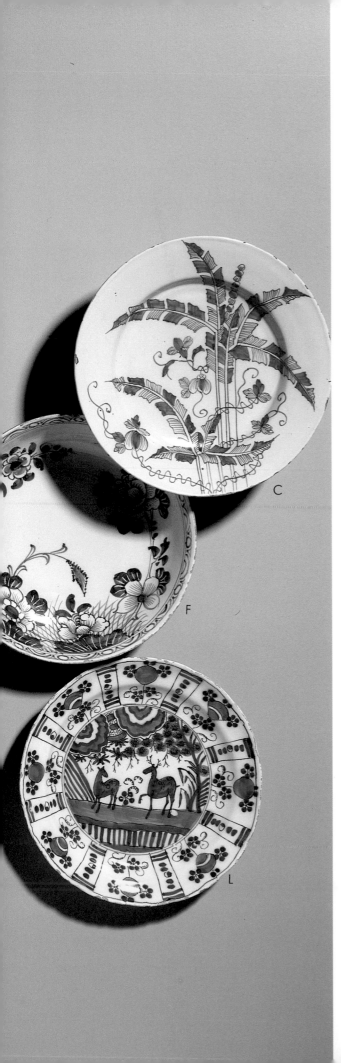

ENGLISH EARTHENWARE, ca. 1710–1760.

A selection of underglaze blue saucers and plates.

A: Plate, (Lambeth, ca. 1730) decorated with a house and tower.
Diameter: 7½".

B: Plate (Bristol, ca. 1710) with swan in river scene.
Diameter: 9".

C: Plate (Lambeth, ca. 1700) with banyan tree.
Diameter: 8¾".

D: Charger (Bristol, ca. 1750) with houses in a landscape. The border is *bianco-sopra-bianco* (the decoration is modeled with a slip of clay of another color and then refired).
Diameter: 13".

E: Plate (Liverpool, ca. 1760) with a house and bamboo.
Diameter: 8½".

F: Plate (Liverpool, ca. 1760) with a floral design.
Diameter: 8¾".

G: Plate (Lambeth, ca. 1730) with a house and fence.
Diameter: 9".

H: Octagonal plate (Liverpool, ca. 1755) with a classic "Willow" scene.
Diameter: 8½".

J: Plate (Lambeth, ca. 1730) with a house and willow tree.
Diameter: 7½".

K: Plate (Liverpool, ca. 1760) with a scene of a crane in the water.
Diameter: 9".

L: Plate (Liverpool, ca. 1730) with divided-panel border design derived from decorations of the Wanli period. The central scene shows a pair of deer.
Diameter: 8½".

All, courtesy Bardith, Ltd.

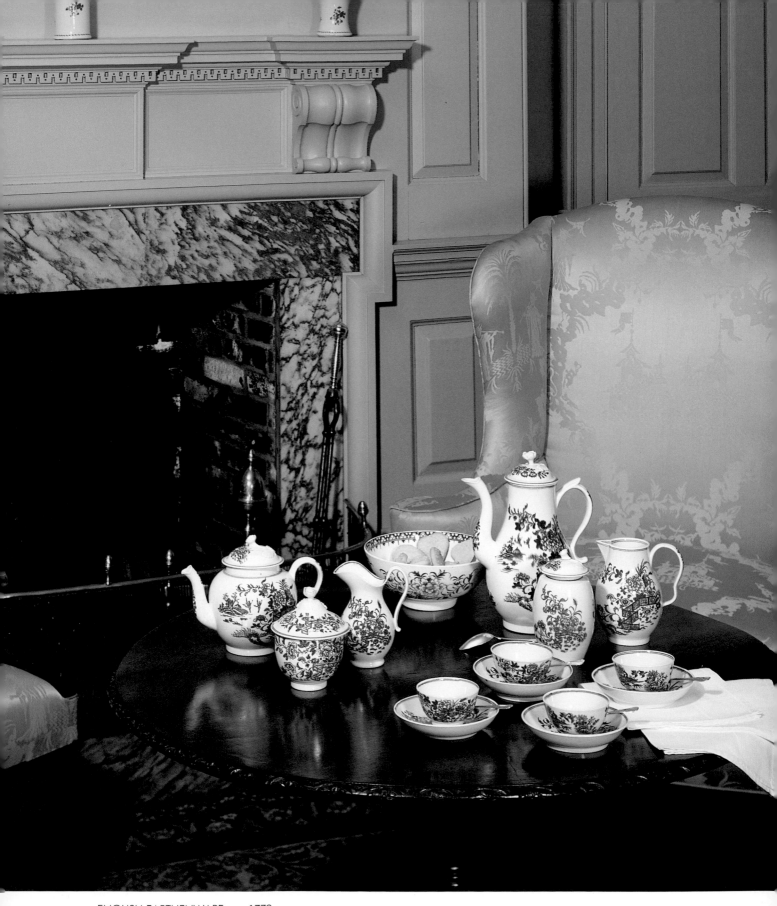

ENGLISH EARTHENWARE, ca. 1772.
Worcester underglaze blue soft-paste porcelain tea
and coffee service of the Dr. Wall period.
Courtesy Philadelphia Society for the Preservation
of Landmarks. Gift of Miss Ethel Moore.
Photographed in the "parlor" of the Powel House, Philadelphia.

ENGLISH WARES

Eventually the English developed their own tin-glazed earthenware, following the examples first of Italian maiolica and then of Dutch Delftware. The superior ware that evolved in the Thames-side factories of Lambeth and Southwark adhered so closely to Dutch models that it was given the name delft. In the eighteenth century, many delftware factories sprang up in the southwest of England, particularly in Bristol and Liverpool, where Chinese porcelains directly influenced the decoration of a delightful and imaginative chinoiserie on tin-glazed earthenware. Once they had absorbed the Chinese influence, skilled painters produced a multitude of designs that gradually became Anglicized.

English blue and white wares were designed mainly for the table. Long after most other Europeans had developed a new taste for polychrome enameled or "colored" wares, the English remained devoted to the blue and white scheme. In the eighteenth and nineteenth centuries, the drinking of tea became inseparably linked with blue and white china as the quintessential expression of English life.

English potters were never under royal patronage. Instead, they were backed by investors, practical businessmen of fairly modest means who were interested in turning a profit. Bernard Watney points

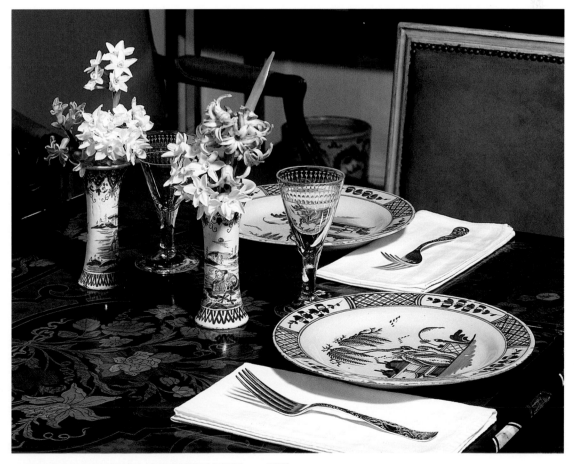

ENGLISH EARTHENWARE AND DUTCH DELFT, ca. 1750.
Underglaze blue plate from Liverpool with a willow tree, house, and fence.
Diameter: 9".
Trumpet-shaped Dutch Delft beakers, with Chinese-inspired landscape design.
Height: 5".
All, courtesy Bardith, Ltd.
BACKGROUND: home of Mr. Inman Cook.

out that "being easier and cheaper to produce than coloured wares it [blue and white] was often the first marketable product of the early factories."[1]

In an attempt to approximate the porcelain of the Chinese, English potters achieved by the 1720s a fine, white salt-glazed stoneware, most often decorated in blue. A hard, glistening glaze resulted from the chemical reaction produced when salt was tossed into a high-temperature fire.[2]

The earliest known production of the more refined "soft-paste" porcelain in England occurred in 1745, the date inscribed on a jug manufactured in the Chelsea factory west of London. Within a few years there were seven more porcelain factories; most notable was the Bow factory in the East End of London near Bow Bridge. At the height of the

chinoiserie mania in the 1750s, Bow factory potters even marked some of their wares "Made at New Canton."[3]

In 1744, the glassmaker Edward Heylyn and Thomas Frye, a successful artist, took out a patent for a type of porcelain made from an exceptionally fine American clay called unaker. In its patent, unaker was defined as "an earth, the produce of the Cherokee nation in America."[4] It had been brought to England by Andrew Duché, a Savannah potter of Huguenot descent, who had been unable to get financial backing for his porcelain experiments in the colonies. While unaker is indubitably exotic, its value in producing porcelain is considered questionable by experts.

Frye's great contribution to ceramic technology

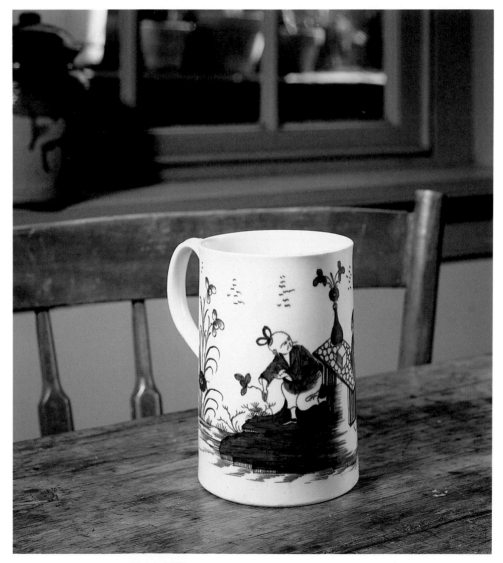

ENGLISH EARTHENWARE, ca. 1765.
Worcester underglaze blue soft-paste porcelain tankard of the
Dr. Wall period. Has a design of a mandarin and "gardener."
Marked with "C" on bottom.
Height: 6".
Courtesy Bardith, Ltd.

was the process for making a soft-paste bone china, which he patented in 1749. He had discovered that the addition of ox-bone ash added fusibility and strength to the porcelain materials. The Worcester factory, established in 1751 by Dr. John Wall and William Davis, developed a durable clay containing soapstone that produced a fine translucent china able to withstand boiling water.

During the "Dr. Wall period" (1751–1776), beautiful tableware was produced, decorated with Chinese designs in underglaze blue. The use of the more efficient process of transfer printing, in blue as well as other colors, had been adopted around 1760 at Worcester. This method involves the transfer, before glazing, of a complete engraved picture or design to the piece by the use of copper plates.

Transfer printing revolutionized the ceramic industry in England.

Kaolin and china stone (petuntse) were discovered in Cornwall around 1748 by William Cookworthy, who was associated with the Plymouth potteries in Devonshire on the English Channel. It was not until 1768 that production using kaolin and petuntse to make hard-paste, or true, porcelain began.

Sometime before 1800, in Stoke-on-Trent in Staffordshire, Josiah Spode combined the ingredients of hard-paste porcelain and bone ash to produce bone china, also called Staffordshire bone porcelain. This new technique made blue and white wares even more widely available.

ENGLISH EARTHENWARE, ca. 1760.
Underglaze blue oblong quill pen holder made in Liverpool.
Width: 6½".
Private collection, Philadelphia.

ENGLISH UNDERGLAZE BLUE EARTHENWARE, ca. 1775–1785.
From left, Bow octagonal dessert plate with reserve
panels against a (powder) blue background.
Riverscape in center.
Diameter: 7½".
Caughley pitcher with fisherman mask spout decorated
with landscape and figures.
Height: 9".
Salopian octagonal platter in Temple pattern, an early
example of transfer painting.
Width: 17½".
Caughley oval dish with key fret border and riverscape
in center.
Width: 6½".
Bow dolphin tripartite scallop-shell sweetmeat dish.
Height: 6½".
All, courtesy Bardith, Ltd.
English Regency chair with original needlepoint,
courtesy Bardith I.
Eighteenth-century paisley throw, courtesy
Doris Leslie Blau.

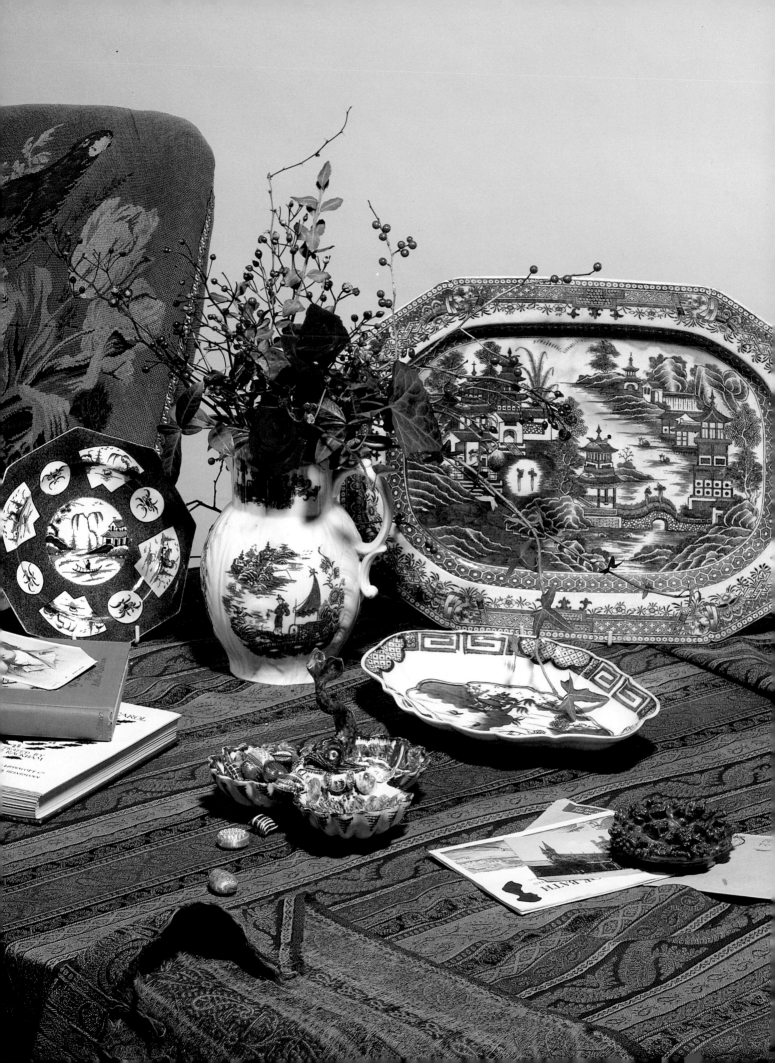

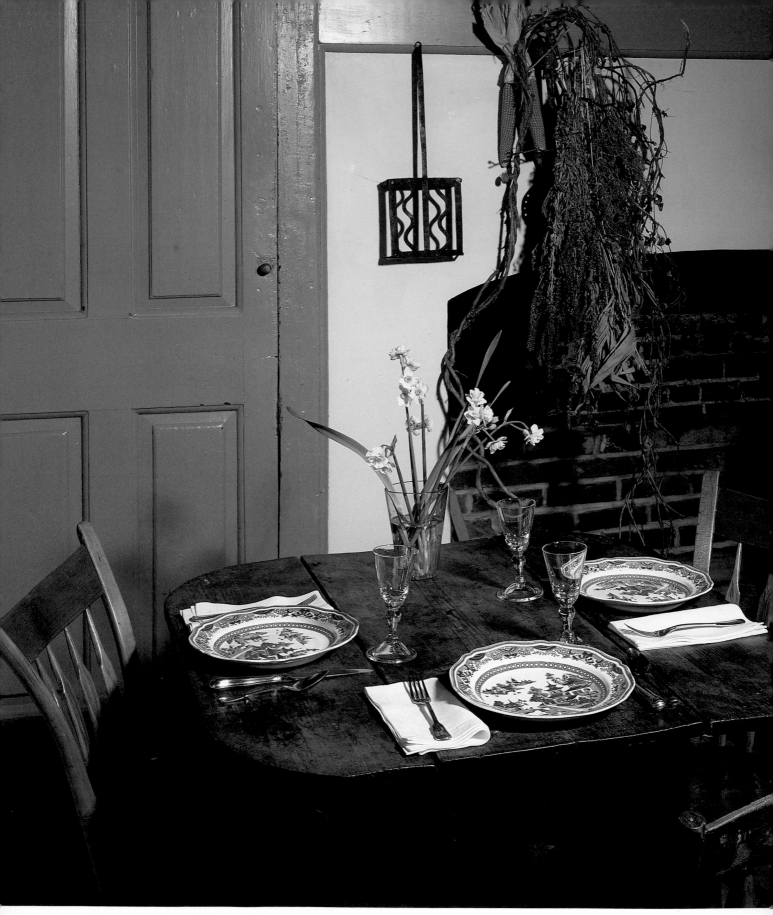

ENGLISH EARTHENWARE, ca. 1810.
Spode transfer-printed underglaze blue dinner plates in the Willow pattern.
Diameter: 9½".
Courtesy Bardith, Ltd.
BACKGROUND: kitchen of Nathaniel Irish House, Philadelphia.

QING DYNASTY, QIANLONG PERIOD (1736–1795).
Underglaze blue dish with finely drawn riverscape. This particular
Chinese design was closely copied in England at the Spode
factory in Stoke-on-Trent and was one of the earliest patterns
produced there. The gilding of the wavy rim was a fashionable
English accent added at an enameling workshop soon after
the dish arrived in England.
Diameter: 9⅝".
The Mottahedeh Collection.

ENGLISH EARTHENWARE, ca. 1930.
Transfer-printed underglaze blue tureen, platter, and
dinner plates, with Willow pattern. These wares were
widely available in department and "five and dime"
stores in England and America.
Width of platter: 17".
Private collection.

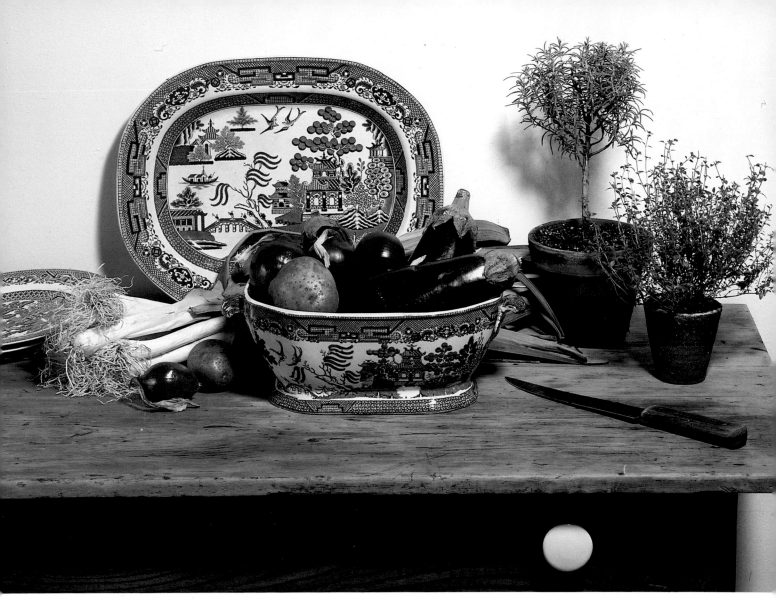

THE WILLOW PATTERN

Variations of the ubiquitous Willow pattern began to appear in underglaze blue on the wares of several English factories beginning in 1760. The willow tree as well as some of the border details derive from traditional Chinese designs that later became standardized on Canton and Nanking export porcelains.

It was the Caughley version of the Willow pattern of about 1780 that really caught the public's fancy. Accompanied by a tale called "The Legend of the Willow Pattern Plate," it had all the elements of popular romance: an irate father and eloping lovers who drown tragically and whose departing spirits take the form of birds. Needless to say, this vision of Cathay was completely un-Chinese.

Originally hand-painted at Caughley, the Willow pattern was later transfer-printed there.

Thomas Minton, a Caughley apprentice who went on to found Minton Pottery, worked on the first copper plates for the transfer printing of the Willow pattern. He sold variations of the design to other factories, among them Wedgwood, Adams, Davenport, and Spode.

The first Josiah Spode, well known for the fine wares of his factory at Stoke-on-Trent in Staffordshire, began to transfer-print the Willow pattern on earthenware around 1785. When Josiah Spode II developed the modern formula for bone china, or bone porcelain, in 1800, the ware he produced also featured the Willow pattern.

Through English mechanized techniques, the Willow pattern was endlessly reproduced in the nineteenth and twentieth centuries. The cheapest versions were a staple of five and dime stores in America up to the time of the Second World War.

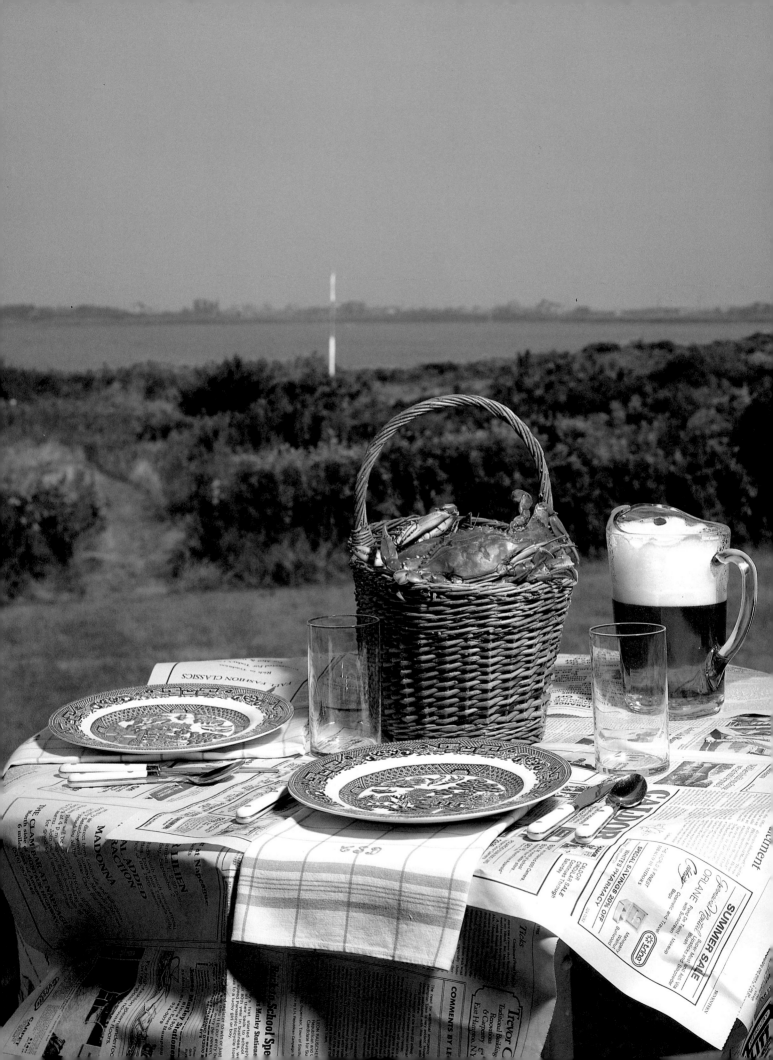

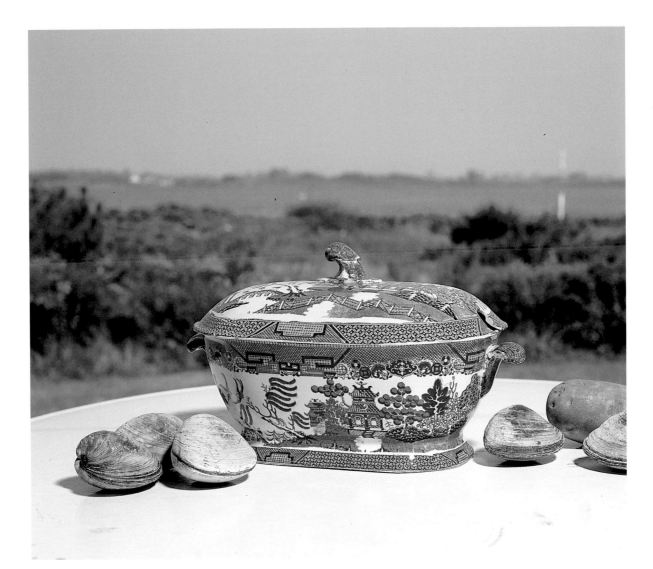

ENGLISH EARTHENWARE, ca. 1930.
Transfer-printed soup tureen in Willow pattern.
Width: 12½".
Private collection, New York City.

ENGLISH EARTHENWARE, ca. 1930.
Transfer-printed dinner plates in Willow pattern from the factory
of John Steventon, Ltd.
Diameter: 10".
Private collection Miss Catharine S. Dives.

GRANT WOOD (AMERICAN,1892–1942).
Daughters of Revolution, 1932 (detail). Oil on masonite panel.
Dimensions: 120″ x 40″.
The teacup shown in the painting is English earthenware transfer-
printed in the Willow pattern.
Cincinnati Art Museum, Ohio, The Edwin and Virginia Irwin Memorial.

ENGLISH EARTHENWARE, ca. 1920.
Transfer-printed tea caddies in the Willow pattern.
Height: 8".
Private collection Mr. William Glasgow Thompson.

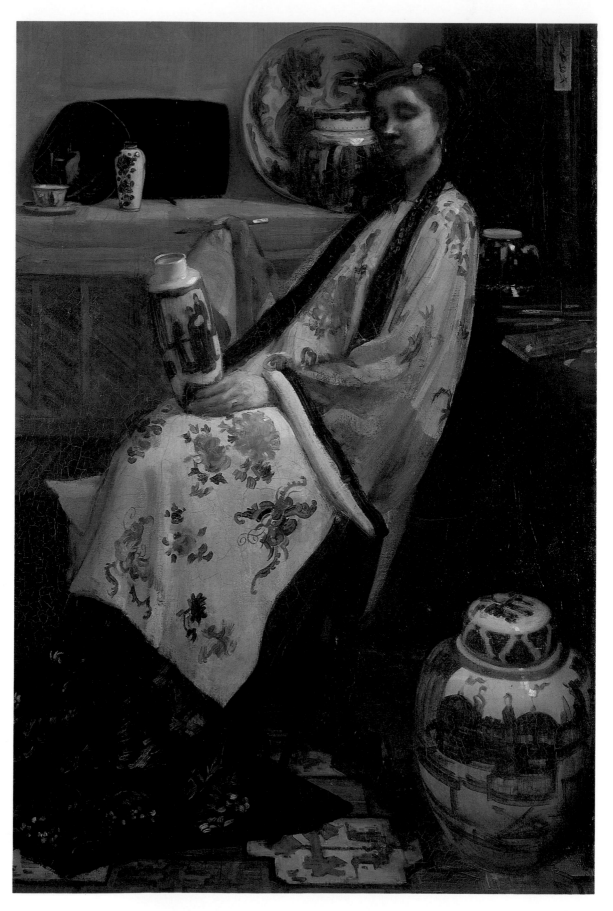

NINETEENTH-CENTURY WARES

Throughout the nineteenth century, the Chinese devoted themselves to reproducing the glorious wares of earlier periods. Although the reign of Jiaqing (1796–1821) maintained high standards in porcelain production, it was a time of great turmoil. The Qing dynasty was doomed, caught between internal dissension and the encroachment of European power.

During the rule of Daoguang (1821–1850), the Chinese lost the Opium War to the British, and the Imperial Kingdom was opened completely to Western trade. This confused time saw a deterioration in the quality of the porcelain, but fine imitations of Kangxi blue and white were produced.

Jingdezhen was devastated in 1853, during the reign of Xianfeng (1851–1861), by the Tai Ping Rebellion. The kilns were not rebuilt until 1864, when respectable copies of Ming and Qing porcelains were produced. During the reigns of the last two emperors, Guangxu (1875–1908) and Xuantong (1909–1911), huge quantities of ordinary blue and white export wares were produced and shipped to the West.

In Europe during the 1860s and 1870s, there was a revival of interest in Chinese porcelain. Porcelain's appeal was now chiefly aesthetic rather than utilitarian. A serious appreciation of the arts of the Orient, including Chinese and Japanese pottery and porcelain, began with the pre-Impressionist painters. The artist Henri Fantin-Latour, who was sympathetic to the artistic aims of the French pre-Impressionists, painted sensitive still lifes of flower arrangements in vases of Chinese blue and white porcelain as well as in eighteenth-century Chinese-style Delft copies. He had probably seen the Chinese originals at La Porte Chinoise, an Oriental curio shop in Paris that opened on rue de Rivoli around 1862.

In London, Fantin-Latour's friend the artist James McNeill Whistler was bankrupted by his extravagant outlays for a collection of porcelain that the dealer Murray Marks called "one of the most important in England."[1] Whistler's omnivorous passion for porcelain was shared by Oscar Wilde, members of the British Aesthetic Movement, and Lazenby Liberty, who "founded one of the world's most famous department stores on the craze for collecting Oriental china."[2]

Whistler painted wonderful watercolor illustrations of Sir Henry Thompson's collection for A Catalogue of Blue and White Nankin Porcelain, which accompanied the collection's exhibit in 1876–1877. "Nankin" was the catch-all term of the time, given mistakenly to all Kangxi export porcelains.

At the celebration to honor Whistler following publication of the catalog, "Foods were carefully selected for the color harmonies they would produce against blue and white dishes. The period's recherché appreciation of the china for its color alone can be seen in remarks made by guests, such as 'observe the effect of the exquisite pink [smoked salmon] on that lovely blue.' "[3]

Whistler's superb contribution to the decorative

JAMES McNEILL WHISTLER (AMERICAN, 1834–1903).
Purple and Rose: The Longe Leizen of the Six Marks, 1864. Oil on canvas. *Dimensions:* 36" x 24½".
Whistler's model/mistress Jo Hiffernan is represented as a painter of porcelain in this idealized Victorian setting. The porcelain shown was part of Whistler's personal collection. Philadelphia Museum of Art, the John G. Johnson Collection.

QING DYNASTY, LATE NINETEENTH CENTURY.
Underglaze blue jar with cover. Classic prunus blossom in
cracked-ice design. The central design shows furniture and flowers.
Height: 9".
Private collection Mr. Arthur Williams.

QING DYNASTY, NINETEENTH CENTURY.
Underglaze blue garniture: a covered jar and a pair of
beaker vases. The body is decorated with *ling-cheh*
fungus surrounding a typical nineteenth-century motif of
stands with containers of flowers. Around the base is a
stylized pattern of breaking waves.
Height: 18".
Private collection Mr. Carl Steele.

QING DYNASTY, NINETEENTH CENTURY.
Underglaze blue beaker based on an earlier Kangxi form, once part
of a garniture set for a chimneypiece. On the neck are figures in a procession.
Height: 12".
Private collection Mr. Carl Steele.

QING DYNASTY, NINETEENTH CENTURY.
Underglaze blue bottle decorated with a landscape and figure.
Height: 11¾".
Private collection Mr. Carl Steele.

arts is the Peacock Room of 1876–1877, a jewel-like exhibition room that was a recreation of a baroque china cabinet, or *porzellanzimmer*. It harmonized French rococo and *japonesque* elements as a showcase for the blue and white collection of the British shipping baron Frederick Richards Leyland. The Peacock Room was moved from London to the Detroit mansion of Whistler's patron, Charles Freer, and later to a permanent location at the Freer Gallery of Art in Washington, D.C.

Interest in Chinese blue and white continued into the twentieth century. Until the First World War, collectors cherished export porcelains, mostly of the later Qing dynasty reigns. Between the world wars, connoisseurs, scholars, and knowledgeable dealers, mainly in London, began to appreciate the wares the Chinese had made for themselves, including those created for the imperial palace.

The development of an international market with a taste for early Ming dynasty imperial blue and white in the 1970s and 1980s has resulted in intense competition for the rarest pieces. Widely publicized auctions of tablewares salvaged from vessels wrecked in the eighteenth century have heightened the sense of romance and adventure surrounding the search for antique porcelains.

What are the rewards today of a voyage to China for the zealous porcelain collector? Although Chinese law forbids the sale and export of objects dating from earlier than the Jiaqing reign (1796–1820), it is still possible to find nineteenth-century blue and white in the antique shops of Canton and other Chinese cities. The handsome hong buildings, sadly, vanished long ago from the Canton waterfront.

For the impassioned collector, the advice of a writer of the late Ming dynasty is as relevant today as when it was first offered. In an essay on flower vases, he recommended: "Prize the porcelain and disdain gold and silver. Esteem pure elegance."[4]

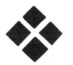

QING DYNASTY, LATE NINETEENTH CENTURY.
LEFT: Underglaze blue hatstand. *Height:* 10⅝".
CENTER: Baluster-shaped vase in underglaze blue with Double Happiness symbol. *Height:* 15".
RIGHT: Covered jar in underglaze blue with Double Happiness symbol and teak replacement cover. *Height:* 8¼".
All, courtesy Nuri Farhadi, Inc.
BACKGROUND: a section of an eighteenth-century watercolor-painted Chinese wall covering made for the English market. Silk on paper, about 60' x 10'.
Courtesy Charles R. Gracie and Sons.

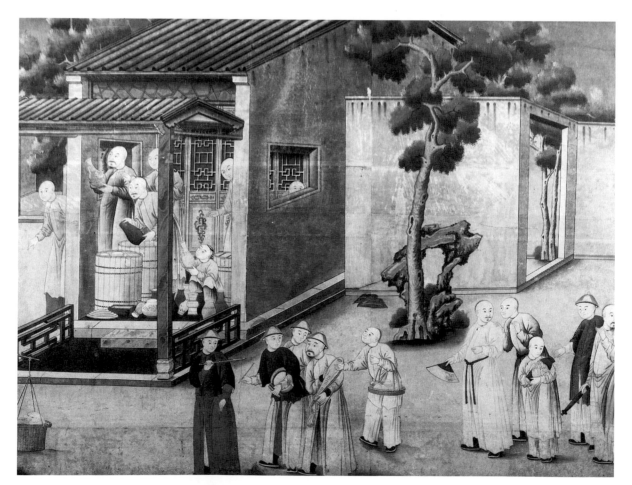

DETAIL OF WALLPAPER PANEL, ca. 1760.
Watercolor on paper.
Dimensions: 34¾" x 47½".
Scene of porcelain inspection. At the left is a porcelain store, with
men examining and packing porcelain in wooden tubs. In the
center are three musicians, followed by a group of merchants
arriving to purchase porcelain.
The Mottahedeh Collection.

EAST-WEST CHRONOLOGY
Principal Chinese Dynasties and Imperial Reigns
(Pinyin and Wade-Giles transliterations)

CHINA		THE WEST
TANG DYNASTY	618–906	
High-fired, resonant porcelain is achieved.		
FIVE DYNASTIES	907–960	
NORTHERN SUNG DYNASTY	960–1127	
SOUTHERN SUNG DYNASTY	1127–1279	
Kublai Khan (r. 1260–1294) establishes his capital, now Beijing.	1264	
	1271	Marco Polo departs for Kublai Khan's court.
YUAN or MONGOL DYNASTY	1279–1368	
Blue and white porcelain is invented in Jingdezhen.	?–1325?	
	1298–1299	Marco Polo relates his adventures to a fellow prisoner in a Genoese prison.
MING DYNASTY	1368–1644	
Hongwu (Hung-wu)	1368–1398	
Yonglo (Yung-lo)	1403–1424	
Xuande (Hsuan-te)	1426–1435	
Jingtai (Ching-t'ai)	1450–1456	
	1461	Doge Pasquale Malipiero of Venice receives a gift of twenty pieces of blue and white porcelain from the Sultan of Egypt.
Chenghua (Ch'eng-hua)	1465–1487	
Hongzhi (Hung-chih)	1488–1505	
	1497	Vasco da Gama discovers a new route to the East.
Zhengde (Cheng-te)	1506–1521	
Jiajing (Chia-ching)	1522–1566	
Longqing (Lung-ch'ing)	1567–1572	
Wanli (Wan-li)	1573–1620	
	1577–1580	Sir Francis Drake circumnavigates the globe.
	1582	Soft-paste porcelain is produced by Francesco de' Medici.
	1600	The London East India Company is chartered by Elizabeth I of England.
	1602	The Dutch East India Company is established.
TRANSITIONAL PERIOD	1620–1683	
Tianqi (T'ien-ch'i)	1621–1627	
Chongzhen (Ch'ung-chen)	1628–1644	
QING (Ch'ing) or MANCHU DYNASTY	1644–1911	
Shunzhi (Shun-chin)	1644–1661	
Kangxi (K'ang-hsi)	1662–1722	
	1675	The Dutch imitate blue and white Chinese porcelain at Delft.
	1699	Kangxi opens Canton to Western trade. The English dominate.
	1709	Bottger discovers the secret of hard-paste porcelain at Dresden.
Yongzheng (Yung-cheng)	1723–1735	
Qianlong (Ch'ien-lung)	1736–1795	
	1784	The *Empress of China* arrives in Canton.
Jiaqing (Chia-ch'ing)	1796–1820	
Daoguang (Tao-kuang)	1821–1850	
Xianfeng (Msien-feng)	1851–1861	
	1856	The Canton factories are burned by the Chinese.
Republic of China	1912–1949	
People's Republic	1949–	

SOURCES

Directory of those dealers specializing in antique porcelain,
furniture, and decorative objects who contributed to this book.

The Antique Porcelain Company
605 Park Avenue
New York City, NY 10022
(212) 758-2363
*Eighteenth-century European ceramics, objets vertu,
and French furniture. By appointment only.*

Bardith, Ltd.
901 Madison Avenue
New York City, NY 10021
(212) 737-3775
*Eighteenth- and nineteenth-century English, Dutch,
and French ceramics.*

Bardith I
1015 Madison Avenue
New York City, NY 10021
(212) 737-6699
*Eighteenth- and nineteenth-century English furniture,
pictures, decorative accessories, and Victoriana.*

Ralph M. Chait Galleries
12 East 56th Street
New York City, NY 10022
(212) 758-0937
*The oldest American firm specializing in all forms of
Chinese art from the Neolithic period to the nineteenth
century, furniture and paintings excepted.*

The Chinese Porcelain Company
822 Madison Avenue
New York City, NY 10021
(212) 628-4101
*Chinese porcelain, furniture, and rugs, from early
export wares to the nineteenth century.*

Rose Cumming
232 East 59th Street
New York City, NY 10022
(212) 758-0844
*Chinese and Continental porcelain, furniture, and
accessories; English and American chintz. To the trade
only. Entrée through interior decorator or architect.*

Nuri Farhadi
920 Third Avenue
New York City, NY 10022
(212) 355-5462
*Eighteenth- and nineteenth-century Chinese porcelain
and furniture.*

Flores & Iva
799 Broadway
New York City, NY 10003
(212) 673-1866
*Eighteenth- and nineteenth-century Chinese porcelain.
To the trade only. Entrée through interior decorator
or architect.*

Charles R. Gracie & Sons
979 Third Avenue
New York City, NY 10022
(212) 753-5350
*Chinese porcelain, wallpaper panels, screens, and
decorative accessories. To the trade only. Entrée
through interior decorator or architect.*

John Rosselli, Ltd.
255 East 72d Street
New York City, NY 10021
(212) 737-2252
*Eighteenth- and nineteenth-century Chinese and English
ceramics and accessories. To the trade only. Entrée
through interior decorator or architect.*

Scarborough Fair
88 Atlantic Avenue
Brooklyn, NY 11201
(718) 237-0879
*Eighteenth- and nineteenth-century English and
Continental porcelain, furniture, and decorative objects.*

David Seidenberg Antiques
836 Broadway
New York City, NY 10003
(212) 260-2810
*Eighteenth- and nineteenth-century Chinese and
Continental porcelain and decorative objects.*

Sylvia Tearston
1053 Third Avenue
New York City, NY 10021
(212) 838-0415
*Eighteenth-century Chinese porcelain, English furniture,
paintings, and decorative objects.*

Earle D. Vandekar of Knightsbridge
15 East 57th Street
New York City, NY 10022
(212) 308-2022
 and
138 Brompton Road
London SW31HY England
01-589-8481
*Seventeenth- to nineteenth-century Chinese, English,
and Dutch ceramics, specializing in complete services.*

Michael B. Weisbrod
987 Madison Avenue
New York City, NY 10021
(212) 734-6350
*Chinese ceramics from the Neolithic period to the
nineteenth century; furniture, paintings, and jade.*

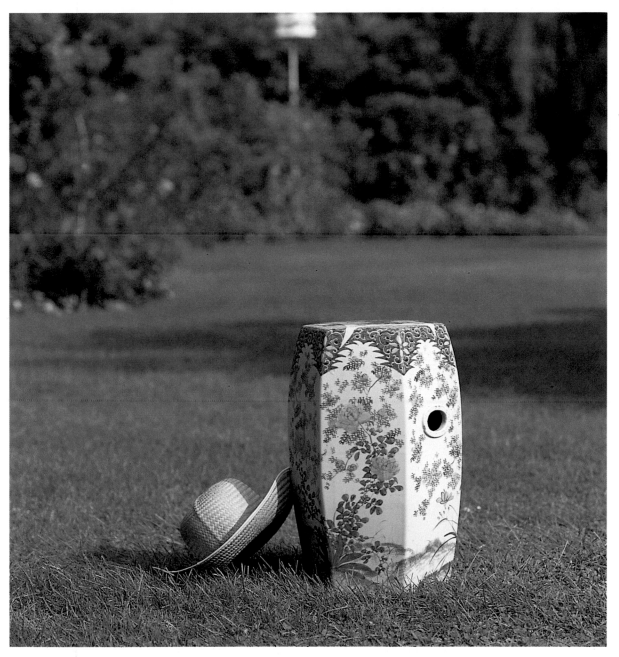

QING DYNASTY, LATE NINETEENTH CENTURY.
Underglaze blue garden seat with decoration of flowers.
Height: 17".
Private collection Mr. Arthur Williams.

NOTES

INTRODUCTION

1. Duncan Macintosh, *Chinese Blue and White Porcelain* (Rutland, Vermont: Charles E. Tuttle, 1977), 105.
2. John Carswell, "Blue and White Porcelain in China." In *Blue and White: Chinese Porcelain and Its Impact on the Western World* (Chicago: University of Chicago, 1985), 13.

BEGINNINGS

1. John E. Vollmer, E. J. Keall, and E. Nagai-Berthrong, *Silk Roads and China Ships* (Toronto: Royal Ontario Museum, 1983), 1.

JINGDEZHEN, THE PORCELAIN CAPITAL

1. John Goldsmith Phillips, *China-Trade Porcelain* (Cambridge, Mass.: Harvard University Press, 1956), 2, quoting from William Burton, *Porcelain: a Sketch of Its Nature, Art and Manufacture* (London: Cassell & Co., Ltd. 1906).
2. Carswell, in *Blue and White,* 18, quoting from M. Reinaud, *Relations des voyages faits par les Arabes et Persans, dans l'Inde et à la Chine dans le IX siècle de l'ére Chrétien* (Paris, 1845), 1: 34, Arabic text, 35–36.
3. Geoffrey R. Sayer, editor and translator, *Ching-tê-chên t'ao lu or The Potteries of China* (London: Routledge and Kegan Paul, 1951) 7–8.
4. Margaret Medley, "Chinese Ceramics and Islamic Design." In *The Westward Influence of the Chinese Arts from the 14th to the 18th Century, Colloquies on Art & Archaeology in Asia* (London: Percival David Foundation, 1973) 3:1.

THE MING DYNASTY

1. Judith Burling and Arthur Hart Burling, *Chinese Art* (New York: Bonanza Books, 1953), 153.
2. Sheila Riddell, *Dated Chinese Antiquities, 600–1650* (London: Faber & Faber, 1979), 87.
3. Macintosh, 27.
4. Phillips, 43.

TRANSITIONAL PERIOD

1. Stephen Little, *Chinese Ceramics of the Transitional Period: 1620–1683* (New York: China Institute in America, 1983), 1.
2. Richard S. Kilburn, *Transitional Wares and Their Forerunners* (Hong Kong: The Oriental Ceramic Society of Hong Kong, 1981), 39.

THE QING DYNASTY

1. Mario Amaya, "Antiques: K'ang Hsi Porcelain." *Architectural Digest* (July 1979): 66.
2. R. L. Hobson, *Chinese Pottery and Porcelain* (New York: Dover Publications, 1976), 126.
3. Phillips, 10.
4. Hobson, 128.
5. Hobson, 130.

TRADE WITH THE WEST

1. Phillips, 17.

PORT OF CANTON

1. Michel Beurdeley, *Porcelain de la Compagnie des Indes,* trans. D. Imber (Rutland, Vermont: Charles E. Tuttle, 1962), 19.
2. Jean McClure Mudge, *Chinese Export Porcelain for the American Trade* (Newark, Del.: University of Delaware Press, 1962), 66.

EUROPEAN-MOUNTED CHINESE PORCELAIN

1. Sir Francis Watson, *Chinese Porcelain in European Mounts* (New York: China Institute in America, 1980), 11.
2. Sir Francis Watson, *Mounted Oriental Porcelain* (Washington, D.C.: International Exhibitions Foundation, 1986), 14, 15.

SPECIAL ORDERS

1. Phillips, 57.

FITZHUGH WARE

1. D. F. Lunsingh Scheurleer, *Chinese Export Porcelain: Chine de Commande* (New York: Pitman Publishing, 1974), 132–133.

NANKING WARE

1. Hiram Tindall, "The Canton Pattern." In *Chinese Export Porcelain,* ed. Elinor Gordon (New York: Main Street/Universe Books, 1975), 164.
2. David Howard and John Ayers, *Masterpieces from the Mottahedeh Collection of Chinese Export Porcelain in the Virginia Museum* (London: Sotheby Parke-Bernet, 1980), 29.

CANTON WARE

1. Tindall, 163.
2. Tindall, 163.
3. Tindall, 163.
4. Tindall, 164, quoting from Alice Morse Earle, *China Collecting in America* (New York: n.p., 1892), 184.

DELFTWARE

1. Edward A. Maser, "The European Imitators and Their Wares." In *Blue and White China Porcelain and Its Impact on the Western World* (Chicago: University of Chicago, 1985), 39.
2. Kilburn, 28.
3. Maser, 40.

MEISSEN WARE

1. Beurdeley, 112.
2. Jerry E. Paterson, *Porcelain* (Washington, D.C.: Smithsonian Institution, 1979), 37.

ENGLISH WARES

1. Bernard Watney, *English Blue and White Porcelain of the 18th Century* (London: Faber & Faber, 1973), 6.
2. W. B. Honey, *English Pottery and Porcelain* (London: A. & C. Black, 1933), 54.
3. Watney, 6.
4. Watney, 9, n. 2, quoting from Il. Jewitt, *The Ceramic Art of Great Britain* (London: 1878), vol. 1.

NINETEENTH-CENTURY WARES

1. David Park Curry, *James McNeill Whistler at the Freer Gallery of Art* (Washington, D.C.: Freer Gallery of Art, 1984), 170.
2. Amaya, 66.
3. Curry, 170.
4. Hobson, xviii.

BIBLIOGRAPHY

Amaya, Mario. "K'ang Hsi Porcelain." *Architectural Digest* 36 (July 1979): 66–71.

Beurdeley, Michel. *Porcelain de la Compagnie des Indies.* Translated by D. Imber. Rutland, Vermont: Charles E. Tuttle, 1962.

Boorstin, Daniel J. *The Discoverers.* New York: Random House, 1983.

Burling, Judith, and Arthur Hart Burling. *Chinese Art.* New York: Bonanza Books, 1953.

Carswell, John. "Blue and White Porcelain in China." In *Blue and White: Chinese Porcelain and Its Impact on the Western World.* Chicago: University of Chicago, 1985. (Exhibition catalog)

————. "Blue and White in China, Asia and the Islamic World." In *Blue and White: Chinese Porcelain and Its Impact on the Western World.* Chicago: University of Chicago, 1985. (Exhibition catalog)

Curry, David Park. *James McNeill Whistler at the Freer Gallery of Art.* Washington, D.C.: Freer Gallery of Art, 1984. (Exhibition catalog)

Du Boulay, Anthony. *Chinese Porcelain.* New York: G. P. Putnam's Sons, 1963.

Garner, Sir Harry. *Oriental Blue and White.* London: Faber & Faber, 1954.

Gordon, Elinor. *Collecting Chinese Export Porcelain.* Pittstown, New Jersey: The Main Street Press, 1984.

————, ed. *Chinese Export Porcelain.* New York: Main Street/Universe Books, 1975.

Hobson, R. L. *The Wares of the Ming Dynasty.* Rutland, Vermont: Charles E. Tuttle, 1962.

————. *Chinese Art.* London: Spring Books, 1964.

————. *Chinese Pottery and Porcelain.* New York: Dover Publications, 1976.

Honey, W. B. *English Pottery and Porcelain.* London: A. & C. Black, 1933.

————. *Dresden China.* London: A. & C. Black, 1934.

————. *The Art of the Potter.* New York: Beechhurst Press, 1955.

Howard, David Sanctuary. *New York and the Dutch China Trade.* New York: The New-York Historical Society, 1984. (Exhibition catalog)

Howard, David, and John Ayers. *China for the West.* Two volumes. London and New York: Sotheby Parke-Bernet, 1978.

————. *Masterpieces of Chinese Export Porcelain from the Mottahedeh Collection in the Virginia Museum.* London: Sotheby Parke-Bernet, 1980.

Jorg, C. J. A. *Porcelain and the Dutch China Trade.* The Hague: Nyhoff, 1982.

————. "The Interaction Between Oriental Porcelain and Dutch Delftware." *Orientations* 14 (September 1983): 10–24.

Kilburn, Richard S. *Transitional Wares and Their Forerunners.* Hong Kong: The Oriental Ceramic Society of Hong Kong, 1981. (Exhibition catalog)

Lee, Jean Gordon. *Philadelphians and the China Trade 1784–1884.* Philadelphia: Philadelphia Museum of Art, 1984. (Exhibition catalog)

Little, Stephen. *Chinese Ceramics of the Transitional Period: 1620–1683.* New York: China Institute in America, 1983. (Exhibition catalog)

Macintosh, Duncan. *Chinese Blue and White Porcelain.* Rutland, Vermont: Charles E. Tuttle, 1977.

Maser, Edward A. "The European Imitators and Their Wares." In *Blue and White: Chinese Porcelain and Its Impact on the Western World.* Chicago: University of Chicago, 1985. (Exhibition catalog)

Medley, Margaret. "Chinese Ceramics and Islamic Design." In *The Westward Influence of the Chinese Arts from the 14th to the 18th Century, Colloquies on Art & Archaeology in Asia,* vol. 3. London: Percival David Foundation, 1973.

Moore, N. Hudson. *Delftware Dutch and English.* New York: Frederick A. Stokes, 1908.

Mudge, Jean McClure. *Chinese Export Porcelain for the American Trade.* Newark, Del.: University of Delaware Press, 1962.

Neave-Hill, W. B. R. *Chinese Ceramics.* New York: St. Martin's Press, 1975.

Paterson, Jerry E. *Porcelain.* Washington, D.C.: Smithsonian Institution, 1979.

Phillips, John Goldsmith. *China-Trade Porcelain.* Cambridge, Mass.: Harvard University Press, 1956.

Riddell, Sheila. *Dated Chinese Antiquities, 600–1650.* London: Faber & Faber, 1979.

Rusl, Gordon A. *Collector's Guide to Antique Porcelain.* New York: Viking Press, 1973.

Savage, George. *Porcelain Through the Ages.* London: Cassell & Company, 1961.

Sayer, Geoffrey R., editor and translator. *Ching-tê-chên t'ao lu or The Potteries of China.* London: Routledge and Kegan Paul, 1951.

Scheurleer, D. F. Lunsingh. *Chinese Export Porcelain: Chine de Commande.* New York: Pitman Publishing, 1974.

Smith, Philip Chadwick Foster. *The Empress of China.* Philadelphia: Philadelphia Maritime Museum, 1984. (Exhibition catalog)

Tait, Hugh. *Porcelain.* London: Spring Art Books, 1963.

Tamarin, Alfred, and Shirley Glubok. *Voyaging to Cathay—Americans in the China Trade.* New York: The Viking Press, 1976.

Tindall, Hiram. "The Canton Pattern." In *Chinese Export Porcelain,* edited by Elinor Gordon. New York: Main Street/Universe Books, 1975.

Vollmer, John E., E. J. Keall, and E. Nagai-Berthrong. *Silk Roads and China Ships.* Toronto: Royal Ontario Museum, 1983. (Exhibition catalog)

Watney, Bernard. *English Blue and White Porcelain of the 18th Century.* London: Faber & Faber, 1973.

Watson, Sir Francis. *Chinese Porcelain in European Mounts.* New York: China Institute in America, 1980. (Exhibition catalog)

————. *Mounted Oriental Porcelain.* Washington, D.C.: International Exhibitions Foundation, 1986. (Exhibition catalog)

Whitman, Marina D. "Sixteenth-Century Persian Blue-and-White Dish." In *Orientations* 14 (September 1983): 26–29.

INDEX

Lys ou Stades Chinois.

50 100 150 200 250

Lieues comunes de France.

5 10 15 20 25

HOU QUANG

QUANG SI

NGAN-NAN
ou TONG KING

NAN HAI

ISLE

DE HAINAN

CHAO TCHEOU FOU

QUANG TCHEOU FOU

CHAOKING FOU

KAOTCHEOU FOU

LIEN TCHEOU FOU

LEIT CHEOU FOU

Chang tchuen Chan
ou Isle de Sancian

Kan-ngen hien

Yai-tcheou

Van-tcheou

LIMOU CHAN

TCHIT CHAN

QUIONG TCHEOU FOU